RELIGIOUS OBJECTS IN MUSEUMS

RELIGIOUS OBJECTS IN MUSEUMS

Private Lives and Public Duties

Crispin Paine

BLOOMSBURY
LONDON · NEW DELHI · NEW YORK · SYDNEY

Bloomsbury Academic

An imprint of Bloomsbury Publishing Plc

50 Bedford Square 175 Fifth Avenue
London New York
WC1B 3DP NY 10010
UK USA

www.bloomsbury.com

First published 2013

© Crispin Paine, 2013

British Library Cataloguing-in-Publication Data
A catalogue record for this book is available from the British Library.

ISBN: HB: 978-1-8478-8774-0
 PB: 978-1-8478-8773-3

Library of Congress Cataloging-in-Publication Data

Paine, Crispin.

Religious objects in museums : private lives and public duties / Crispin Paine. — English ed.
p. cm.
Includes bibliographical references and index.
ISBN 978-1-84788-773-3 (pbk.) — ISBN 978-1-84788-774-0 () 1. Museums—
Religious aspects. 2. Museums—Social aspects. 3. Religious articles. 4. Museums—
Curatorship. 5. Museum visitors. 6. Museum exhibits—Religious aspects.
7. Museum exhibits—Social aspects. 8. Religion and culture. I. Title.
AM7.P25 2013
200.75—dc23 2012027469

Typeset by Apex CoVantage, LLC, MI, USA.
Printed and bound in Great Britain

for my mother

CONTENTS

LIST OF ILLUSTRATIONS

PREFACE

As a young man I went backpacking in the Middle East and Asia. It was affordable in those days and (except for Burma and Israel) most countries were easily accessible. Among all the transforming experiences the adventure gave me, two stand out. The first was the realization, standing in the local museum in Sarajevo in what was then Tito's Yugoslavia, that this was what I wanted to do. Using objects to help people to understand how their community had grown seemed to me (and it still seems) a high ambition and a fascinating challenge. The second experience was more diffuse. My wanderings took me into Sufi shrines; Sunni mosques; Saivite and Vishnavite temples; The Golden Temple at Amritsar; Buddhist and Ethiopian monasteries; Orthodox, Coptic, Assyrian, Catholic, Anglican and Armenian churches; and on the way home, the Holy Sepulchre in Jerusalem. At the time, not having the language to ask about what I was seeing was frustrating. But looking back, it made me pay attention to what people were actually doing, and to the things they were doing it with. To understand, I had to rely on my own religious upbringing and on the interest in ecclesiology and liturgy that had so amused my university friends.

It was many years before these two experiences came consciously together. In 2000, I edited a book of essays about museums and religion, *Godly Things*, apparently the first book to treat the subject. Meanwhile, the world had changed dramatically. Formal religion was fast declining in much of Western Europe (though 'spirituality' wasn't), but in much of the rest of the world religion was becoming ever more powerful and so more political. Museums, too, had changed, with a huge new public interest, a new recognition of their political role and social potential, and new attention to their visitors. *Godly Things* concluded that, though museums still largely ignored religion, there were signs of change, and that there was an important role for museums to play in what was always a central part of the human experience.

Twelve years later, there seems a need to take another look. The first aim of this book is, thus, to review the way museums now handle religion. As we shall see, there is now much more going on, and as the bibliography shows, much more academic interest. But most of this debate is about museums as media, and how they increasingly address religion, and the challenges they face. My intention here is to

concentrate on religious *objects*. The unique role of museums is to use objects to tell stories, to raise spirits and to advance arguments, and though museums have many other agendas and use many other techniques, it is their collection and deployment of objects that is their special genius.

My second aim is simply to celebrate the extraordinary diversity of religious objects in museums, and of attitudes and approaches to them by curators and visitors alike. I confess it is this celebration and fascination that draws me most strongly.

My third aim is to suggest that religious objects take on in museums a variety of roles and meanings, personalities and duties—not merely that of art objects, or of historical or scientific specimens. I shall argue that each of these roles and meanings is the product of a three-way interaction between object, curator and visitor, or if you prefer, a negotiation between curator and visitor. I shall accept that objects have agency, and that that is a useful way to consider them (though I shall not go in any depth into all the arguments around that idea), but that each of those personalities and duties is imposed on them by curator and/or visitor. For me (though not, I appreciate, for everyone) this is self-evident.

My final aim is more a hope: that museums will be more aware of the religious background and character of so many different objects in their collections, and will be more adventurous in celebrating that character.

This book is intended for people interested in museums as visitors or museum workers, for people interested in how religion plays out in everyday life and how it relates to some of our secular institutions, and for people interested simply in one way in which cultural institutions reflect 'humankind's eternal search for meaning'.

A great many people have contributed to this book, some consciously, more unconsciously. The latter include a great many writers and commentators from within and without the museum profession, as well as those who have created displays and exhibitions, websites and study collections. They include a great many people I have talked to at conferences and seminars or just casually, or to whose lectures I have listened. They certainly include my fellow editors of the journal *Material Religion*, who have so patiently helped my stumbling in the strange new world of academia. The conscious contributors include my wife Ani, whose encouragement has been beyond price, and our son Peter, who would have made me start again if he could. Graham Howes, Mark O'Neill and Mary Brooks gave an extraordinarily generous amount of their time to try to make this book better, and though I'm afraid they will feel I've failed adequately to respond, nevertheless I am deeply grateful. I also owe a large debt to UCL's Institute of Archaeology; without its support, this project and a number of others would have been impossible. Some of those who consciously helped I have been able to acknowledge in footnotes, but to the many others—you know who you are, and I really am very grateful, even if you don't think I took your advice properly.

I offer my grateful thanks, too, to Bloomsbury, and especially to Anna Wright, a wonderfully patient Commissioning Editor, to her successor Louise Butler and Editorial Assistant Sophie Hodgson, and to Emily Johnston at Apex Publishing.

One reader of an early draft (it must have been extremely badly written) shocked me by asking, 'Why do you hate curators and conservators so much?' On the contrary, I greatly admire curators and conservators and am very proud to have been associated with museum people throughout my career. This book is dedicated to all those museum workers who have struggled and are struggling to collect, research, display and interpret objects from the world of religion, that key element of the human experience.

INTRODUCTION

To our surprise, religion is once again challenging the secular world. One little-regarded way this is happening is through the impact of 'religious' objects demanding recognition in our museums. In the past, museums insisted on changing the meaning of icons or statues of the gods from sacred to aesthetic, or on using them to declare the superiority of Western society, or simply as cultural and historical evidence. Only in natural history museums were specimens sometimes presented as evidence of the wonderful works of the Lord. Over the past generation a major change has developed, with scholars paying a new and quite different attention to objects generally, faith groups demanding to control 'their' objects, and curators recognizing that religious objects can only be understood if their original religious meaning is recognized.

UMBRAWARRA GORGE

When in the late 1990s the US National Aquarium in Baltimore was planning (with some $75 million to spend) a huge new display on the wildlife ecology of northern Australia, they decided on the most dramatic presentation possible: a ten-storey replica of the Umbrawarra Gorge in Queensland. They built a thirty-five-foot waterfall, occupying 65,400 square feet, behind 33,000 square feet of glass in a building designed by the famous architect Peter Chermayeff. To stock it, they had to transport 1,800 animals from Australia to Baltimore. It never occurred to them that they were facing religious issues.

Yet what they were creating in the museum, all unawares, was a religious object. To the local Wagiman people living around it, the gorge was a sacred place, and to reproduce it without consultation was effectively an act of sacrilege.

> Wagiman traditional owner's objections highlighted important aspects about the nature of Indigenous dreaming and the sacred landscape. The Eagle and Chicken Hawk dreaming links the Wagiman with other Aboriginal language

groups and country by travelling from place to place. For the Wagiman, it was logical to deduce that as the name of Umbrawarra Gorge travelled to the replica in Baltimore, then the dreaming and significance of the place travelled with it. This includes all cultural attributes and restrictions that apply to culturally significant places. (Guse 2005)

The Aquarium dropped reference to Umbrawarra Gorge, and named the new display 'Animal Planet Australia'—which raised a new issue by changing its meaning from a place of sacred significance for the aboriginal people to a place valued only for its natural environment. Only after protracted discussions and the involvement of Wagiman leaders in the project was the issue resolved. This 120-foot display is dramatically larger than most religious objects in museums; yet it exemplifies, on its huge scale, many of the issues that museums today face in dealing with religious objects.

MUSEUMS MAKE ALL THINGS NEW

'Museumification'—the entry of an object into a museum—has a striking parallel with 'sacralization'—the making of an object sacred. Both are processes that remove the object from the mundane world, and most notably remove the object's exchange value. In theory at least (and the principle, though often violated, is still normally held), neither museum objects nor sacred objects, once they have been accessioned or consecrated, can be exchanged. Thereafter, they share a unique character: they are both outside the normal world of commodities. They have become priceless, joining the very few other things our society still regards as not available for sale, such as (as Ronald Grimes points out in his 1992 paper) your mother or your children.[1]

Moreover, as soon as an object comes into a museum, it becomes a 'museum object'. It acquires a new meaning, a new value, a new personality which more or less completely overlays its previous one. This effect is particularly dramatic and intense when the object concerned is in some way 'religious', because of the contrast between the new value or meaning the museum ascribes to the object and its previous meaning as a symbol or even object of devotion. However, its former meaning may never be completely obscured, and there may be people, perhaps quite a lot of people, who wish to see the object restored in part or in whole to its former value.

The aim of this short book is to take a look at what happens to objects which may in some sense be considered 'religious', once they enter a museum. That religious objects change their meaning when they enter a museum is widely recognized. Usually, though, it is assumed that they just change into 'works of art'. They often do, but the aim here is also to examine other ways they can change: into historical evidence, scientific specimens, militant fighters for their new masters' cause, objects still worthy

of worship (or at least of veneration), objects demanding respect, objects supporting the political struggle of their former masters, objects promoting or illustrating their religious cause.[2] My aim is also to look at some of the implications of these changes. How stable are they—do objects regain a 'religious' meaning when lent back to a place of worship, as church plate, for example, sometimes is? How much do meanings vary according to the viewer, the interlocutor? How far can the curator control this interaction between religious object and museum visitor? What might be the curator's aim—perhaps to use the object for a particular missionary, educational or political cause? How far should museums go in observing the conventions of their source communities in day-to-day treatment of religious objects? What are the implications for conservators and store-managers and designers of the various rules and taboos that religious objects may carry? The fact is that acknowledging the 'religious' aspects of religious objects can make life very difficult for museum staff. But the rewards, in public understanding and empathy between communities, are enormous.

RELIGIOUS OBJECTS ARE ASKING FOR ATTENTION

The situation of religious objects in museums is changing rapidly. As we shall see, anthropology museums have always taken religion seriously, as it is practiced, and as it reflects and inspires patterns of living. History museums, however, have largely limited their treatment of religion to religious institutions, while art galleries have concentrated on aesthetics. Increasingly though, art galleries are arranging exhibitions which bring out the sacred character of the exhibits, conservators are taking into account the religious meaning that inheres in the objects they treat, some faith groups are consulted over the way in which they are represented, and other faith groups are turning to museum techniques to present their beliefs. Why are things changing? The main explanation lies in the current dominance of religious discourse, and in the way that globalisation has made people throughout the world aware of other faiths, and often concerned to protect and promote their own. We shall see how museums respond to these demands and concerns in a variety of ways. We shall see, too, that a major incentive to museums to take religion very seriously, one largely led by museum learning staff, is the demand that museums join in helping to promote community harmony.

Museums' new interest in religion is reflected, too, in the literature and in both professional and academic debate. Discussion of the role of religion in museums and of museums in religion takes place in the context of the explosion of interest in the material culture of religion. Grimes (1992) was one of the first (and remains

one of the best) studies of sacred objects in museums, and Paine (2000) was one of the first books to explore how different religions have been presented in museums in the world. There have since been a limited number of general studies[3] and a larger number of studies of individual museums or groups of museums.[4] There is also now a significant corpus of journal articles, not least in *Material Religion: The Journal of Objects, Art and Belief*, a journal founded in 2005 that takes a special interest in religion in museums.[5]

This book begins (chapter two) by examining how objects entering a museum are given a new meaning by their curators, and then (chapter three) looks at their relationship with their visitors, and (chapter four) their sometimes insistence on being worshipped. Source communities can demand their return, or that they be treated with 'respect' (chapter five). Chapter six asks what this respect means. Holiness can be dangerous, and so sometimes can religious objects in museums, which can also merge into shrines (chapter seven). Chapter eight, at the other extreme, considers how works of art are held to elevate the secular soul, either through their beauty or through their spiritual intent, while chapters nine and ten review the way in which religious objects can be 'turned' to fight for their new masters, or enlisted to promote a religious cause. Finally, chapter eleven discusses the far-more-familiar role of objects, especially in history museums, that helps to explain their faith and culture. This book is inevitably preliminary and exploratory, which means that much must be left out. I shall, for instance, look more at how religious objects acquit themselves in permanent collections and displays than at how they are used in education projects, public events, digital services and the like. I shall also largely ignore the question of human remains in museums, though these have attracted a great deal of attention in recent years, and the issues involved are very closely related to those surrounding religious objects.

WHAT ARE OBJECTS?

At least since Anaxarchus was accused of abolishing the criterion of truth because he likened 'things' to painted scenery and said they resemble the experiences of dreamers and madmen, philosophers have debated the nature and meaning of the object, the thing. Were objects merely painted scenery? What, if anything, lay behind them? Marx (1965: 71) observed: 'A commodity appears at first sight, a very trivial thing, and easily understood. Its analysis shows that it is, in reality, a very queer thing, abounding in metaphysical subtleties and theological niceties.' Since the 1980s, there has been a revolution in academic understanding of objects, and before considering religious objects, we must at least note some of the ways in which scholars and thinkers have thought about objects generally. Led by anthropologists and archaeologists, this revolution has been fought under the banner of 'material culture studies'

but, suggests Buchli (2002: 13),[6] 'has never really been a discipline—it is effectively an intervention within and between disciplines; translations from one realm into another'. This has indeed been its strength, and the ability to see a wide range of human activity, and a wide range of traditional academic disciplines, through the lens of things has contributed greatly to our understanding. It has also given back to museums and their collections an academic importance they had lost. As we shall see (in chapter eleven), Victorian museums were central to the idea that human societies everywhere go through a series of evolutionary stages intimately linked to technological development. Not only did this mean that those stages could be examined through the objects that survived from them, it also meant that more 'advanced' societies could justify their interference in less 'advanced' societies—a valuable support for imperialism. The abandonment of this theory in the 1920s went along with anthropologists turning away from an interest in material culture to a concern with how societies functioned as social systems—'the kinship diagram prevailed over the material culture "fossil"' (Buchli 2002: 7).

The new approach to material culture studies, though, is crucially concerned with social relationships, and with the relationships of things with people (Hicks 2010). As one university course description succinctly put it: 'The new field of material culture studies . . . inverts the longstanding study of how people make things by asking also how things make people, how objects mediate social relationships—ultimately how inanimate objects can be read as having a form of subjectivity and agency of their own.'[7] We shall come across the idea of objects having 'agency'—doing things—throughout this book. As Nicholas Thomas pointed out in his Foreword to Alfred Gell's famous *Art and Agency* (1998), 'For many scholars, and indeed in much common-sense thinking about art, it is axiomatic that art is a matter of meaning and communication. This book suggests that it is instead about *doing*'. For Gell, 'art works' had nothing to do with beauty; they were always intended to have an effect, they were about 'agency', and their importance lay in the web of social relationships in which they played their role. Artworks were not symbols, as many anthropological theorists had suggested, but social agents, the equivalent of persons. 'Art' was a special kind of technology, a technology that can enchant the public through its skill. But some critics have pointed out that Gell puts little emphasis on what the public bring to the table—on the role of the viewer's response in the process. We shall look at the importance of that response, in a museum context, in chapter three.

We should note, though, that much of this debate about the nature of things is limited to academia, and indeed very largely to those scholars involved in the material culture studies field. In the museum world, it has made very patchy impact, mainly among anthropologists and the more academically inclined archaeologists. Does this matter? Perhaps not so very much, for a thing may be understood in many

different ways. As Gell (1998: 123) put it, 'it does not matter in ascribing "social agent" status, what a thing (or person) "is" in itself; what matters is where it stands in a network of social relations.' We shall see how true this is of religious objects.

SOME RELIGIOUS OBJECTS ARE HOLY

There is a range of ways in which objects in museums may be 'religious', and this book will try to take a preliminary (it can only be that) look at some of the main ones. It will, though, eschew any attempt to define too carefully the 'religious object', considering that it is precisely their imprecision and variety that makes religious objects so interesting, and their recognition in the museum so important. Besides, the distinction between the religious and the mundane is not recognized in much of the world, nor in much of history, so to define an object as 'religious' is to say something about one's own thinking and categories, very probably not about the understanding of those who originated the object. As one First Nation commentator from British Columbia remarked:

> There aren't terms in Kwakwala that are the equivalent of 'sacred' or 'spiritual.' We talk about things not being ordinary, which is closer to 'not natural', maybe 'supernatural', but I don't know if I ever heard old people talk about 'sacred' or 'spiritual.' It's part of this whole invention—the invention of culture. (quoted in Clavir 2002: 181)

Her view would be reflected by countless people in countless different cultures. People find all sorts of categories through which to understand objects: religious and not-religious are just two of them. Better, surely, simply to accept as 'religious' any museum object anyone regards as such—that is what we shall do in this book. Nor should we forget that, even in the West, other objects could acquire a significance that is comparable to that of religion, and prompts a similar response of veneration. Such quasi-religious objects are particularly found in institutions such as schools, clubs and armies. Regimental colours—the flags that symbolize the regiment and that were once its rallying points in battle—receive a respect that comes close to a religious veneration. In pre-Independence India, each new recruit to Skinner's Horse took an oath of allegiance to the regiment on the sword of its founder James Skinner, much as in medieval Europe oaths were taken on holy relics. At Indian Independence, the regiment's British officers took the sword to England and presented it to the National Army Museum. It was returned 'on permanent loan' in the 1970s, and is once again used to swear in new recruits (Kaye 1980). But by the same token, by no means all 'religious' objects are 'holy' or 'sacred'; some may merely throw light on religion, and help to tell its story. A Methodist tea-service (Figure 1) would be

seen by few as inherently holy, but it can play a crucial role in the museum in telling the story of Methodism and the lively sub-culture it created, as well as carry many memories for elderly Methodists.

Modern museums recognize very clearly that the visitor to the museum brings to the object a range of knowledge, understandings, sympathies and moods, and that every encounter between visitor and object is an interaction in which the curator is playing the role of moderator. This relationality is particularly key when we are considering religious objects. Here the debate is often about the sanctity of the object, its nature, and how that sanctity got into the object. An excellent example is the debate that has, since the beginnings of Christianity, surrounded the Eucharist (Mass, Holy Communion, Lord's Supper), the central rite of Christianity. The bread and wine in this rite is almost universally agreed to 'be' the Body and Blood of Christ. But what is meant by 'be', and what actually happens in the rite, has been the subject of intense, often bitter, dispute. Since the twelfth century, the Roman Catholic Church has explained it through the theory of transubstantiation, whereby while the superficial 'accidents' of the bread remain the familiar bread, the underlying 'substance' is transformed into Christ's Body. Some Protestants, by contrast, think that the bread and wine merely symbolize or represent Christ. Others hold that though the bread and wine remain the same, they are given a power to transform the lives of those who receive them. For one group of theologians, it is those who receive the bread and wine who, through their active faith, enable themselves to receive Christ also. All this complicated theology reminds us that the relationship of person and object is never straightforward, and that the relationship of person and religious object is particularly not. It reminds us, too, that to understand religious objects in museums, we must give as much attention to the visitor looking into the showcase as we do to the object looking out.

Srikanda Stpathy discussed the same issue—how objects become sacred, and the role of the devotee in maintaining that sacrality—with the historian William Dalrymple. Srikanda is a bronze-founder, an 'idol-maker' whose family has made gods in Tamil Nadu for 700 years.

> 'God is inside us,' he said. 'It is from our hearts, our minds and our hands that god is formed, and revealed in the form of a metal statue. My statues are like my children . . . Once the eyes are opened by having their pupils chiselled in with a gold chisel, once the deity takes on the form of the idol and it becomes alive, it is no longer mine. It is full of divine power, and I can no longer even touch it. Then it is no longer the creation of man, but a god only.'
>
> 'It contains the spirit of god? Or it is a god?'
>
> 'It is a god,' he replied firmly. 'At least in the eyes of the faithful.'

'What do you mean?'

'Without faith, of course, it is just a sculpture. It's the faith of devotees that turns it into a god.'

It seemed to me that Srikanda had mentioned three quite different ways in which an inanimate stature could become a god: by the channelling of divinity via the heart and hands of the sculptor; a ceremony of invocation when the eyes were chipped open; and through the faith of the devotee. I pointed this out to Srikanda, but he saw no contradiction . . .

. . . as the idol heads for its millennium, the *jivan* in even the most adored and carefully tended idols will start to fade and disappear. If the idol was not properly tended to, the *jivan* could ebb earlier, and if stolen or abused, the deity would leave the statue immediately. Such was the case with all the idols in museums, none of which was now alive. (Dalrymple 2009: 178, 198)

All religious objects in museums, especially in the West, struggle with the inability of many of their visitors to understand or empathize with religion at all, least of all with the idea that *things* can be holy. At least this is so in secular Europe and in much of the rest of the developed world. The first kind of religious object is the one that has the greatest difficulty in relating to the visitor, in winning his or her understanding—the holy object. Most modern secular museum-goers find it almost impossible to accept that a piece of dumb matter, a human-made *thing*, can have supernatural powers. As Victoria Nelson (2001: 25), talking about a Krishna figure and a crucifix, puts it:

holy [is] a lost perception for us. To see them violates one of the deepest taboos of our empirical-materialist belief system, namely, accepting a vision of the universe that includes both a level of non-material reality and a direct connection to the other level through that which seems most profoundly to negate it: the 'dead' inanimate matter of which sacred objects are made.

Yet this worldview is restricted in time to the past three centuries or so, and in space to developed, urban, society—and certainly not all of these. For most people in most of the world in most of human history, there has been no distinction between the world of the spirit and the world of matter, between the sacred and the mundane. Museums have the responsibility, if they are to interpret their objects to visitors, to reach out to those visitors—to both their affect and their understanding. We shall look at some of the strategies museums adopt to do so, and the challenges they meet when source communities demand a say in that interpretation, and when some visitors insist on their own response, whether that response is over-enthusiasm or violent objection.

SOME RELIGIOUS OBJECTS ARE PERSONS

This concern with what an object really is, and with the relationship between objects and people, has been key to recent attempts to better understand the nature of religious objects. Indeed, religious objects sometimes point up dramatically the nature of objects more generally. One of these issues is over the distinction between a person and an object. The sharp distinction between things and people, between sentient beings and dumb objects, would be quite unfamiliar to most people in most human societies over the ages. What is more, as we shall see repeatedly in this book, there are many nooks and crannies in our own society where this distinction is ignored. So it is not surprising that, in a post-modernist intellectual world where all overarching ideologies are challenged and there are many competing truths, there is lively debate over what objects are. At the heart of this debate about the theory of materiality—what things are—is indeed the challenge to the idea that objects and persons are essentially, always and forever distinct. On the contrary, as Daniel Miller put it, all *things* are ambiguous between persons and non-persons. Over recent decades, academics have taken very seriously the notion that not all persons are human persons—some may be statue-persons, or tree-persons, or rock-persons, say—and enormous numbers of bytes have been spilled in trying to define what this means. In reality, we are quite accustomed in daily life in modern Western society to using such ambiguity. Personhood is frequently attributed to pets, a practice one sees extended to boats, and even to cars. Conversely, racism is essentially the denial of full personhood to certain groups of humans.

Some objects, of course, are more persons than others, if only because they receive more attention, more 'relationality'. Relics and certain statues stand near the top of this hierarchy, and are a reminder that we are never far away from a purely materialist debate, for they also stand at the centre of huge economies (relic—reliquary—shrine—cathedral—city—hinterland and pilgrimage) and are as powerful economically as they are spiritually.

The 'material turn', and the development of material culture studies generally, has converged with the realization by scholars in the religious field that it is not enough to study what people say they believe: to understand religion one must study what people actually *do*. And since they very largely do things with *things*, here has been a major contribution to understanding both things and religion.[8]

Indeed, what has been called the 'new animism' (Harvey 2006)[9] recognizes that an object-person is only 'alive' when it is interacting with a human-person—the act of relating is what does the animating. This 'relationality' means that every encounter is different, and any attempt to define the 'true nature' of the non-human person involved is doomed. It also gives added emphasis to the importance of *performance*,

another area of study that has made big contributions to material cultural studies and especially to religious studies. In our field, 'performance' largely means ritual, and ritual describes and defines ways of relating to the religious object—in fact, it is ritual that makes the object 'religious'. As Jonathan Smith (2005: 33) put it, 'A ritual object in action becomes sacred by having attention focussed on it in a highly marked way.' But what people do to and with objects in museums is very different. Museum workers examine them, measure them, write about them, clean them, conserve them, show them to children, put them on display—few of these are similar to what devotees do to object-persons that makes them live. But it might be considered to be ritual, even so. Ronald Grimes (2011: 82) extends the term to include virtually any regular handling of, and interacting with, an object, 'until meaning began to arise "magically", like sparks from flint striking steel'. This is a liberal approach that may be helpful to remember when, in chapter three, we look at the ways in which people in museums relate to objects.

RELIGIOUS OBJECTS HAVE LIVES

One of the most useful aspects of the renewed interest in material culture is the seeing of objects as having personalities and lives. Igor Kopytoff set this approach going (or going again) among academics in 1988, and in the field of religious objects a major impetus was Richard Davis's *Lives of Indian Images* (1997). We shall take this approach in this book, looking as far as possible at issues from the point of view of the objects themselves—that approach gives an understanding and close attention that abstract discussion cannot give. It is particularly appropriate in a book about *religious* objects, for, as we have seen, the tradition of treating religious objects as persons is found in faith traditions throughout the world. As Davis (2009: 82) puts it:

> Objects have life stories just as humans do. Many objects are born and live their entire lives without leaving their own villages, just as many humans do. But some objects experience lives of travel and change, disruption and transformation, influence and celebrity, and it is the lives of such mutable objects that make for the most interesting biographies.

Religious objects in museums have no lack of change, disruption and transformation, and often influence and celebrity, too. It is this, then—the imagined experiences of the objects themselves—that is the organizing principle of this book: how objects behave in museums, the demands they make of curators, visitors and source communities, and how they respond to the demands of those stakeholders.

Museums are not the only context in which religious objects slip into new and uncertain roles and meanings. The role played by objects in museums can be compared

to that played by props—stage objects—in the theatre. Andrew Sofer (2003) has fascinatingly described the way stage props take on a life of their own in performance, and it is no coincidence that one of his principal examples is the Host (the bread in the Mass) in late-medieval liturgical drama. Here, the religious object hovers ambiguously between being a 'real' thing and 'merely' a stage prop, and between being a piece of bread, an unconsecrated wafer, or a consecrated Host. Museum objects and stage props, religious or otherwise, both take on quite new dramatic roles when they enter the museum or theatre, and the analogies and congruities between them deserve more attention than is possible here.

RELIGIOUS OBJECTS HAVE DUTIES

Religious objects in museums have two great responsibilities and challenges today, and much of this book will be taken up with exploring them. The first is to help visitors understand how the object was understood in its religious context—to help the museum visitor to see the object through the eyes of the devotee. This is surely the most difficult of all efforts at interpretation, and the most intense. Surveys tend to find that visitors want above all to know how things work, how they are used, and it is partly this realization that has led art galleries to (begin to) interpret paintings no longer merely as great works of art, or even as images of particular saints with particular significance and resonances, but as ritual objects that play or played a part in a key ritual. But religious objects are not merely functional in this sense; an important part of their function, in how they were used, is their *significance* to those taking part in the ritual. To explain this slippery and elusive meaning to a very varied crowd of museum visitors is the greatest challenge. We shall look at some—though inevitably only some—of the ways museums help objects to explain themselves. While museums today show much more interest in religion, and religious objects in museums are permitted to be much more open about their origins and inner natures than they were a decade ago (Paine 2000: 151), this sympathy is more evident in temporary exhibitions and public programmes that it is in permanent displays. We shall see that learning staff and conservators are, for different reasons, often taking a much more lively interest in such things than are curators.

The second great responsibility is to meet the demands of all those people who feel that the object is personally important to them. A large group of religious objects that has led the way in promoting awareness of their role in museums have been the sacred objects of the indigenous people of North America and Australasia. Demands for their 'return' or for influence over how they are treated have generated a large literature and a great deal of media attention (Sullivan and Edwards 2004). Rather than add to this, here we shall try to look at similar demands being made in

other parts of the world and by other faith traditions. Here again, responsibility falls on the museum team (we have used the term 'curator' to include everyone involved). Theirs is the job of reconciling competing demands from different faith groups— groups which may indeed include secularists who object strongly to any concessions to religion, and insist that museums are secular institutions which must treat their objects only as historical or scientific evidence, or as works of art.

It is not surprising that we shall find that religious objects are treated—behave— very differently in different museums. Some museums still treat their objects purely as works of art, while at the other extreme some are almost shrines in their rever- ent recognition of the sanctity of their objects. We shall be looking at a variety of ways in which religious object behave in museums, and a variety of ways in which museums use them. All museums, though, have a responsibility to society at large. Museums exist to serve the public, and that does *not* mean (as curators sometimes seem to be implying) giving in to the groups that shout the loudest. It means having a clear understanding of the needs of their society and of the larger world, and a clear mission to help to do what they can to meet those needs in whatever (maybe quite modest) ways their resources allow. Today, one of *the* great needs of society and the wider world is reconciliation between different faith traditions. The sudden (it seems sudden) revival of religion, which has so surprised us who live in what we thought were largely secular societies, is creating one of the great challenges of the twenty-first century. Museums which hold religious objects (and that is most museums) have a responsibility to use those objects to promote mutual understanding between people in the whole field of religious faith and practice. The aim of this book is to discover something of the potential of religious objects in museums to contribute to this great purpose.

1 OBJECTS CURATED

How curators ascribe a new significance to their objects, but still offer them respect even when keeping them under tight control

Curators make new meanings for objects coming into the museum, and have a large degree of control over how they are understood by visitors. What is or should be their purpose? What is their responsibility to their visitors and their museums' funders? What, if anything, is the curators' responsibility to the religious background of their objects?

Curators[1] retain control over the way religion appears in museums because they retain the power of choice. Objects are inevitably the slaves of their curators, who choose which ones to acquire, whether to display them or put them in store, and how to display them. To a very great extent, this gives curators the power to determine how their visitors understand them and respond to them. In his classic 1989 survey of public opinion, Nick Merriman (1991: 62) found that forty-four per cent of his interviewees identified museums with churches, temples or monuments to the dead. It has often been observed how museums can be deliberately built to look like classical temples or Gothic cathedrals, and how close are the parallels with temples and churches in the ways in which visitors (the laity) are expected to behave; we shall look again at this in chapter eight. Many people have pointed out that there is a parallel, too, between curators and clergy. It is no coincidence that 'curate' and 'curator' both mean carer—someone who cares, in the one case for souls and in the other for

collections. Curators also share with priests an arcane knowledge and an authority to control the access of lay people to the 'sacred' things they control (Curtis 2003: 30). In that sense, all museum collections are 'sacred'—in the sense of things set apart, separated from the world at large and treated in prescribed, formalized, 'ritual' ways. Here, though, we shall look in a much less metaphorical way at curators and their collections, and at how museum people behave towards museum objects regarded overtly as in some sense 'religious' or 'sacred'. As the conservator Chris Caple (2000) so tellingly puts it, the question is, should we treat a 'lucky rabbit's foot' differently to any other rabbit's foot? That should not sound flippant—it is only a matter of degree. Should we treat a consecrated *murti* differently to any other Indian statue? Should we treat a consecrated Host differently to any other piece of bread?

THE CURATOR'S TASK: MAKING MUSEUM OBJECTS

Once an object is taken out of its original context, it willy-nilly changes its meaning. This was pointed out by Quatremere de Quincy at the very time the modern museum was invented in Napoleon's Paris (McLellan 1999; Sherman 1994): by taking objects out of context, a museum robs them of their identity and value. It cannot be avoided. When an old farm tool is taken from the corner of the shed and displayed in a folk museum, it inevitably stops being a farm tool and becomes a museum object. It does so, indeed, even if it is left where it is and the shed itself becomes a museum. How much more is this true of a religious object removed from church or temple or home? 'Take the crucifix out of the cathedral and you take the cathedral out of the crucifix' (Fisher 1991: 19).

Thus, (whether he or she likes it or not) the curator's first task is to give the object, once collected, a new meaning for its new life in the museum. Normally that is one—or a combination—of three broad categories of meaning: as a beautiful/powerful/meaningful work of art, as a scientific specimen, or as an illustration and evidence to a story being told. We shall see in the next chapter that the curator cannot do any of this alone, for though he or she can do a great deal to manipulate that relationship, in the end the meaning of any object depends on how it is understood by its interlocutor, the museum visitor. The curator uses increasingly elaborate and sophisticated display techniques to ensure that the visitor responds to the object in the way he or she wants. Nor are such techniques limited to architecture, design of displays, lighting, text and so on. The very act of creating a collection, or juxtaposing one object with another, creates meaning of itself. Sue Pearce, in her seminal book *Museums, Objects and Collections* (1992), quotes a Newfoundland Museum label

announcing, 'When you look at an artefact you are looking at a person's thoughts.' One might add that when one is looking at a collection one is looking at a conversation. It is the forming of collections, not merely the acquiring of individual objects, that lies at the heart of the curator's role. The curator's task is to assemble individual objects into a collection, and thereby to create meaning greater than the sum of the individual objects.

Does the curator's own faith or lack of it affect the experience of religious objects in his or her care? Does the faith of curators make it easier or more difficult for a religious object to reveal and communicate its once and 'real' meaning? Is it better to be curated by an insider or an outsider? It is sometimes claimed that, in social history museums at least, religion has been ignored largely because curators (in Europe, at least) have tended over the past generation or two to be agnostic (Paine 2010a: 14). Possibly, the growing interest in the subject reflects a change? At present, it seems we have no information on the beliefs of curators; anecdotally, some of the key exhibitions of religious objects are attributed to curators and museum directors interested in and sympathetic to religion, or at least with a religious family background, but the mere fact that religion is so prominent in world politics may be sufficient explanation. We need, anyway, to remember how exceptional secular Europe is in the modern world.

ASCRIBING RELIGIOUS QUALITIES TO OBJECTS

Museum curators routinely divide the information they have about objects into 'intrinsic' information and 'extrinsic' information (Ambrose and Paine 2012: 191). Intrinsic information is that carried by the object itself, merely awaiting someone to 'extract' it. Intrinsic information includes the object's shape, its colour, its material and its condition. All of this may tell us a great deal about the object. Just by looking, we may be able to estimate its age from its style and its function from its shape and wear. And we can also deploy an increasingly sophisticated range of techniques to extract more information. Extrinsic information, on the contrary, is information derived from *outside* the object: where it came from, who owned it, how it was used, etc.

But there is a third category of information, distinct from the extrinsic. This is information *ascribed* to an object, rather than derived from studying the thing itself, or certainly known about it. It includes its *significance* to an individual or to a group, for example grandfather's beloved clock, which for the whole family encapsulates his memory; the tree regarded with affection by the whole village, whose felling causes

real distress; or the frisson many suddenly lose again when they learn that a painting is a fake. 'Significance' is a concept that has made big inroads into museum thinking in recent years. It originated in Australia, where the Collections Council defines it rather broadly:

> Significance means the historic, aesthetic, scientific and social values that an object or collection has for past, present and future generations. Significance refers not just to the physical fabric or appearance of an object. Rather, it incorporates all the elements that contribute to an object's meaning, including its context, history, uses and its social and spiritual values. When you consider this information you can draw informed conclusions about why an object is significant. Significance is not fixed—it may increase or diminish over time. (Russell and Winkworth 2009)

Significance is the meaning an object or place has for a person; that meaning certainly derives from the intrinsic and extrinsic information he or she has about the object, but is different from either. If a newly coined word is acceptable, it is 'adtrinsic' knowledge. Adtrinsic information is also the *religious* meaning people ascribe to objects. Here, indeed, it is at its most dramatic.

Other commentators have given other names to the meaning people ascribe to the same object in different circumstances. Thus, Carrier (2006) speaks of the 'envelope' that makes an object a work of art, emphasizing the transformative effect of the art museum itself, while Walter Benjamin (1973: 218) speaks of 'cult value' being replaced by 'exhibition value', emphasizing the changing utility of the object itself as replication deprived the object of its 'aura', which derived from its uniqueness and its role in cult.

CURATORIAL CONTROL

In 2007, Simon Knell, Professor of Museum Studies at Leicester University, achieved the apparently impossible: a witty and engaging account of recent museum history. In it, he notes:

> The supposedly objective collection conceals irrational passions, poetry, debts, claims, and so on, mixed with all those museum inadequacies and vices: neglect, territorialism, bias, poverty, ignorance, and misunderstanding. And while we rightly push objects and collections to the fore as the distinguishing features of museums, we need to remember that if those objects *are* 'made to speak', they do so through a human act of authorship with all its editing, contextual manipulation and censorship. This combines in an interpretative coupling of speaker and listener where both are manipulating meaning, often unknowingly. But in this 'conversation', is the object active or passive? (Knell 2007: 7)

The answer is surely that the object plays an active role in a triple alliance with curator and visitor. But it is willy-nilly curators (in our broadest sense) who play the key role in controlling collections and determining what museum objects say.

In the 1990s, academic interest in museums accelerated. One of the academics' great contributions was a new appreciation of the social role that museums can play, and the political role they must play, whether they are aware of it or not (Vergo 1989; Bennett 1995). Especially, they drew attention to the way in which too many museums have effectively excluded large swaths of the population. People who have never been educated or conditioned into appreciating art or science or history, and who have never developed the habit of museum-going naturally feel excluded from a unfamiliar environment, and all too often feel patronized, as well. Curators have always been conscious of the challenge of presenting their collections in ways that their visitors will accept and understand. Offering too much information when most visitors know little about a subject can be as alienating as offering too little to experts can be patronizing. Adopting the wrong tone, whether in the design of the displays or in the wording of panels and labels, can be equally off-putting and excluding. If curators have usually been conscious of this in their own institutions, now they were told how this has a much wider political effect in supporting the status quo, and further empowering the educated élite for whom museums are familiar and friendly, rather than patronizing and alien. Moreover, the choices curators make in collecting and in choosing objects for display are also political decisions, for the formation of collections is a meaning-making activity. The 'new museology' (a term used rather differently by the museum profession than by academics) which has swept through the museum world since the 1980s is all about forcing museums to break out of their elitist box and to engage with the public which—through taxes or admission charges—pays for them. This campaign has gone along with that of reaching out to marginalized groups. Museums have been taking very seriously their commitment to engage with minority groups of all kinds, whether unrepresented social and economic groups, the LGBTI communities, ethnic minorities or people with disabilities. Of course, there has been a big element of fashion in all of this, as well as a real reflection of changing political, economic and cultural concerns. At its worst, it has been simply a matter of ticking the boxes required by politicians and funding bodies. What is more, the idea that museums in the past were mainly elitist institutions, interested only in their narrow scholarly and upper-class interests and clientele, is largely an Aunt Sally—in reality the showman tradition deriving through Phineas Barnum from the fairground is just as strong in today's museums as is the scholarly tradition deriving through Elias Ashmole from the antiquary's study or nobleman's cabinet.[2] For all that, the new museology has transformed museums in many parts of the world, and created a generation of curators and other museum workers with a

real commitment to ensuring that their museums both reflect and serve the interests of the *whole* of their communities.

Who determines how museums should serve their communities, and indeed what museums are for? In the UK, this question has arisen fiercely in recent years in what has been called the 'instrumentalism' debate (Holden 2004). As with so many public services in the past generation, central government has made big efforts to ensure that its spending achieves intended results, and it has done that by setting targets for outputs that relate—hopefully—to broad outcomes in the field of social development. Thus, museums have been required, in return for their annual grants, to achieve specified levels of visitors from specified social and economic groups, ethnic minority communities and people with disabilities. They have been required to develop formal learning services in direct support of the National Curriculum. This approach has been nicknamed 'instrumentalism'. In recent years it has suffered a backlash, government being criticized for not appreciating that museums are *intrinsically* valuable, and that micro-managing a service through the setting and assessment of targets is anyway a thoroughly inefficient way of achieving ends. This defence is just a small part of the defence mounted against the apparently world-wide attack by governments on the humanities in general (Bate 2011). Proponents of the 'intrinsic' argument do not challenge the broad aims of government, but call on government to trust museum workers to use their judgement in working out how to achieve them, and call on museum workers to articulate much more clearly the value of museums.

The 'intrinsic' approach has in turn been heavily criticized, not merely for its historical ignorance (most museums were founded for very specific educational and other societal purposes), and for its failure to explain what this intrinsic value really is, but above all as a mere defence of the privileges of the self-interested clique of professionals who run museums. Mark O'Neill of Glasgow has been heavily involved in this debate. In 2008, he published a very critical analysis of the processes that resulted in the Jameel Gallery of Islamic Art in London (O'Neill 2008: 301). The project for the new gallery set out with laudable aims, to 'develop interest in, and to promote understanding of, the diversity of Islamic art, and to inspire in all people an appreciation of its beauty' (Moussouri and Fritsch 2004), and that 'people get a balanced view of the great Islamic civilization of the medieval and modern periods to see what a wonderful civilization it was. We hope people will see that the Islamic civilization of the past was very self-confident and open to the outside world.' 'Front-end' visitor research was carried out, including with a weighted sample of Muslims. The main request from those consulted was a 'desire to see Muslim cultures from the inside, not just from the "neutral" perspective of the curators, to understand their contemporary relevance and human meanings as well as their cultural and historical backgrounds.' Yet, by the time the gallery was completed, most of this approach had

got lost. What we have is an old-fashioned art gallery in which objects are seen almost entirely from an aesthetic and art-historical perspective.

Having shown how good intentions fell victim to a very traditional curatorial approach, O'Neill goes on to criticize the gallery and to analyse the results. He makes what are, in the context of current sensitivities over Islam, very serious criticisms. Above all, the gallery fails to meet the consultees' desire to 'see Muslim cultures from the inside'; the perspective is exclusively curatorial. Even more seriously, 'The whole display could be read (by both Muslims and non-Muslims) as showing that Islam's days of greatness are over and its current state is one of decline, meriting no respect—a view often represented in the media. Muslim consultees specifically asked for this to be countered by the inclusion of contemporary Islamic art and images of Islamic culture, a request which was denied.' Thus, great art objects do not speak for themselves, they respond to their visitors, and the message they can be understood to give can be dangerous indeed. Moreover, the gallery misses its golden opportunity to address the 'Islamic' of its title as well as just the 'art': 'The narrow, singular perspective through which the material is seen also fails to take the opportunity to evoke Muslim spirituality, as *Seeing Salvation* in the National Gallery in 2000 had done for Christianity.'

Since O'Neill made his attack, the Victoria and Albert Museum (V&A) has published a summative evaluation of the gallery (Fakatseli and Sachs 2008). The V&A should be warmly thanked for publishing this, for it is quite critical of the success of the gallery, even on its own terms. The findings of the evaluation 'may suggest that the gallery does not provide sufficient help with furthering visitors' pre-existing knowledge and enhancing their understanding of more challenging and complex issues of Islamic art'. Moreover, visitors were predominantly white, middle-aged and middle-class, and spent an average of four minutes in the gallery! Disappointingly, the summative evaluation does not really refer back to the front-end evaluation. Thus the latter noted:

> There were two distinct learning approaches to visual arts taken by PMM [Personal Meaning Making] respondents. One group was very interested in colour, pattern, and noticing the world around them; this is what attracts them and is how they would orient themselves within a museum context. However, the other group did not see 'art, design, beauty, aesthetics' as a single motivation— their overriding reason to visit would be in facts that are historical/economical. They are interested if an object embodies some sort of important historical/ social influence. These two approaches are the key entry points for respondents and are very strong. (Moussouri and Fritsch 2004)

But the summative evaluation did not examine how far or whether these two approaches were reflected in the gallery as it eventually emerged, or whether the

previous consultants' suggestions had been taken up. The curators were in control, but missed their opportunity.

CURATORS AND MEMORY

The central role of the curator is to choose, collect, research and understand objects, in order to present them and to explain them to as wide a public as possible, for their interest and enjoyment. In every one of these actions curators find themselves involved with memory, for (as we shall see, p. 52) memory is invariably associated with objects. Curators cannot escape their controlling role, nor should they try to do so, any more than a film director can avoid controlling the film or an author the book. They can, of course, be up-front about their roles, and some museums now publish the names of staff involved in developing displays, and even statements of intent. And they can and increasingly do involve representatives of the relevant community in developing the displays—as those developing the Jameel Gallery at least initially tried to do. Yet, however hard they may try to set up programmes of collecting by a community, or 'objective' means of collecting from a community, the curator inevitably hold the reins and sets the ground-rules. The result is that living memories become mummified. The complex and confused, individual and collective meanings that objects once held give place to an official, coherent meaning. Moreover, curators are under huge pressure to use this power, willy-nilly imposed upon them, in severely circumscribed ways. Even in temporary exhibitions, let alone the permanent displays, there is a real limit to how imaginative or radical the curator can be. He or she is, after all, usually a civil servant, and if not a civil servant, then a kind of businessperson or cultural entrepreneur.

Curators may be becoming more generous in allowing religious objects to speak of religion, but there are distinct limits to what they will tolerate. One way in which curators exert a baneful influence over their objects is the way in which they suppress all evidence of religious conflict—or rather, force it safely back into the past. Because issues of faith are so sensitive, most museum displays on religion are celebrations of diversity, stressing exclusively the positive and ignoring conflict or oppression (O'Neill 2010: 36). This is, of course, entirely understandable. We ask our curators to work closely with their many diverse communities, to reflect their concerns and to use their knowledge, understanding and skills. How can we possibly also ask them to deal bluntly with religious conflict, to recognize explicitly in their displays that the meaning of one object completely denies and challenges the meaning of another? There was a time when geographical distance made it possible to treat of conflict and oppression in distant lands, but today the only safely distant country is the safely distant past. Thus, we can (in most but by no means all European countries)

contentedly exhibit objects that reflect the conflicts of the Reformation, and slightly less easily address the oppression involved in Victorian colonialism and its alliance with mission, but we cannot dare to deal with issues around Islam and Hinduism, Pentecostal Christianity and African traditional religion, or—often—even around faith and science.

In passing, we might note that it is not only curators in the museum who affect how objects are understood; sometimes it can also depend on the collectors who gave them to the museum in the first place. This is an area about which museums are seldom very explicit; curators often forget the extent to which the messages of their displays are determined by what they happen to have been given. Very often a 'decorative arts' collection was formed by a private enthusiast and given or bequeathed to the museum. It reflects, therefore, not the research interests of the museum today or even in the past, but rather the enthusiasms, whims and preferences of its original collector. This can give extraordinary distortions to the story museum collections tell. Most of the seventeenth-century embroideries in the Ashmolean Museum were bequeathed in 1947 by the antique-dealer Francis Mallett. Many of these depict biblical scenes (Figure 2), but Mallett seems to have had a distinct preference for scenes that convey a message of feminine submissiveness (Brooks 2004: 9).

REFLECTING POPULAR RELIGION

Curators' freedom is limited by the 'political' pressures on them, by their own upbringing, skills and inclinations, and by public reaction after the event. Yet deny it as they will, and often do, within that field curators' power of choice is absolute. They alone can decide which objects to allow to speak, to a great extent what they are allowed to say—and, hence, what their museum says about religion. About some aspects of religion most museums say virtually nothing at all. A family friend has in her bedroom an 'altar' on her chest of drawers, on which is displayed a crucifix, an image of the Holy Trinity, figures of Guan Yin, Siva and Buddha, and family photographs. Each morning, she lights incense and meditates in front of it. She is not so very unusual (Turner 1999). There has probably always been a distinction between the religion of ordinary people and the religion of the churches. Ordinary people have (always?) taken what they found useful from 'official' religion, and used it for their own purposes, resisting the efforts of the clergy to force them into an approved pattern of practice and belief. While in the past the sources available to ordinary people to construct their own religion were largely limited to the local official religion and popular tradition, today the whole universe of religions is available for people to plunder, adapt and reuse. Syncretism, at least among the Western middle classes, is almost becoming the norm.

Museums reflect little of this. When they do try to present religion, it is the official religion they turn to, the muddled mixture of ordinary life only becoming recognized when it can be solidified into a new formality, as Catholicism and West African traditional religion melded into Vodou (now an official religion in Haiti), or as popular religion is defined and corralled as 'witchcraft'. Partly, this is because curators take the easy option of turning to official religion for their information and collections (finding out what people actually do would require a very great deal of research), partly it is because doing anything else might cause a row. In Europe, the sharp decline in formal religious practice has opened ever wider the gap between 'official' religion that is displayed (when it is) in our museums, and religion as it is increasingly lived—the pick-'n'-mix religion that reflects the individualistic ideology of our society. As the sociologist Grace Davie put it (1997: 99), 'No longer anchored by regular practice, belief drifts further and further away from anything that might be termed orthodoxy.' But practice continues, in all sorts of personal ways. What has declined over the past few generations is not religious belief, or even religious practice, but *orthodox* religious belief and practice. If my friend gives her Guan Yin statuette to a museum, it is likely to end up displayed (if at all) as an illustration of Chinese religion, with a label describing how the Indian male Boddhisattva Avalokitesvara transmogrified into the Chinese goddess Guan Yin. But it sits on her bedroom 'altar', alongside the Buddha figure and the crucifix, and plays and has played a crucial role in her spiritual journey through Catholicism, Zen Buddhism and Anglicanism into a personal mixture that works for her. Unless one day—improbably—a museum interviews her and collects these figures, this example of religion as it is actually lived in the early third millennium by millions in the developed world will be forgotten.

The 'New Age' is almost entirely ignored. One of the few museums to recognize the role of the unofficial healer in modern urban society was at the late-lamented Musée National des Arts et Traditions Populaires in Paris. This presented the reconstructed consulting room of a Paris fortune-teller, used between 1954 and 1977. Edmond Belline claimed healing powers, but in practice offered insights into his client's past and future, and considered himself a 'confessor of souls' and a 'counsellor of spirits', offering sympathy, understanding and support. Far from being the traditional fortune-teller's booth, his room was a bright modern-looking office (Cuisenier and de Tricornot 1987: 101).

'WE ARE A SECULAR MUSEUM'

The throwaway remark of one art museum director, faced with his curator's enthusiasm to involve a faith group in developing a new gallery, reminds us of just how

completely in most museums the recognition of religion depends on the personal attitudes of key members of staff—and on the tos and fros of internal museum politics.[3] Few museums have a formal policy on this issue, relying on vague published commitments to public consultation and involvement, though one or two larger museums are, under the influence of staff members concerned with diversity, beginning to form 'faith groups' to address these issues.

One might perhaps expect to find at least some curators and conservators refusing to make any concessions to religion, no matter how 'sacred' an object may be. Strongly held atheist or feminist convictions could well inspire a museum worker to defy rules about 'respect', let alone (for example) to avoid touching an object held to be taboo to women. Often these rules rely entirely on the conscience of the museum worker; no one can know what goes on in the privacy of store-room or laboratory (see p. 56). Yet—at least in the English-speaking world—no examples of a defiant stance are reported, and by all accounts, museum workers are conscientious in acting in accordance with faith communities' wishes, once procedures have been agreed. A search of the Web will find the occasional remark such as, 'An Israeli museum curator once told me that she removed a statue of Buddha from an exhibition after finding somebody kneeling before it' (Gerstenfeld 1999), but generally curators and conservators seem to bend over backwards to accommodate religion, regardless of their own personal convictions, and even beyond the call of professional codes of ethics.[4]

Much more challenging than any of these situations is that of the curator of an art exhibition who is committed to allow artists freedom of expression, or who believes he or she has a duty to present an argument to society. In 2010, the Gallery of Modern Art in Glasgow put on an exhibition in their series using art to challenge social injustice. Previous shows had covered violence against women, sectarianism and disabilities. This one was to challenge homophobia and the social exclusion of gay people, a much more 'difficult' subject. The exhibition drew on a variety of artists, some established and some little known, and a sub-section of the exhibition focused on the role of religion in marginalizing LGBTI people. One of the artists invited visitors who felt excluded from the Bible, especially on the ground of sexual orientation, to record their names in the margins of a copy in the gallery. The consequences were eminently predictable, though apparently no one did predict them. As well as adding personal testimony, some visitors defaced the Bible and wrote obscenities. More thoughtful comments included 'This is all sexist pish, so disregard it all' and (on the first page of Genesis) 'I am Bi, Female & Proud. I want no god who is disappointed in this.'[5] Many Christians objected loudly and some called for the resignation of the Director of Culture; the *Daily Mail* ran the story and the row went international (O'Neill 2011). The display was the idea of Glasgow's Metropolitan Community Church; its minister said:

Writing our names in the margins of a Bible was to show how we have been marginalised by many Christian churches, and also our desire to be included in God's love. As a young Christian I was encouraged by my church to write my own insights in the margins of the Bible I used for my daily devotions—this was an extension of that idea . . . I had hoped that people would show respect for the Bible, for Christianity and indeed for the Gallery of Modern Art. I am saddened that some people have chosen to write offensive messages.

This is just one of very many instances in which the clash between freedom of speech and blasphemy has played out through museum objects.

So curators, in the end, have almost absolute control over how their museums present religious objects, as they do for every other exhibit. But that does not mean they can control how their visitors *receive* those objects—how visitors interact with them. Visitors make their own meanings, and apply them to the museum's objects, not always passively accepting the museum's meanings. There is only so much the curator can do to control the interaction between visitor and object, and in the next chapter we shall look at how religious objects relate to their visitors.

2 OBJECTS VISITED

How religious objects relate to their visitors

Increasingly, museums allow—even encourage—visitors to show devotion and to relate in a 'religious' way to objects in their collections. Even when they don't, visitors sometimes do so anyway, undermining the mundane understanding the museum imposes on its collections. The new emphasis on understanding how museum visitors interact with objects has strengthened the need for museums to consult both their objects' source communities and their visitors.

PEOPLE AND THINGS

A major feature of the museum scene during the last generation or so has been the emphasis on how users receive and interact with the objects and information museums present to them. This has not been just a renewing of the old commercially driven demand to give visitors what they want, and to meet them where they are. Hopefully, all museums realize the importance of that. The new emphasis has, rather, been on the way in which visitors—and other users—can only receive experiences through their existing understandings, emotions and inclinations. This is a turn common to a great many other fields, as well: literature, theatre, media studies, art, and above all education, where the focus has moved from teaching and how to teach, to learning and how people learn (Bransford, Brown and Cocking 2000; Holden 2004).

Recently, a leading American researcher into museum visitors, John Falk, argued that museums' traditional efforts to analyze visitors into demographic groups is not that useful, since people decide as individuals whether and when to visit a museum,

on the basis that the visit will reinforce the individual's identity. (Identity he defines as a changing reflection and reaction to the social and physical worlds, but influenced by the 'vast unconscious set of family, cultural, and personal history influences each of us carries within us' [Falk 2009: 72]). Though such 'identity work' is individual, Falk argues that visitors' motivation falls generally into one of five distinct categories, and he sets out strategies for museums to meet their distinct needs. Gaynor Kavanagh has also stressed the individual nature of the museum visitor experience and warned against making assumptions drawn from what we know about the demographics of visitors: 'People bring with them to the museum not just characteristics drawn from their class status, cultural upbringing and political environment but also individuality of self, which has the capacity to rupture at least some of the features of cultural patterns and political assumptions' (Kavanagh 2000: 158).

The drawback of these approaches to visitor research,[1] from our perspective, is that they all quite correctly try to analyse visitors' responses to the complete museum visitor experience. This involves every aspect of the visit, from the decision to come and the journey there, through the visit itself and response to the building, its displays, cafe and shop, to the interaction among visitors. What we also want to know, though, is how individual visitors respond to individual objects or small groups of objects, and here there seems to be disappointingly little hard information (Durbin Morris and Wilkinson 1990). The decoding of objects has been likened to the decoding of text (van Kraayenoord and Paris 2002: 233). Just as reading the symbols on the page are interpreted, thanks to the reader's prior knowledge, as both sounds and concepts, so analysing objects also depends on prior knowledge to extract or recall a whole range of information about the objects' nature and background, and so about its intrinsic, extrinsic and adtrinsic nature.[2] Visitors create a significance for objects which may be shared with others, or may be entirely personal to themselves. When visitors are considering religious objects or religious stories, what understandings and attitudes are they bringing with them? This chapter asks, what are they wanting to *do* with their interaction with religious objects?

'THE REAL THING'

Museum curators often argue that 'the real thing' has a power and an authority that no other medium can rival. Yet this justification for expensive museums is very seldom either challenged or defended. Besides the philosopher's sense, there is another sense in which an object can be 'real'. This is the sense exemplified by the old joke about 'grandfather's axe': grandfather's axe has had two new hafts and one new head, but it is still grandfather's axe. In fact, it is *seen* as grandfather's axe, so there is one sense in which its authenticity is entirely in the eye of the beholder. This is the

thrill the historian feels when handling the original manuscript instead of merely a transcript, or the child feels in the presence of a 'real' dinosaur fossil, or an American patriot before the Declaration of Independence. This awe has been called 'magical contagion', a kind of sympathetic magic (Evans, Mull and Poling 2002: 73). Researchers and commentators have overwhelmingly stressed the crucial role of prior knowledge and prior experience in visitors' interaction with and understanding of objects, and have very often found their analysis of interaction with objects segueing into an analysis of the museum visit experience more generally (Paris 2002).

CONSULTING SOURCE COMMUNITIES

'Consulting source communities' has become almost standard practice in twenty-first century museums, despite the obvious difficulties of identifying which modern 'community' can justly claim to be the source of an old object, and who can justly claim to speak for that community. The particular difficulty involved in identifying a 'source community' for a religious object can be illustrated by an English museum looking for guidance in treating a medieval reliquary with its relics still intact. Both the Roman Catholic Church and the Church of England claim to be the heir of the medieval English church, and might (though it is true they probably wouldn't) resent the legitimation that choosing the other might imply. Moreover, the Church of England, in particular, comprises a range of attitudes and beliefs ranging from near-Roman to solidly Protestant. A Church of England minister of one tradition might regard the relic with great reverence; another might see it as at best a historical curio, at worst a superstitious menace. Dig beneath the surface and most communities will reveal similar muddles, especially those without a strong central authority, or which have not been forced in recent years clearly to define their identity, and to determine their attitudes to these issues.

Still, the difficulty of defining the 'community' and finding a representative is not a good reason not to try. Museums need to keep the difficulties and dangers firmly in mind, but they must keep trying to consult those with a legitimate interest in their objects—among whom those claiming to represent 'source communities' are prominent. Indeed, more and more they are doing so. London's Victoria and Albert Museum (V&A) is a good example of the way in which major museums in the West are beginning nowadays to approach the care of religious objects. The conservators there start from the Ethics Checklist that V&A conservators offered to the conservation profession in the 1990s (Richmond 2005), and particularly the questions, 'Have I consulted stakeholders, peers, other specialists?' and 'Have I considered and weighed the factors contributing to the identity and significance of the object(s)?' Stakeholders include communities, while the factors include 'historical, aesthetic, technical, associations,

sacred, and maker's intentions (sic)'. The conservators there do not believe that hard and fast rules can be laid down to cover the treatment of every kind of object— certainly not yet—but that the key must be to flag up those objects where concerns over correct treatment may arise, and to ensure that the relevant stakeholders are consulted. In this case, those stakeholders are representatives of the relevant faith communities, but the museum staff recognize the difficulties of finding broadly acceptable 'representatives', and that views may differ even among—for example—priests of a single tradition. One example of the latter was when a Greek Orthodox consultant argued—unusually—that a Bible should not be handled by a menstruating woman.

Consultation does not just mean seeking advice on how the museum should care for objects; sometimes it means inviting outsiders actively to engage with 'their' objects. In the Sukuma Museum in north western Tanzania, a local leader of the Bagalu Society often comes in to 'cleanse and repower' the Bagalu Dance Society objects. Most of the ritual *dawa* or medicines contained in the calabashes, dance bags or animal horns apparently sustain their power while in the museum, but some must be used or cleansed to revitalize their strength. Being displayed in a museum is not a problem, but these objects need the respect and attention of someone initiated in the knowledge of the medicine. Other cultures have different approaches. The Head Conservator at the Washington Museum of African Art, Stephen Mellor, gives a number of examples from Africa: '[D]espite the extraordinary power of nkisi figures, one of the most effective ways the Kongo people have to render them powerless is simply to treat them with indifference, that is to ignore the behavioural restrictions required towards them or neglect their cultural status' (Mellor 1992). In other cultures, too, religious objects can lose their power; the willow shavings that the Ainu people of northern Japan use to bring prayers to the gods are said to lose their power over time (Simpson 2002: 37).

Even more complicated is the situation when groups without obvious objective and historical links to an object nevertheless claim an interest in it. The clearest example is the concern neo-pagan groups have shown over the ways in which archaeological finds are treated and displayed in museums. This concern has primarily focused on human remains,[3] and on 'sacred sites' (Blain and Wallis 2008), but museums are now very aware of the issues that may arise when they acquire or display objects that could be seen as in some sense 'sacred'. Some museums, such as the one at Manchester University, go to great trouble to ensure that they consult as widely as possible.

ASKING VISITORS

We noted above the 'front-end evaluation' study carried out for the V&A's Jameel Gallery. Such studies are nowadays largely standard practice for museums—at least

the better-resourced ones—before developing a new permanent gallery or temporary exhibition. Generally these are qualitative studies, designed to discover what approach would work best. What seems to be lacking is any really useful information on what attitudes to religious objects visitors are bringing with them on their visits to museums. What do visitors themselves believe? What understanding and empathy do they bring to encounters with objects from other faith traditions? How do their attitudes to these things change when the encounter is in a museum? If any museums are carrying out the quantitive surveys that might give them and us this kind of information, few seem to be making it widely available, let alone consolidating it. An exception was Chicago's Field Museum which, in planning an exhibition on evolution, asked 'Do you believe in the facts of evolution? Do you believe in God? Do you believe that humans are descended from animals?' (Asma 2001). But what we do know about what happens when religious objects and visitors meet in the museum comes largely from anecdotes, or from a very few surveys of visitor response to existing exhibitions. If the religious meaning in religious objects in museums is to be allowed to communicate with visitors, museums must take much more trouble to understand their visitors' relationship with those objects.

In 2000, the National Gallery in London staged a major exhibition 'Seeing Salvation—the Image of Christ'. It was remarkable for being one of the rare exhibitions to focus specifically on a religious theme, rather than on an artist, a style or a period. It was remarkable, too, for its extraordinary popularity, averaging five thousand visitors a day over four and a half months, and breaking all records for art exhibitions in the 1980s or '90s.[4] Its success attracted the attention of the Cambridge sociologist and art historian Graham Howes, who undertook a study of the exhibition's visitors, using interviews with visitors as they came out, a market-research survey carried out by the Gallery, interviews with major art critics, and (especially) letters from members of the public to the Director. He published what he learned in a chapter in his book *The Art of the Sacred*. Howes sees two patterns of public response to such an exhibition, which he describes as 'transactions' and 'experiences'. 'Transactions' he further defines as of four distinct kinds, 'cognitive', 'didactic', 'iconographic' and 'credal'. As examples of 'cognitive' transactions, Howes quotes correspondents: 'I knew I was somewhere special', 'it was a most enlightening and moving experience' and 'the space was jammed with people, but all with such a sense of the contemplative, allowing the works gathered to speak in many diverse ways to those before them.' 'Didactic' transactions for Howes are those where visitors saw the exhibition as essentially a learning experience: for example, 'Here were well-loved paintings presented in a new light as aids to devotion besides being great works of art. Hidden meanings, often lost to the modern viewer are revealed to increase understanding.' The third type of transaction, the 'iconographic', relates

to the power of the images themselves: 'These are images that teach the Faith', or although 'I am not a practicing Christian, I was moved to tears by these images.' The power of the image is shown by one moving quotation from a letter:

> Please accept my praises, which are sincere . . . my son, my only child, died of anorexia two and a half years ago at the age of 26 . . . I found the exhibition intensely moving and as a mother who has just lost her son (Jamie was eight weeks on the life support and I watched him dying inch by inch, day by day) unforgettable for its imagery and emotion. Thank you. (Howes 2007: 52).

'Credal' transactions, the fourth category, are those which see the exhibits as affirming Christian belief—'Art drew people to God once—perhaps it could do so again?'—but Howes also quotes here an interviewee who commented, 'Frankly I found the show yawn-inducing . . . "Seeing Salvation" makes you feel Christianity itself needs a bit of saving.' How useful these categories are may perhaps be debated, and Howes accepts that his data also 'point to a wide spectrum of richly variegated visitor experience.' Such experiences range from the 'sense of presence' ('it was wonderful . . . wandering through the rooms became a pilgrimage following Christ's life'), through the 'loosely numinous' ('I felt we hadn't entirely left the spiritual in art behind') and the 'secular historicist' ('Here on display is the heart of the religion which nourished Western culture from the beginning . . . this should help us to maintain a connection with our shared Christian heritage') to the other end of the spectrum, the 'essentially negative' ('an occasion where I saw everything and felt nothing'). Howes uses all this as at least one explanation for the huge success of the 'Seeing Salvation' exhibition:

> while many—visitors and art critics alike—saw 'Seeing Salvation' as heritage, albeit a shared *religious* heritage, rather than as a focus for primary religious experience, their reactions also demonstrate that modern secular audiences can engage with Christian art at an emotional as well as a purely aesthetic or historical level. (Howes 2007: 57).

The exhibition, and its accompanying television series and books, also attracted the attention of sociologist of religion Grace Davie (2003). Her analysis of the 461 letters to the Director suggested three themes: the extraordinarily powerful emotional response; the assumption of correspondents that Christianity is *passé* in modern British society and that, therefore, the National Gallery is the more praiseworthy for arranging this exhibition; and the link that some correspondents made apparently for the first time between art and religion. A high proportion of the letter-writers were clearly Christian. What was perhaps surprising in their letters was the absence of those *universal* themes mentioned in much exhibition publicity: maternal love, persecution of innocence, pain, and the triumph of love over death.[5]

A comparable range of responses emerged from the analysis that French sociologist Patrick Michel carried out in 1997 of messages posted on the 'response board' in St Mungo's Museum of Religious Life and Art in Glasgow. St Mungo's is, of course, trying to do something very different to the National Gallery—to encourage mutual respect among Glasgow's different communities by showing how religion plays in different cultures. Michel stresses the shock that the museum gives to many visitors: 'A totally new experience, a frankly declared bias, a sensitive object, so many ingredients of a quite explosive cocktail'. Of the 1,570 comments he was able to analyse, fifty-six per cent were more or less passionately pro the museum, nine per cent anti, and twenty-one per cent included some criticism. Though Michel reminds us that the very fact of having made a visit automatically engenders satisfaction, the fifty-six per cent unqualified approval rate remains astonishing in a museum that opened to intense controversy. Many comments are testimonials to die for: 'Now I know why I came to Glasgow'; 'The loveliest and most peaceful and harmonious museum I have visited'; 'A really amazing and interesting museum.' Approval was given to the way the museum was presented, to its multicultural bias, but also by many to the human, religious and spiritual experience which made the trip something beyond an ordinary museum visit. 'A profoundly moving experience,' said one visitor. 'A marvellous experience. Well worth exploring what other religions are based on and I think it is important to understand what other people's beliefs are about,' commented another.

Not all approval, though, was so unqualified. Many visitors were concerned that their particular religion or interest was too little represented. There was also concern that atheism and humanism were afforded too little place, and religion generally given too positive a slant: 'Religion has a very very dark side that must be shown, especially in here.' When visitors hated the museum, they really hated it: 'I thought it was boring and the best thing about it was this noticeboard—at least I got a laugh! What a waste of public funds. Religion causes far too much trouble—we can live without it.' Negative reactions, though, were not generally the product of hostility to religion as such, but came from three complaints: the museum is superficial, presentation is muddled, and the whole thing is blasphemous.

The accusation of superficiality is one that museums will always be prone to, if they are to take access issues seriously. For some of St Mungo's visitors, though, the superficiality of the displays undermined the whole endeavour: 'The presentation of information is at primary-school level—it trivialises rather than illuminates all of the religions.'

Some found the museum's thematic approach confusing: 'Mixing different aspects of different religions in the same showcase is very confusing . . . Scots and visitors are intelligent enough to make their own comparisons.' For other visitors, though, the implications of this approach were fundamentally wrong: 'the concept

that all religion is somehow the same disturbed me somewhat. It is not and . . . it would be far more meaningful and worthwhile to explain the history and foundations of each religion.' Others again found exactly this approach valuable: 'I think the fact that different religions are interspersed is confusing—but isn't that the whole point? All part of a wonderful whole, no one entirely right or wrong?' Much more serious is the view that holds the whole St Mungo agenda as at best misguided and at worst blasphemous: 'Interesting. Unfortunately all religions are not the same and all cannot be right. What we think about what is right is at the end of the day an irrelevance. It is what God thinks that counts and he thinks there is only one way to get to him.' Mark O'Neill (*pers. com.*) rightly notes that 'this is the single most important challenge in the idea of a museum of world religions and why their interfaith, social-cohesion role is difficult if not self-contradictory. Multi-faith museums by definition reject any individual religion's claim to exclusive truth.'

In the second half of his book, Michel discusses what visitors to St Mungo's think about religion itself. Michel notes a number of tendencies identified in wider contemporary society by sociologists: a strong tendency to individualism and distrust of institutional religion, an ability to construct one's own personal system of belief, the tendency of traditional beliefs to close in on themselves, and the dream of a 'grand religion'—or alternatively of the passing of all religion. In part, just because it was based on the museum's 'public response board', Michel's study concentrates on visitors' reaction and responses to the museum in general rather than to individual objects or displays. The objects in St Mungo's Museum have, however, attracted some powerful reactions. The most dramatic took place only two months after the museum opened in 1993; a visitor attacked and permanently damaged the museum's image of the Hindu god Shiva as Nataraja—the man responsible said that he was acting in the name of Christ.

HOW VISITORS REACT TO OBJECTS

Most (all?) behaviour towards objects is learnt. The baby learns to use a spoon for eating, but not to bang it on the table. The older child learns to use a keyboard, but not to use his uncle's without asking permission. The temple-visitor learns to touch the *murti*, and the churchgoer learns to genuflect before the altar. Confusion can occur when the novice museum visitor meets a *murti* or an altar in the art gallery—his or her instinct is to touch or genuflect, but he or she soon realizes that this is wrong. The anthropologist and writer Irna Qureishi[6] took a group of elderly Muslim women from Beeston (a very deprived area of Leeds and home to some of the London 7/7 bombers), who had no experience of participating in heritage activities, no English, and very little formal education, to an Islamic art exhibition at a Sheffield museum. The group clearly viewed the exhibition space as sacred—insisting on performing

ablutions before entering, wondering whether they should remove their shoes, keeping their heads covered—as they would in a mosque. With no previous experience of museums, they perhaps saw the mosque as the nearest equivalent space, and therefore behaved in the most appropriate way they knew.

> The ladies found the experience incredibly moving, particularly because they regarded the viewing of objects from their faith as 'sawaab'—they felt they were earning religious merit—which for them legitimised the 'fun day out'.

Objects cannot impose their new meanings on their visitors if those visitors have never been taught to recognize them. Hindu statues in the Indian Museum in Kolkata are similarly treated as holy *murtis* by visitors not conditioned into appropriate museum-going behaviour (Elliot 2006: 63).

Visitors' reactions to religious objects in museums may take all sorts of forms, some of them surprising. In the 1900s, the British Museum's 'unlucky mummy' (see chapter seven) won very special attention from two gentlemen interested in the paranormal. One was Thomas Murray, an amateur Egyptologist and colleague of the great archaeologist Flinders Petrie, and the other W. T. Stead, a well-known campaigning journalist. These two 'decided that the expression on the face was that of a living soul in torment' and 'wished to hold a seance in a room and to perform certain experiments with the object of removing the anguish and misery from the eyes of the coffin-lid'. The publication of their views resulted in donations of money from Algeria and New Zealand to pay for floral offerings to be laid before the lid. 'Sad to say', recalls the curator, 'I believe that the money offerings were absorbed by the hard-hearted Treasurer of the Museum, and no flowers were bought' (Budge 1934, quoted in Caygill 1985: 102).

One of the ways in which modern museums seek to build stronger relations with their visitors, and to involve new visitors, is by inviting lay people to write object labels and to express publicly their personal response to objects. Birmingham Museum and Art Gallery published a beautiful little guidebook to some of their Islamic objects, and invited members of the local Muslim community to comment on an object that appealed to them. 'Shaista' chose a large oil painting of 1843, *Prayers in the Desert* by William James Muller (Figure 3). For many people, this might be just a rather unfashionable early Victorian Orientalist picture. But for Shaista,

> My first encounter with this painting touched the very core of my heart. I was not content with seeing it just once and felt frustrated at the thought of having to say goodbye at the end of my visit. . . . It instilled in me a certain spiritual comfort, that, no matter what, no matter where, God is ready to hear your call.

In the same sort of way, Kelvingrove Museum in Glasgow displays a Qur'an picked up on the battlefield outside Kabul by a Scottish soldier in 1879. The museum

invited an Afghani Glasgow resident to add his comments to the object label. As part of its effort to attract more diverse audiences, and to make its services more relevant, the V&A ran a lottery-funded project for three years. The museum brought together distinct groups of Hindus, Christians, Jews, Jains, Sikhs, Buddhists and Muslims. In one exercise, museum curators presented them with some fifty objects relating to their faith, and invited the group members each to choose and to comment on one. One member of the Jain group chose a remarkable nineteenth-century bas-relief panel depicting the Jain pilgrimage site of Sammeda-sikhara, Bihar, India:

> I have selected it because I would like to visit the place and I have not been there and it is an important place where most of the Tirthankaras have attained Nirvana. Most Jains wish to visit the place once in their lifetime and people who are not able to make it would be happy seeing Sammeda-sikhara and visualising that they are already there.[7]

Such visualization is, of course, a major function of a great variety of religious images. The image acts as a prompt for the imagination, and very often also as a lens through which the devotee can 'see' the reality beyond (Morgan 2005).

Other museums invite not just ordinary local people, or people from the relevant faith community, to contribute comments on their objects, but also celebrities and people with a special interest or expertise. The V&A's website includes a link to a newspaper review by Anthony Gormley of its new Buddhist Sculpture gallery in which he offers not formal analysis of the works displayed, but an inspiring exposition of how artists have shown the enlightened Buddha as 'a body which, while having the attributes of this world, is no longer in this world.' Indeed, it was the curator's ambition to 'provide a significant new resource for Buddhist practitioners, scholars, students, teachers, pupils, artists, designers and all those interested in Buddhism' (Clarke 2009: 42).

USING THE MUSEUM

Whether the commentator is an insightful artist, a believer, an academic specialist or just a neighbour, when a museum consults 'the public' in any sort of formal way there inevitably arises the question of where the balance lies between the 'curatorial' voice and the 'community' voice. In the end, of course, the curator remains in control. Sometimes, though, faith groups use the resources of museums very much for their own purposes. Some of the best-known faith-based museum tours are those organized by, and very largely for, Jehovah's Witnesses at the British Museum. The

largest company in the field is Meander Travel, who offer at least one tour every Saturday.[8] The nine tours on offer include:

> The Stones are Crying Out: Although pieces of propaganda the unearthed Assyrian Stones cry out that the Bible is right. Sennacherib's Palace and the sad outcome of Judean inhabitants at Lachish.

> Surviving a Famine: What was the inspired arrangement to survive the 7 year famine in Joseph's time? What was the purpose of the 10 plagues? Unearthed Egyptian stones and your Bible provide the answers.

Clearly it is indeed the Bible that provides the answers, and the role of the museum objects is to confirm and reinforce those answers. But not all such answers satisfy everyone. One sceptical *Times* journalist went on the tour billed as 'This Is History Written in Advance: Alexander the Great. Powerful Caesars of Rome. How did Daniel accurately describe them?' This tour aimed to tie down prophecies in the Book of Daniel to Greek and Roman items fabricated centuries afterwards, such as busts of the early Roman emperors and coins struck by Alexander the Great. The guide, so we are told, 'neglected to mention the dispute over the date of Daniel; prophecies work much better when they predate the events they foretell. But if these were prophecies and they are true, the Witnesses hold, then all the others in Scripture—including the rapid approach of the Apocalypse, as calculated and then recalculated by the Witnesses—must be true.'[9]

Comments on the contrast between such tours and the museum's founding Enlightenment principles are heard from time to time. However, the official attitude of the British Museum seems entirely relaxed. Meander Travel's website proudly displays a thank-you letter from the museum's director for the donations they receive: 'The amount donated since 1989 is staggering and we are most grateful to the Jehovah's Witnesses and their friends for their generosity.'

The London School of Jewish Studies, an independent educational charity, organizes regular tours of the principal London museums from an Orthodox Jewish perspective. The Natural History Museum, for example, 'is home to 70 million specimens, ranging from microscopic slides to mammoth skeletons. Should a traditional Jew feel challenged by what they find here? In this highly original tour we will study ancient creatures and Jewish creation texts in order to gain an ever deeper understanding and appreciation of our world.' A tour of the British Museum 'is designed to transform your understanding of the Bible through ancient texts and unique artifacts. The tour will span more than 500 years of ancient Jewish history. Explore the politics of Israel's monarchy, the Assyrian annihilation of the northern kingdom

of Israel and the Babylonian destruction of the southern kingdom of Judah.'[10] The School offers a programme for primary schools that makes use of key paintings in the National Gallery. Run by a freelance museum learning consultant, it involves the children in studying three biblical narrative paintings: Guercino's *Elijah and the Ravens*, Claude's *Landscape and the Marriage of Isaac and Rebecca* and Rembrandt's *Belshazzar's Feast*. The children study the Bible text in the classroom, visit the gallery to look in detail at the paintings, and the final session is an art-making session in response to the learning and critical thinking that has taken place.[11]

These lecture-tours make few demands on the museums in which they take place, though curators may sometimes be concerned that their understanding of 'their' objects is being contradicted. In the next chapter, we shall look at what happens when visitors seek—even demand—a much more active involvement with 'their' objects.

3 OBJECTS WORSHIPPED AND WORSHIPPING

How objects in museums can be worshipped or even 'worshipping'

Some museums positively encourage acts of devotion within their premises, whether to explain their objects better, or to attract minority communities into the museum. Some museums go so far down this road that they virtually double as shrines.

In the V&A Museum in London is a massive copper and silver-gilt Italian reliquary from the cathedral of Reggio Emilia (Figure 4), made in 1496 for the arm-bone of St Catherine of Alexandria. It is in the form of a six-sided tabernacle, surmounted by a figure of St Catherine, its sides decorated with niello-work panels showing scenes from the saint's life. Around the tabernacle is a Latin inscription recording how the arm-bone was brought to Reggio by a Franciscan friar 'in the time of the Most Reverend Father, the noble lord Bonifrancesco Arlotti, Bishop of Reggio, who on 25 October 1496 granted forever an indulgence of forty days to anyone kissing this reliquary' (Litten 1997). But the devotee can no longer benefit from this indulgence, for the reliquary is kept firmly locked in a glass case.

Temple treasuries have long fulfilled some of the roles of museums and today, as we shall see in chapter ten, some religions deliberately deploy museum techniques as a way of encouraging devotion. However, even secular museums sometimes positively encourage the worshipping of objects in their collections, usually as a way of involving minority communities. Sometimes, indeed, the permitting of devotion

goes so far that the distinction between museum and shrine begins to fade. In other museums, the provision of a contemplation space points up the complicated relationships between 'religion' and 'spirituality' and between the material and immaterial.

ENCOURAGING WORSHIP

One of the most famous objects in Birmingham Museum & Art Gallery is the Sultanganj Buddha. This big (2.3m tall) copper statue of the Buddha was found in 1862 during the building of a railway at Sultanganj in northern India. Seeking ballast for their line, the engineers noticed an immense brick mound. It turned out to be the ruins of a Buddhist monastery containing many valuable artefacts. The Buddha figure, however, only narrowly avoided the melting pot, thanks to the interest of Birmingham metal manufacturer Samuel Thornton who, on hearing of the discovery, paid £200 to have it transported to Birmingham. In 1867, the Sultanganj Buddha was put on exhibition in the new museum. The Sultanganj Buddha is the largest metal figure of its kind in the world, and was made by the lost-wax process in the sixth or seventh century. A splendid example of the Gupta sculptural style, it is famous for its serenity, beautifully embodying through its almost-ethereal flowing form the detachment from the world that is at the heart of the Buddhist aspiration.[1]

For years, this splendid object stood at the top of the museum's stairs, with just a simple label. Today, it stands in a niche as the central feature of a gallery devoted to Buddhist, Jain and Hindu sculptures, including some borrowed from the V&A and the British Museum. Since 2006, the Buddhist festival of *Wesak* ('Buddha Day') has been celebrated every year in the gallery by a group of local Buddhist monks and lay people, a celebration organized jointly by the museum service and the West Midlands Buddhist Council (Figure 5). The pattern varies, but in 2009 they came in procession from the city's central square to the Buddha Gallery, where an address by a Buddhist military chaplain was followed by the chanting of Homage to the Buddha, the Three Refuges and the Five Precepts, and a blessing by the abbot of the local Theravadin monastery.

For the Buddhists, a major aim was (in the words of one of the organizers) 'the desire to sensitise people to the mindset of faith and encourage them to express and champion their own moral values in the face of the liberal/secular attack upon them'. For the museum, though, the motive behind this and many similar religious activities in other museums' is very often the mission to expand the diversity of the museum's audience, and in particular to attract and involve ethnic minorities. Thus, Birmingham Museum's Forward Plan identifies the Buddha Day celebration as part of its

Equalities Action Plan for the year. Similarly, the Metropolitan Museum of Art in New York has a Multicultural Audience Development Initiative. Originating in an effort to involve New York's African American community more with the museum, it undertakes a number of programmes, including tours, talks, a mentoring programme, and a variety of activities to involve the city's Asian American and Hispanic/Latino as well as African American communities. Some of these are distinctly religious, but when they are, it appears—to an outsider at least—that it is the cultural identity that is most important. Thus, Diwali is celebrated by a sophisticated dance performance, and joins a programme ranging from 'Post Pride' and 'Asian Pacific American Heritage' to 'Fiesta! Celebrating Hispanic and Latin American Culture'.

In 2002, the Brighton Museum and Art Gallery set about a project with the local Gujerati community that 'hoped to recreate a religious space, and one which the local community would use and view as sacred.' A nineteenth-century Hindu shrine from the museum collections was revived and decorated (though not repainted) for display in the museum gallery, as part of a project that encouraged local Gujeratis to become involved with the museum, making textiles, garlands and jewellery. The completed shrine was blessed by a local pandit on Lord Rama's birthday, and all present were invited to perform *puja* (Parker 2004: 64).

It is noticeable that Christian equivalents to these religious events in museums are seldom seen. Birmingham Museum arranges a Christmastide tour of paintings on the Nativity theme, but there is no worship involved. When museums such as York Castle arrange carol singing in their premises at Christmas, they seem to take place there because the venue is attractive, rather than in relation to any particular sacred object or space. The exception is those open-air museums that include places of worship among their—usually relocated—buildings. Skansen, the hugely influential open-air museum established near Stockholm, Sweden, in 1891, received its first church in 1916. Today, many open-air museums include places of worship reconstructed or moved from elsewhere, and these are very commonly actually used for worship; one African example is the Ghana National Cultural Centre in Kumasi, Ghana, which includes both a chapel and a traditional Ashante shrine (Duah 1995: 110). By contrast with open-air museums where buildings from elsewhere are reconstructed, 'ecomuseums' comprise an alliance of buildings, sites and object-collections still in their original places, and very often these include places of worship. The ecomuseum of Hirano-cho in Japan, founded by the Ryonin Kawaguchi, priest of the Senkouji Buddhist Temple, comprises fifteen different attractions, including a number of active temples and shrines (Davis 2004: 98).

Just sometimes, it is the donor who determines the negotiation between meanings that every museum acquisition must go through. The donor of a Siva figure to

the Prince of Wales Museum in Mumbai made a condition that it continue to be worshipped. The museum staff make offerings every Monday.

These have all been examples of museums for various reasons encouraging people to do religious things in their galleries. Just as common, possibly more so, must be instances of people who pray, leave offerings, kiss icons or the like, against the museum's rules. We very seldom hear about these, and often such behaviour must be known only to the museum attendants, never reaching management. Often, too, the fact that a visitor is worshipping may be invisible to others. Wallis (forthcoming) points out:

> Pagan museum visits may outwardly seem typical: looking at the displays and learning more about the past, drinking tea in the café, buying books and mementos from the shop. But pagan visits are, in addition, private and sometimes public religious acts, involving pilgrimages and ongoing reaffirmations of spiritual identity. While the past may be closed and the archaeological artefacts on display in museums may be presented as inanimate 'dead' objects, displayed primarily for the didactic transference of knowledge, these objects are often perceived by Pagans as more than objects, with their own agency and personhood. For these pagans, visiting objects in museum collection displays enables a tangible link to the ancestral past. Even buying a postcard in the museum shop can be much more than a simple memento of a visit—positioned at home on a shrine, it becomes a religious thing; framed and hung on the wall above a shrine it becomes an icon of religious identity.

At the opposite extreme, there is a story that when Thich Nath Hanh, the Buddhist preacher, visited China in the days when religion was still firmly suppressed, he was refused permission to visit any Buddhist monastery. In response, he took the opportunity of a museum visit to prostrate himself before a Buddha image—in which he was joined not only by his entourage, but also by Chinese visitors.

ALTARS

Museum people have a tendency to believe that their generation is the first to throw off the dusty elitism of 'old' museums, and to discover a new public-oriented inclusive museum service—the 'new museology'. In fact, such public orientation has been the driving force for very many museums for at least two hundred years, and most 'modern' approaches were pioneered generations ago. So it is with worship in museums. John Cotton Dana founded the Newark Museum in New Jersey, USA, in 1909. He held the key view that a museum object had no intrinsic value 'if it were not of use', and that meant usefulness in educating the community: 'A good museum attracts, entertains, arouses curiosity, leads to questioning—and thus promotes learning.' Thus, the museum's growing ethnographic collections were seen as

'World Art' long before that phrase was invented, and Dana asked, 'Would exhibits of the life, the customs, the problems, and the ideas of a neighbor people lead us to a better understanding of the people? Would it help break down hostility and open up paths to friendship? We answered these questions in the affirmative' (Price 2004: 72). Dana's tradition was maintained by his successors, even as they built up the museum from two rooms above the public library to an eight-building campus with huge and hugely important collections.

The Newark Museum received its first large Tibetan collection two years after opening, and by 1935 it had grown into one of the world's most important collections of Tibetan material. In that year, the idea emerged of creating an altar setting for the great liturgical objects of the collection. Funding from the Federal Emergency Relief programme made it possible—not the least of the imaginative cultural benefits the New Deal brought to America. The altar was conceived as an engaging and comprehensible way of presenting unfamiliar Tibetan objects, but it very quickly attracted the affection and respect of visitors, and especially of local Buddhists. Mongolians settled in New Jersey after World War Two, while after the Dalai Lama's exile in 1959 the museum built up strong relations with the Tibetan diaspora in the US. The Dalai Lama himself visited in 1979 and 1981. Originally intended simply as a way of displaying objects so that their intended function could be more easily understood, the 'altar' gradually took on a sacred character and became more and more 'altary', until it came to be considered a Tibetan altar, even (or perhaps especially) by Tibetans. As the present museum director put it, 'The transformation of a "tableau" into a sacred space occurred over a period of six decades in a series of transfiguring events, an accumulation of single moments of veneration.' So when in the 1980s the museum came to redisplay its Tibetan galleries, it had an extra reason for doing so in close consultation with the Tibetan community, and went so far as to seek advice from the Dalai Lama himself. The Venerable Ganden Tri Rimpoche led the ceremony to deconsecrate the old altar in 1988, and a Tibetan artist, trained in a Tibetan monastery in Sikkim, spent two years building, painting and gilding the new altar room. The project had its climax when the Dalai Lama came back for a third time to consecrate the new shrine (Price 2004; Gaskell 2003). This was, of course, a highly political act, reinforcing the cause of 'Free Tibet'. But it also evinced a major change in the nature of these objects. They had successfully reasserted their religious meaning, helped by a sympathetic museum curator and an assertive Tibetan community, while a museum tableau had taken onto itself a sacred character.

Elsewhere, 'altars' in museums tend to remain merely props for the display of objects. Thus, when the Horniman Museum in South London commissioned Pai Rogers of Rio de Janeiro to create two Candomblé altars, he deliberately avoided including sacred matter that would consecrate the emblems of the *Orixas* (spirits or

deities), so as not to activate their life force (Tribe 2000: 135). The altars were there not to be altars in the sense in which Candomblé devotees would understand them, but to symbolize for visitors the way in which African religious culture was able to regenerate in the diaspora even after the tragic assault of slavery (da Silva n.d.: 27). Much rarer is the museum that positively encourages the visitor to empathize with the religious character and context of objects; signs in the Field Museum and in the Petrie Museum's exhibition 'Digging for Dreams' invited visitors to recite an Ancient Egyptian prayer for the souls of the resident mummies (Day 2006: 167); the Egyptian gallery in Oxford's Ashmolean Museum, reopened in 2011, does the same.

MEDITATION PLACES

As we have seen, museums are very selective in what objects they allow—let alone encourage—visitors to worship. Perhaps the main way in which museums actively encourage religious practice is not focused on objects at all, but is the provision of 'meditation spaces'. A small number of museums offer such a space, often similar to the bland inter-faith rooms commonly found in airports and sometimes in international exhibitions and even shopping centres. The most famous, and surely one of the earliest, is Dag Hammarskjöld's meditation room in the United Nations Headquarters in New York. In museums, these are often associated with displays treating an emotive subject. Thus that in the Museum of London Docklands is in the section of the historical exhibition devoted to the Blitz—the bombing raids of World War Two in which so many dock workers and their families lost their lives, their loved ones and their homes. Most of these spaces are virtually empty, with perhaps just an artwork or two—that at London's Natural History Museum looks like a large empty cupboard. Very different, but still a place for contemplation, is the Zen Garden at St Mungo's Museum; here the whole space is a 'worshipping object'. Designed by the Japanese garden designer Yasutaro Tanaka (who also designed the very different Kyoto Garden in London's Holland Park), this garden comprises nothing but large stones, carefully positioned, raked gravel and moss. 'It has a power which goes beyond the aesthetic', said museum director Mark O'Neill, 'and summarises the aim of the museum.'

The distinction between museum, memorial and shrine dissolves in such places as the National September 11th Memorial and Museum at the World Trade Centre. The use of the museum as a memorial dates back at least to the 1917 British Cabinet decision to found a museum to collect artefacts from World War One—a collection that by 1920 had become the Imperial War Museum. In New Zealand, the call for physical memorials after the Great War was especially strong, since even those whose

graves were known were buried on the other side of the world. The Auckland War Memorial Museum devotes its whole upper floor to memorializing New Zealanders who fell in the First World War and later wars. Besides the historical galleries, there is an information centre and database, and the World War One Sanctuary and World War Two Hall of Memory, with the names of the fallen inscribed on the walls and an altar of Belgian marble. There is also now an exhibition that 'tells the story of our dual history as both Auckland's museum and war memorial. Here you can both discover the meaning of the beautiful stained glass, inscriptions, Rolls of Honour and other architectural details which adorn and sanctify our building.'[2] Use of the term 'sanctify' suggests strongly that the whole museum has become in some sense a religious object.

The elision of shrine and museum sometimes comes from a surprising direction. In 1950, the communist authorities destroyed the temple to Chen Shisi Niangniang, the goddess Jinggu, in a village in Zhejiang, China. But:

> When it was possible to worship her openly again, people constructed a make-shift shrine next to the school and burned incense to her image. Local elders concluded that the only way that the government would agree to erect a new building on the spot was if it was thought the building was a cultural palace, and that is how the building was presented when it was completed in 2000. It just so happened that its traditional architectural style, with its shiny green-tiled roofs curving upward, fantastic mythological wall paintings, and opera stage bore all the hallmarks of a deity temple. (Yang 2004: 720)

RITUAL-MAKING IN THE MUSEUM

Museums are primarily places for objects, and for most there is a limit to their opportunities to show the processes involved in the creation of those objects—though many open-air and craft museums offer demonstrations of craft skills and the simpler industrial production processes. Yet, for many religious objects, their making is a key ritual part of their nature, and a few museums do try to present this to the public, either through video clips or through live enactments by ritual masters. The commonest such demonstration is perhaps the creation of mandala sand paintings by Tibetan monks (Figure 6), for this is dramatic, beautiful, authentic and comparatively tidy. Sometimes the resulting mandala is consolidated and accessioned in the museum's collection, but normally it is swept away or washed into a river—it is the creation of the work which is the 'religious object' here.

A much more profound example of ritual-making taking place in the museum was in the Cambridge University Museum of Archaeology and Anthropology. The museum invited a practicing Pa-chyu shaman of the Gurung community in central

Nepal, Yarjung Kromchhain Tamu, to put together a collection of shamanistic material for the museum's collections. He was then asked to carry out a purificatory ritual by which the special box destined to hold the collection was transformed into a sacred space, and to organize a display. The collection, which included ritual costume, a drum, and empowered shells and bones, was chosen entirely by the shaman, who laid down the rules for their future care and display. The museum accepted his rules: the collection must be kept together, items must not be frozen as part of the pest-control process, some five particularly potent objects out of the fifty or so were deposited rather than given, since they 'might be needed in Nepal for ritual purposes in the unlikely event of a crisis there' (Herle 1994: 3). Moreover, the museum accepted Yarjung's stipulations over what could be displayed. These comprised one group of objects fully accessible to the public, another group about which prepared museum specialists could be informed but not the general public, and a third group that the museum might hold but about which the museum would not be given any information.

Here, then, the ritual-making is of a collection rather than an individual object, as part of the museum's deliberate handing over to a ritual specialist control of the whole process. In return for this suspension of normal museum principles and procedures, the museum gained a vastly increased understanding of these religious objects—gained, indeed, something of their underlying meaning and value (Spira 1994). In the next two chapters we shall look in more detail at the relationship between modern museums and the communities from which their religious objects came, and at the increasing demands for 'restitution' or control these communities have been making, and then at some of the ways museums try to show respect to the religious objects in their care.

4 OBJECTS CLAIMED

How religious objects are demanded 'back' from museums

A central theme of cultural politics over the past generation has been the claims made, especially by groups of indigenous peoples, for the 'return' of objects from museums, or for control over their interpretation. Religious objects have been central to this struggle.

The Parthenon sculptures or Elgin Marbles are the classic example of antiquities claimed 'back' from a museum. They, too, are religious objects—the pediments and metopes from the Temple of Athena illustrate episodes from Greek mythology, while the frieze represents the people of fifth-century BCE Athens in religious procession. We tend to forget their religious character, because they have taken on so many more meanings, and there are few devotees of the classical gods around to remind us. Above all, they have had twin modern careers as a major foundation of classical antiquity's underpinning of modern Western civilization and its power structures, and as symbols first of Hellenic nationalism, and later of modern Greek democracy, revived after the military dictatorship. No one, though, has so far laid claim to the Parthenon sculptures on *religious* grounds.

Museums have, however, received a very great many other claims to religious objects in their collections. Indeed, requests for the return or 'restitution' of religious objects—alongside human remains—have given rise to much debate both within museums and far beyond. The question of restitution is what people most readily think of when religious objects in museums are mentioned, and is one important reason why more attention has been given to religion in museums in recent years. The impetus has come from the indigenous peoples of 'settler' countries, above all in

North America and Australasia (Clavir 2002). In the United States, these demands culminated in the 1990 Native American Graves Protection and Repatriation Act (NAGPRA). This law required museums to list, and to return when asked, a wide range of significant cultural objects, as well as human remains. Australia had in part led the way with the Aboriginal and Torres Strait Islander Heritage Protection Act 1984. At both a legal and ethical level, debate about the care of sacred objects has been closely bound up with debates about the care of human remains,[1] about the restitution of looted property, and—in some countries—about the treatment of sacred sites. The International Council of Museums' *Code of Ethics*, adopted as long ago as 1986, demanded that material of sacred significance be looked after 'in a manner consistent with professional standards and the interests and beliefs of members of the community, ethnic or religious groups from which the objects originated'.

Despite some high-profile returns, such as the Ghost Dance shirt from Glasgow to the Lakota Sioux, the issue of claims by indigenous groups for the restitution of their sacred objects remains controversial—less so today in museums themselves than among cultural commentators more widely, where the subject has strong political overtones.[2] Struggle for control of objects is a fundamental characteristic of human society, for human beings are apparently wired to invest meaning in objects, and their control both reinforces and represents political power. The sacred relics of Sariputta and Mahamogallana, two main disciples of the Buddha, were discovered by Sir Alexander Cunningham in two sandstone caskets at Satadhara village near Sanchi in 1851 and were taken to London and kept in the V&A for almost ninety years. After a long campaign, in 1949 the relics were returned to India and formally handed over by Prime Minister Jawaharlal Nehru to the Maha Bodhi Society of India.

CLAIMS POLITICAL

Very often that struggle is between a community that sees itself as disadvantaged, and an authority seen as—sometimes mildly, sometimes cruelly—oppressive. Too often, 'heritage managers', whether they are museum curators or archaeologists or planners, are seen as alien, dominant outsiders and are resented by local communities for illegitimately claiming rights over 'our' objects. When a community feels itself disadvantaged or threatened in some way, certain key objects or places become symbols of independence or resistance. We are accustomed to this situation when indigenous people from New Guinea, say, or New Zealand claim rights over 'their' things in Western museums, and this situation is seen as restitution, not just of the claimed objects but of the colonial oppression that lost them in the first place. But tension between 'us' who have 'always owned' the symbolic object, and the 'alien other' occurs all over the world, and maybe it always has. 'We' may be European

villagers bitterly resentful of being excluded from the Roman site where our children have played for generations, or Egyptians mourning the Sphinx's lost beard; 'they' may be seen as foreign, rich, insensitive, greedy, middle-class, or all of these.

In pride of place in the Early People Gallery of the National Museum of Scotland in Edinburgh stands a magnificent sculptured Pictish stone (Figure 7). Weighing 1.9 tonnes and measuring 2.34m tall, it is one of the finest of the stones carved in Scotland around 800 CE to celebrate the coming of the new religion of Christianity. Once, it had a huge cross on one side, but that has gone. The surviving face bears mysterious Pictish symbols amongst splendid interlace decoration, but also a hunting scene with a lady riding side-saddle. The Hilton of Cadboll stone once stood near the ruins of a chapel between the shore and cliffside at the northeast end of the village, some hundred miles north of Edinburgh. It was rediscovered in 1811. One face of the sculpture had in 1676 been completely removed and replaced by an inscription to Alexander Duff and his three wives. Intended as a grave-slab at Fearn Abbey a few miles away, local legend says that the slab was found too heavy to transport, so it was abandoned where it lay. For fifty years after its rediscovery it was left in a nearby shed, until the Macleods of Cadboll had it re-erected in the grounds of Invergordon Castle. When the Macleods sold up in 1921, the stone was sent to the British Museum in London. There was such an outcry over this move that within the year it came back north to Scotland and was installed in the National Museum in Edinburgh (James et al. 2008).

The story, however, was still not over. Having failed to secure its return to the village, local residents promoted a project to create a replica, and in 2001 an archaeological excavation discovered the cross's missing base; this led to a fresh surge of interest and concern. Local feeling was intense:

> I feel that while that stone is in Edinburgh museum it's a dead stone but it could be made live . . . And when it's alive it'll be back in Hilton and the stump of the stone is a catalyst for this . . .

> the Hilton stone, you almost feel attached to it, it's almost like being attached to rocks or the sea or it's always been here, it's part of the place and for generations . . .

> . . . was like something that was born there and it should go back . . . It's, it's like people who emigrate or go away, they should always come back where they were born and I feel that that stone should go back.

> But to know that my people were here and that stone is there just to touch it you know they must have seen it, they must have touched it you know going back these years, it was like something holy I just, I just needed to touch it. (quoted in Jones 2004)

This example, and innumerable others like it, demonstrate the power of objects to take on new meanings and to become symbols of great significance to particular communities. They do not at all need to be originally *religious* objects to do so—though the language of spirituality is often used about them and about their significance.

Objects which take on this kind of symbolism can—sometimes at least—be treated as living beings, indeed as people. By contrast, actual human remains—at least older ones—are often regarded simply as so much archaeological evidence. Thus, in 2009, a survey of English public opinion revealed that, 'The vast majority of the England adult population support museums that wish to display and keep human bones for research purposes . . . Many are unconcerned about the age of the bones used in displays and for research purposes, and bones being at least 100 years old satisfies the vast majority' (bdrc 2009). What matters is how people feel about a thing, and meaning and significance can be attributed to anything. But even museum staff can be torn. A struggle has been going on between archaeologists and local people in the Altai Mountains of Siberia over the fate of the extraordinarily well-preserved body of an Iron Age Pazyryk girl. Led by local shamans, many Altai people are blaming her excavation for earthquakes and sickness. The director of the local ethnographic museum, Rima Yerkinova, said: 'Personally I am torn. As the director of the museum, I feel she must be returned to us to be put on display for our people to see. But something inside me says she should be reburied. It is the belief of our people.'[3]

Very often, this struggle is political as well as personal, and the contested object becomes a football in power-play between leading families in the village, between regions of the country, or between states. People can effectively demand control over 'their' objects only when they have a sufficient degree of leverage; such control then gives them greater prestige and authority in the eyes of their neighbours and the world—and their victory over those who once had supreme power, the once-omnipotent museums, itself gives immense satisfaction and reinforces the group's identity. It also reinforces power structures within the group. In 1991, a collection of photographs by the American anthropologist Matilda Coxe Stevenson was given to the A:shiwi A:wan Museum and Heritage Center in Zuni, New Mexico, while a duplicate set was given to the National Anthropology Archives in the Smithsonian Institute in Washington. 'Once the images arrived at the Zuni museum, they were absorbed into the Zuni system for the control of knowledge' (Isaac 2007). In Zuni society, as with many North American peoples, tribal elders tightly control knowledge. The photographs were divided into two lots: those revealing sensitive or esoteric imagery were kept separately, and only initiated members of Zuni religious societies were allowed access.

ASKING FOR CONTROL OF UNDERSTANDING

Sometimes, the dominant people in the 'reclaiming' group want to control not access, but understanding. In 2000, the American Museum of Natural History in New York signed an agreement with the Confederated Tribes of the Grand Ronde Community of Oregon to ensure access to the fifteen-and-a-half-ton Willamette Meteorite, one of the museum's most notable exhibits. This is the largest meteorite ever found in the US, and has been on display in the American Museum of Natural History since 1906. In return for an annual ceremonial visit and a promise never to cut samples off it again, the Grand Ronde dropped their claim under NAGPRA for its 'repatriation'. Significantly, the museum also agreed to include in the meteorite's interpretation an explanation of its significance to the Native Americans.

What is that significance? Before the arrival of Europeans, the Willamette Valley was inhabited by the Clackamas people. They knew the meteorite as 'Tomanowos'. According to the tradition of the Clackamas:

> Tomanowos has healed and empowered people in the Willamette Valley since the beginning of time. The Clackamas believe that Tomanowos came to the valley as a representative of the Sky People and that a union occurred between the sky, earth, and water when it rested in the ground and collected rainwater in its basins. The rainwater served as a powerful purifying, cleansing, and healing source for the Clackamas and their neighbours. Tribal hunters, seeking power, dipped their arrowheads in the water collected in the Meteorite's crevices. These traditions and the spiritual link with Tomanowos are preserved today through the ceremonies and songs of the descendants of the Clackamas.

In the mid-nineteenth century the Clackamas, along with many other peoples, were moved from western Oregon and northern California to Grand Ronde Reservation in Oregon. Their claim to the Willamette Meteorite is an important part of the Grand Ronde people's efforts to re-establish their tradition and identity.[4]

On a vastly greater scale is the approach taken at the National Museum of the American Indian in Washington. There, the museum eschews any scientific explanation of the history of the indigenous peoples of the Americas in favour of the traditional origin-myths of Native American people themselves. For example, there is no mention of people moving across the Bering Strait; rather the museum assumes, along with the (some?) Native American people themselves, that they have 'always' lived there. One critic called the displays 'a monument to Postmodernism—to a way of thinking that emphasizes multiple voices and playful forms of truth over the lazy acceptance of received wisdom, authority and scientific certainty' (quoted in McKeown 2007). The museum has a rule: 'The wishes of Native American peoples

with respect to access, treatment and use of ceremonial and religious materials needed in the practice of their religion must be granted.'

> For example, a group of tribal representatives accompanied by one of their recognised religious leaders asks to see an object in the museum's collection that they consider to be sacred and imbued with its own life essence. Upon seeing the object, the religious leader reaches for it, opens it, and begins to use the contents. Before the object is put away, the practitioner may ask the museum staff if an offering, provided by the practitioner, can be placed near the object for a period of time. The key to this scenario is that the practitioner, *not* the museum staff, engaged the object or employed active practice. (Sadongei 2004: 18)

WHO SPEAKS FOR THE COMMUNITY?

The question of who speaks for the community—and their motives—can pose huge problems for a museum faced with a request for return or control. Museums have to be very careful. In the 1980s, there were massive demands for the return of the 'crown jewels' of the Sikhs, especially the throne of Maharaja Ranjit Singh, which has been in the V&A Museum almost since 1849, when it was seized by the British who annexed his kingdom. But this demand came at the time the Khalistan Movement was campaigning for independence for a Sikh Punjab, a campaign that ended in the brutal crushing of an armed insurrection in the Golden Temple of Amritsar itself. For the British Government to return such a highly charged symbol of Sikh independence would have been seen as an act of extreme hostility by the Indian government—would indeed have been unthinkable. Seldom are the issues quite so clear cut, but always a museum, faced with a claim on one of its objects, must ask, 'Who is making this claim? What authority do they have to do so? If we accede, what will be the impact on their wider community and on its neighbours?' Such questions are quite as germane when the context is religion rather than, more overtly, politics. The V&A Museum had some problems when they encouraged the Friends of the Western Buddhist Order (FWBO) to install a shrine to the Boddhsattva of Compassion Guan Yin as part of their 2000 Sacred Spaces exhibition. The FWBO is a group founded in 1967 with the specific aim of making Buddhism meaningful to a Western population, but it has not been without controversy. The museum received complaints that the FWBO did not represent true Buddhism and was a cult undeserving of a place in a national museum.

As we have already seen, 'return' does not necessarily mean to another country. Since the fall of communism, elements within the Russian Orthodox Church have been campaigning for icons to be returned to worship from their role as art-objects in museums (Munis 2010). Museums in Russia, still recovering from the

claims of Germany for the return of wartime loot and from claims by the heirs of pre-Revolution art-owners, are feeling under attack. In 2009, the miracle-working fourteenth-century Virgin of Toropets icon was moved from St Petersburg's Russian Museum to a newly built church near Moscow. The *Moscow Times* reported this as done at the behest of the Ministry of Culture, which had been approached by Patriarch Kyril. The church is in a new 'upscale gated community', and both were built by the Sapsan construction company whose president, Sergei Shmakov, sponsors the restoration of Orthodox churches and the collection of icons. The museum's director is quoted as saying that the loan was temporary, but, 'Of course, I am concerned that the icon may not be returned, for such precedents have been known. However, this time the church, state and museum have gone for a compromise on many questions, so I'm sure the icon will return to the museum.' Museum staff were much less sanguine. One curator declared:

> 'The fact that the icon was removed from the museum in defiance of the opinion of experts and the public shows that we have a situation in which all the museum's standards of preservation have been violated . . . besides, we really don't understand why such a precious icon should go to a newly built church in an upscale gated community that has no relation to the icon.' The museum was often willing to meet the interests of Russia's churches and had given them 169 icons during its history. 'However, there are works that cannot be taken anywhere, under any circumstances. It is difficult to imagine how, for instance, Rafael's Sistine Madonna could be given to a church. The same applies to our icon . . . Therefore, we will fight for our icon to the end.' (*The Moscow Times* 14 December 2009)

This reaction was not just that of one disgruntled employee. The director of the State Hermitage Museum itself said:

> Religion and culture are not opposed to each other. They supplement each other, though they speak different languages. Moreover, in times of trouble they can substitute for each other. At the time when the church did not virtually exist in our country, the knowledge about religion was passed on through museums . . . The story with the Toropets icon of the Virgin Mary also has nothing to do with religion. This is yet another proof of the fact that in our society money answers all things. If a person has money, then he can bring an icon to a newly built church. This is the matter we are speaking of; it has nothing to do with the fact that it is a sacral icon, and religious people should pray before it. If by whim of some rich religious person an ancient and fragile icon can be taken from a powerful museum, this means that anything is possible. It concerns not only icons and museums.[5]

We have seen from the example of the Umbrawarra Gorge (introduction) that to be considered a stolen and traduced religious object, an object need not be an original.

A replica, too, can be claimed, and by 'source communities' in many different parts of the world. Thus, the Zuni people of the western United States claimed back a replica war god from the Museum of New Mexico, made of cardboard and painted feathers, because, 'Information is power and the replicas embody power or information that belong to the Zuni people which should not be revealed to uninitiated people.' They also (unsuccessfully) claimed one back from the Pitt Rivers Museum in Oxford, on the grounds that the anthropologist who made it had been initiated and trained as a Bow Priest (Simpson 1998: 59).

Do such returns really strengthen those communities, and if so, in what ways? Are there negative effects, for example the reinforcing of oppressive social structures? Do the objects themselves remain significant, or was the importance in the campaign? So far, research seems to be encouraging, though more is needed. Thus, Seema Bharadia (1999) researched the effects of the return of sacred bundles to the Blackfoot people by the Glenbow Museum of Alberta, Canada. She found these almost entirely positive, contributing significantly to the reinforcing of community identity and to social relationships both within and without the community.[6]

OBJECTS AS CARRIERS OF MEMORY

Central to discussion of objects claimed is the role of memory: memory individual or collective, memory real or imagined.[7] Much attention has been given over recent years to the encapsulation of memory in objects, and the role of the souvenir. This use of objects to carry memories can, though, work at one remove; this was the intention behind biblical museums and exhibitions in Western Europe in the eighteenth and nineteenth centuries. In a culture where the Bible was regularly read or heard in almost every household, yet where the lands of the Bible were almost unimaginably remote, objects from those lands brought Bible stories to life—to a present reality—in a way that no mere verbal account could. And because the Bible was so familiar to most of those visiting such museums, stones, plants or stuffed animals from the Holy Land were not just explicatory objects, but carried their own kind of sanctity, and acted as powerful souvenirs, recalling to memory stories known probably since childhood. Thus, the Dutch Reformed minister Leendert Schouten (1828–1905) included in his private collection rather random objects from the Jerusalem area and beyond, ranging from oil lamps, coins and a Second Temple period ossuary to grasshoppers from the Red Sea area and a stone from the Western Wall of the Temple (van der Meer 2010: 134). This collection eventually became the Amsterdam Biblical Museum. If the 'collection' can seem slightly absurd to us, to someone steeped in the Bible but knowing little of the Holy Land itself, these were no doubt powerful objects, powerful carriers of memory (Wharton 2006).

Whether the memory that an individual enshrines in an object comes from their personal experiences, or is part of a collective memory, whether it is 'genuine' or fashioned, matters little to how that person regards the object. Whatever the origins of the attachment, however outsiders may judge it, that attachment is very real and leads directly to a claim upon the object. In this chapter we have seen that this claim is sometimes for direct possession, sometimes for control of its interpretation. In the next chapter, we shall see that it is very often a demand that the desired object be offered respect, and we shall try to understand what that means.

5 OBJECTS RESPECTED

What respecting a religious object means, and how respect is shown

Religious objects, we are constantly told, should be treated with respect. What does this mean, in theory and in museum practice?

WHAT IS 'RESPECT'?

'Respect' is an odd concept, its meaning slippery, especially when that 'respect' is given to an object. Yet, we come across it often in daily life. I may, for example, still give respect to my grandfather's favourite clock, even though he is long dead, and I may even ask you to do so, too. The phrase often used in this kind of situation is 'out of respect for his memory'. In a sense, therefore, the respect is not actually given to the clock itself, but to my (or your) memory of Grandpa and of *his* relationship with the clock. So perhaps, really, I'm signifying my respect for myself or for you, and for what *we* bring to *our* relationship with the clock. In other words, there is a four-way relationship here: between me, you, Grandpa and the clock, and the core of this is my relationship with you—I want you to share my happy memories of Grandpa, and to symbolize them through our mutual relationship with the clock. You may go along with this, in order to avoid upsetting me. But if I've moved away, I shan't actually know what you do with the clock—you can put it on eBay with impunity. If you do not, it may be because you know that I trust you, and you want to continue feeling you deserve that trust.

So perhaps it is with curators and religious objects. If nobody knows what a curator or conservator is doing when alone in the store or lab, will they still show

a sacred object respect, if in truth they simply think of it as a beautiful or interesting thing, to which foolish people in the past once attributed special meaning? If they do—continue to keep the sacred book wrapped in silk, avoid using pig's hair brushes when cleaning it, or refrain from touching the sacred object while menstruating—they will have to ask themselves why. They may be hard-pressed to find a satisfactory answer; at best they may feel that they promised its devotees that they would, and that it matters that they continue to deserve their trust. Mind, they probably will keep their promise. One of the odder consequences of our post-modern, multi-faith world is that we feel we need to respect not just other people's beliefs, but also the symbols of those beliefs. It is perhaps only those with firmly held beliefs of their own who feel able to disrespect those of others. As we have seen, even when relaxing safely among like-minded colleagues, few if any museum workers admit to betraying the trust placed in them, or even to cutting corners.

'Respect' as a concept has gained the attention of many philosophers, though few have considered how it applies to material things. Respect involves both behaviour and feeling, action and emotion. At its core lies the relationship between the respecter and the person or thing respected, in which the former responds to the latter in an appropriate way. This may involve attention, deference, judgement, acknowledgment, valuing, as well as particular behaviour. Naturally enough, most thinkers on the subject have concentrated on respect given to people, or to oneself. They see the package of responses that is respect as something that is owed to and claimed by the person or thing respected; it is the recognition of something 'as directly determining our will without reference to what is wanted by our inclinations' (Rawls 2000: 153). So, 'In this way respect differs from, for example, liking and fearing, which have their sources in the subject's interests or desires. When we respect something, we heed its call, accord it its due, acknowledge its claim to our attention' (Dillon 2007). But, 'in respecting an object, we respond to it not as an extension of feelings, desires, and interests we already have, but as something whose significance is independent of us.' Moreover, 'our reasons for respecting something are, we logically have to assume, reasons for other people to respect it (or at least to endorse our respect for it from a common point of view).'

This raises difficult questions when the respect is being given to a human artefact, or to human remains. 'Inanimate objects, do you have a soul which sticks to our soul and forces it to love?' asked Lamartine. For most objects, the answer is surely 'no'. But this assumes that objects are not people, and we have seen in the Introduction that religious objects, in particular, are often regarded as people in their original cultural contexts, and even in our own society the categories of 'object' and

'person' can be less than utterly distinct. Besides, we are in fact offering respect not so much to the artefact itself, but to the person, community or culture that produced it, and perhaps even ultimately to the very notion of the diversity of humankind, and to the many ways human beings try to order their lives and understand their world. When we offer respect to an Egyptian statue of Thoth, it is probably not because we ourselves are devotees, nor because we have strong memories of our parents worshipping in his temple, nor because Thoth devotees are watching what we are doing. What we are doing when we handle his statue reverently (or, if that word is too strong, with care and courtesy) in the privacy of the museum store is to remind ourselves of the respect we owe to the very diversity of humankind's quest for meaning.

But what happens when we really *don't* respect an object? When it symbolizes something we really detest? Is there a kind of respect that one could offer a knife used for cliterodectomy, or a Nazi flag, or an Inquisition torture-rack? Can we extend the idea of this kind of respect to cover all objects symbolic of humankind's quest for meaning? By the same token, can we then insist that *everyone* accepts a duty of respect to all objects? We do so in society at large, insisting that everyone in a multi-cultural society is deserving of respect, and if not actually refusing anyone permission to despise anyone else, certainly forbidding them to encourage such despising. Perhaps all we can do here is to acknowledge the historic interest of the object.

In England, an official report noted the difficulty of tying down 'respect'; this was an attempt at guidance on the treatment of archaeological human remains. The report concluded: 'respectful treatment of ancient Christian human remains can be defined as that which is in keeping with Christian beliefs concerning the status of the body and which would not be likely to cause significant offence to members of the general public, regardless of whether they hold strong religious views'. As one of its authors remarked, 'Respect is a bit like fairness—you know it when you see it (or not!) but it's tricky to define'.[1] The report noted that 'a society that cares for the dead demonstrates that it values life.' and that is perhaps the most sensible view that can be taken where neither belief nor tradition lay down a strong requirement for particular practice (Church of England/English Heritage 2005).

'Respect' when applied to objects is a highly elusive concept, for all that is so often demanded. Perhaps the most useful definition is 'to pay attention to, in a culturally appropriate way.' In practice, this normally means respecting the wishes of the communities from which the objects came, even if (as we saw above, chapter four) this may mean the wishes of the modern-day leaders of the religion they represent. In the next three sections, we shall look at what 'respect' is actually taken to mean in current practice in museums.

WHAT 'TREATING WITH RESPECT' MEANS IN PRACTICE

What does this 'respect' mean in practice? How are museums asked to look after religious objects? The areas of concern fall into five main categories.

1. Handling. Restrictions include *who* an object is touched by (for example, only by a priest, only by someone in a state of ritual purity, not by a menstruating woman, not by a woman at all, not by anyone not initiated, and so on). They also often cover *how* an object should be handled (for example, only touched with gold or silver, or with cloth, always carried upright, always carried above the head, and so on).
2. Seeing. Many objects may only be seen by particular classes of people, or only at particular times (for example, only by priests, by the initiated or by men, only at particular seasons, etc).
3. Storage. Some objects must be oriented in a particular direction, kept at a particular height, stored only alongside or near compatible objects (for example, women's objects with women's objects, or our things with things from friendly tribes); some must be 'aired', some wrapped in a particular way, etc.
4. Treatment. 'Live' objects must never be treated in such a way that they might be harmed or even 'killed', for example with pesticides or deep-freezing. Treatment of sacred things must never use forbidden substances—which can cause difficulties for conservators accustomed, for example, to using saliva for cleaning.
5. Active honouring. Some faith communities want regularly to treat certain objects with particular rituals, either for fear they may 'die' of neglect, or simply to give them honour.

An extraordinary variety of objects may call for our respect, and may be called 'religious'. Often things which appear mundane at first sight are of religious significance to their host community, for as we have seen, the distinction between 'religious' and 'mundane' is a curious modern Western idea, incomprehensible to most people at most times. Simpson (2002: 17) gives the example of a carved wooden figure from Hawai'i believed by curators to be a simple stand for resting fishing spears. The native Hawai'ian organizations seeking its repatriation claimed that 'The *ki'i lā'au* is not an ordinary support figure, but an aumakua image created by the *kaua ali'i* [warrior chief] for the purpose of housing an ancestral spirit to care for his spears.'

At the Museum of the American Indian in Washington, the staff are 'conscious of the traditional nature of almost every object and holds the utmost respect for it. This is a major component of handling Native materials—having respect for them' (Drumheller and Kaminitz 1994: 58). In practice, this means that thought

has to be given not only to the *intrinsic* qualities of each and every object—this textile must be protected from light damage and insect attack, that metalwork must be protected from potentially corrosive humidity or gases—but to their attributed qualities, what we called *adtrinsic* qualities, too. Thus, tribal enemies should be kept apart to prevent any disturbance between the objects themselves; some objects need to face the right way, even on a museum storage shelf; men's things—fish-hooks, bows, shields, etc—may need to be separated from women's things—scrapers, cradleboards, bowls, etc; certain objects should be handled only by certain people; others must not be suffocated in airtight boxes, or 'killed' by pesticide gassing or freezing.

Museum objects with similar kinds of demands can be found from many different faith traditions in many different parts of the world. A 2002 survey of culturally sensitive material in museums in north-east England (Simpson 2002) found an extraordinary variety of material originating from Australasia to South Asia, from Africa to the Pacific. Each object had different needs, and different requests to make of its curators.

When we turn to look at how followers of the three Abrahamic religions prefer 'their' objects to be treated in museums, we find some clear principles, but plenty of room for disagreement and variation, especially amongst those outside the mainstream. Thus for Muslims, it is principally the Holy Qur'an that is most sacred, and this sanctity extends to the words of the Qur'an when they appear as inscriptions on ceramics, weapons, clothing, pictures and so on. Thus, a Mahdist banner from the battle of Omdurman should be treated 'with respect' by virtue of the Qur'anic lettering it bears. This might, for example, mean that such things are kept in storage on a top shelf rather than a bottom one, or that they are not displayed mixed with objects from other religions. The different schools of Islamic jurisprudence have slightly different attitudes and requirements, but Malaysia's Islamic Arts Museum has published its own rules for handling the Qur'an and other Muslim art objects (Zekrgoo and Barkeshli 2003: 94), which give helpful guidance. The overall aim is to maintain the boundaries between the sacred and those things regarded as polluting. These include bodily fluids, liquid intoxicants, dogs, pigs and—more problematically—those who do not have faith in God. The Malaysian rules can be summarized very briefly as:

- Muslims should wash their hands according to the *wudhu* rituals before handling the Qur'an, and non-Muslims should wear gloves.
- The Qur'an should always be carried, placed or stored in a position that is higher than waist level, and should never touch the floor.
- Polluting substances must be kept away from the sacred, so for example, brushes made of pig bristle or adhesives incorporating pig fat must not be used in the conservation or marking of anything bearing a holy text.

In Judaism, things are rather more complicated. For some, the Torah should not even be displayed unless Jews are among the visitors, for it has only one purpose: reading and learning God's wisdom. Nor, on the strictest view, can non-Jews carry out conservation on Torah scrolls. In Judaism, too, it is primarily the rules concerning purity and impurity that affect how museums are asked to treat things, but the range of objects accorded a degree of sanctity is considerable. The Judaica collection in the Israel Museum includes the following objects of sacred materials by degree of importance (Maggen 2005: 102):

- Holy texts, prayer books and manuscripts.
- Holy banners.
- Holy objects associated with the Torah scroll.
- Ceremonial objects.
- Personal holy objects.

A simpler separation is between *tashmishey kedusha*, things closely associated with the Torah or bearing the name of God, such as Torah mantles and the Ark curtain, and *tashmishey mitzvah*, things essential in performing a commandment, but not intrinsically holy (Greene 1992; Morris and Brooks 2006: 245). The former call for special care in museums, and although different traditions—and, indeed, different individuals—may differ in what they feel appropriate, this will probably include the use of only kosher materials in conservation work, and the avoidance of work on the Sabbath. When a Christian theme park in the United States stuck pages from the Torah onto walls, the local Jewish community reacted angrily, arguing that, 'A Torah should not be a display item. It is a holy item, and it should not be used' (Branham 2008: 29). In reality, of course, Torahs are frequently displayed in museums and libraries, sometimes with the active support of Jewish religious authorities. But respectful display is one thing, use as part of a missionary campaign is another.

Christianity is perhaps even more difficult, if only because a majority of the larger museums of the world were until recently found in countries where the dominant culture was Christian. Perhaps it illustrates the (cautiously) changing attitudes within professional museums that when in 1955 British Museum conservators found a number of relics in the golden head-shrine of St Eustace, respect prompted their 'return' to a Catholic church in Basle. But when their successors recently found thirty-nine relics in a twelfth-century portable altar, respect took a different form. The museum kept them there, and the curator in charge commented, 'We are treating them not as artworks, but as devotional objects, alongside other objects related to liturgy or the power of prayer. If people want to engage with it spiritually, they can. These items are still part of a functioning belief system. We are very sympathetic to this as long as it does not endanger the public and as long as it is personal and not

flamboyant.'[2] The *Church Times* began its story, 'Visitors to the British Museum will be able to pray in front of a 12th-century portable altar'.

One version of Christianity, that of indigenous communities in Mexico, met the modern conservation profession in a fascinatingly productive exchange. The village of Xochimilco, close to Mexico City, guards a sixteenth-century Christ-child figure, which is enormously revered. A carefully negotiated arrangement with the National Coordination of the Conservation of Historic Monuments secured its professional conservation, during which the figure was brought in formal procession to the laboratory, members of the community observed the whole procedure, and the working table became something like an altar, with a daily-increasing number of blankets, flowers and toys offered to the baby. Some of this devotion seems to have rubbed off on the conservators, who are reported to have brought their own offerings, and even prized the cotton swabs used during the cleaning process (Magar 2005: 88).

Another complication is that some religious traditions are quite happy to relax their rules when an object that would have been considered sacred when in religious use comes into a museum. Mellor points out, though, that however powerful and important African objects may be in their own cultural context, they are integral parts of a whole range of cultural activities and behaviours, and do not have lives of their own. So,

> it is not necessary for conservators to treat African objects that are out of their cultural context with the same strict behavior required when they are within their cultural context; nor would Africans expect them to receive that kind of treatment. We need not feed these objects, wash them, dance them, suckle them, spit on them, beat them, insult them, sacrifice upon them, or subject them to limited visibility. Indeed, it is somewhat patronising to presume we could replicate these complex patterns of cultural behavior toward objects. Furthermore, we need not approach African objects with uncertainty, fear, or trepidation.
> (Mellor 1992)

We have already seen that objects of 'dead' religions make few demands. Their curators are largely unconstrained by the need to consult anyone else, or the fear of complaint. Though an Internet search will reveal devotees of virtually every imaginable divinity that ever was, in practice the gods of ancient Egypt, South America or the classical world are these days undemanding. Public concern over 'religion' in Ancient Egypt galleries is virtually exclusively a more generalized concern over the care and display of human remains. However, we have also seen that the same is by no means true of north European paganism, where neo-pagans are making considerable demands of museums, particularly perhaps over the treatment of human remains, but also over the way other potentially 'religious' objects are displayed and interpreted (Figure 8).[3]

RESPECTING SECRECY

What responsibility do curators have to respect secrecy? In many faith traditions, certain objects are kept secret, or restricted to initiates. Yet, it is the mission of a museum to present and explain their objects to the public at large. Is there ever any responsibility on a curator to show this kind of respect?

In Tibetan Buddhism, the purpose of art is to aid devotees in their search for enlightenment. To do so, the art has evolved a complex set of forms and symbols that encapsulate and communicate all sorts of metaphysical ideas. Tibetan images are normally associated with particular meditations, which have specific, often obscure, texts associated with them, but which also need guidance from an experienced teacher. Much of the ritual is explained only to qualified practitioners, and each meditation requires the practitioner to be formally initiated. This is because many of these techniques are regarded as dangerous for those who are not properly prepared, or not under the guidance of an experienced teacher. Thus, the images of Tibetan Buddhism are intended to supplement written texts and teachings. Their aim is to aid learning and memory of the important details of deity visualizations, to focus attention while one contemplates the inner meaning of the teaching, and to help others to share the artist's or patron's meditation experience (Reedy 1992: 42). While some Tibetan Buddhist images are free for anyone to look at (the Buddha himself, the principal Boddhisattvas, Buddhist teachers and saints), some are traditionally kept covered, and only exposed to initiated devotees using them in meditation. Reedy discusses the dilemma of museum curators and conservators responsible for Tibetan objects, and wishing to maintain the appropriate kind of respect. Undergoing initiation oneself does not seem to be an option, not least because it involves accepting serious religious responsibilities, and may even involve a vow not to reveal certain aspects of the ceremony or practice to non-initiates. Reedy suggests that respect is best shown by studying and understanding the beliefs, traditions and practices that underlie Tibetan art, and by meeting Tibetans and learning about their history and culture; in other words, by traditional scholarly curatorship.

We have seen that religious objects make a big variety of demands on their curators and their visitors. These demands can perhaps be summed up under the catch-all title of 'respect', even when we know that the respect (esteem) we show is really directed towards the object's original and present-day stakeholders and to our relationship to them. Objects can, however, demand much more than mere respect. We have already seen (chapter four) that they can demand worship. In the next chapter, we shall look at the other demands they sometimes make, and the retribution they can take if those demands are not met.

6 OBJECTS DEMANDING AND DANGEROUS

How religious objects are put into museums to render them harmless, and how relics can turn the museum into a shrine

Many cultures attribute personality and great power to made objects—and not just statues and icons. Powerful objects are sometimes put into museums to keep them from causing harm. But even in museums, objects can be scary, and museum staff in many cultures have been known to be afraid of them. This is also a recurrent theme in modern stories and films. Powerful objects in museums can also include holy relics; again, museums merge with shrines.

A museum can be a display case or a shrine, but a museum can also be a safe, in which to lock up dangerous objects. Tahupotiki Wiremu Ratana was a Methodist ploughman in North Island, New Zealand, until he felt he was called by God to unite the Maori people and cleanse them from sin. He began preaching and healing in 1918, with dramatic success—his Ratana Church soon became one of the largest denominations in New Zealand. Ratana believed that salvation could come only by rejection of the old Maori religion, and worship of the one God. Yet, despite his opposition to *tapu*, he still recognized spirits residing in pictures, cloaks, carved objects and other artefacts, and saw them as potentially very dangerous. So from 1930, he deposited all he could in a traditional meeting house, treated as a museum, along with the many crutches, spectacles and wheelchairs abandoned by those he

had healed. When Ratana died in 1939, the museum began to fall derelict because, according to the Ratana Church's official history:

> For a long time these items remained on display in the mostly locked building which also housed old documents, diaries, books and genealogies important to the Ratana heritage. Unfortunately, the superstitions from the past seemed to linger with people fearing to enter the building after Ratana's death, leaving it to fall into disrepair. Many believed that to care for the objects and items might reawaken the spiritual forces, which they believed still resided there.[1]

But even when corralled in a museum, objects can still endanger museum staff who have to look after them. Staff need to protect themselves. In northern Vietnam in the 1990s, a power struggle between two groups of village residents, and a series of law cases, led to a decision to remove a recently presented statue of the One-Eyed God from the village's Communal House. The trouble was that this was not just a statue any longer, but had been 'animated' by a ritual master in a long and elaborate series of nighttime ceremonies. At the conclusion, the ritual master said, 'My mind and my heart have to be completely focused on the incarnation to sanctify the ears, the eyes, the nose, the tongue, and the heart-mind of the statue. At this instant, the wooden statue changes its nature and becomes a god, animated and powerful' (Van Huy 2008: 207). Moreover, the god could not be buried, burned or thrown into a river—the usual way of disposing of a statue no longer venerated—without further offending one of the village factions. Instead, the provincial authority decided it should be given to the recently founded Vietnam Museum of Ethnology. This required that the statue be deanimated again. For this, a new ritual master had to be hired for a new ritual. His elaborate petitions to the Buddhas and gods to allow the statue to be taken out of the Communal House were followed by a similar petition from the local authority representative.

> This is also the most dangerous moment in the deanimation ritual, the moment of transformation from a sacred image animated by a resident god to an empty statue. No one knows for certain whether a statue has been effectively deanimated. Did the One-Eyed God really agree to have people carry the statue out of the communal house. If not, what would happen to those who tried? It was a moment of great tension. (Van Huey 2008: 214)

Happily, all went well. But even when the statue arrived at the museum, it caused nervousness. Some of the museum staff were reluctant to approach it, afraid it might still be powerful, and it remains in store. The monk who carried out the original animation seems to think it still powerful; he has said that to exhibit it would endanger the village. Had all this happened in Japan, it would have been simpler: there, there is a standard ceremony, *hakkenshiki*, for the temporary deconsecration of Buddhist

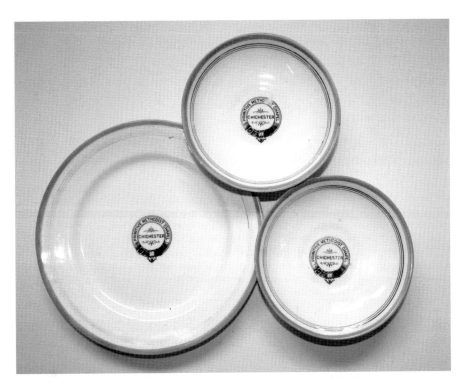

Figure 1: Plate and saucers from the Primitive Methodist Chapel, Chichester. Religious objects in museums need not be in any sense 'holy', but may be quite everyday things that still help tell an important story about the character and social life of the religious community from which they come. Photo: Crispin Paine, with kind permission of The Novium (Chichester District Council).

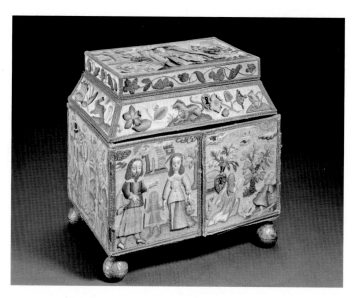

Figure 2: Box covered with embroideries made around 1660 by a London schoolgirl. This side depicts on one door Abraham dismissing Hagar (and her son Ishmael—a variation on the Bible story), on the other Hagar and Ishmael beside a well in the wilderness, about to meet the angel. The story of Hagar was often used to emphasize the importance of marriage, heirs and the proper obedience of women. It thus taught its young artist not merely the stories that underlay her Protestant faith, but also how to obey God and put up with men. Today in the museum, the box celebrates English amateur craft skills of the seventeenth century, but also points out the relationship between religious image and social mores. Photo: Ashmolean Museum, University of Oxford.

Figure 3: *Prayers in the Desert*, by William Muller. This may be the first British painting to depict Islamic religious practice. Painted in the 1830s, after the artist's return from a trip to Egypt, it can be seen as merely a minor Orientalist picture; but for some Birmingham Muslims, it has been a moving affirmation of their faith. Photo: Birmingham Museums and Art Gallery.

Figure 4: Reliquary of the arm of St Catherine of Alexandria, made 1482–96 by Raffaello Grimaldi of Reggio nell'Emilia for the arm of St Catherine of Alexandria. It was probably designed to be carried in procession, and its inscription records that the bishop of Reggio granted an indulgence to anyone who kissed it. Today, it lives in a showcase in the V&A Museum, and is admired as a superb example of late-medieval metalworker's craft. Photo: © Victoria and Albert Museum, London.

Figure 5: Buddha Day 2006 in Birmingham Museum and Art Gallery. Local Buddhists venerate the 'Sultanganj Buddha'. Photo: Birmingham Museums and Art Gallery.

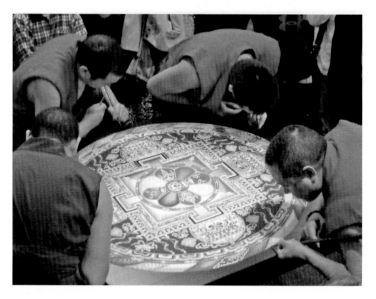

Figure 6: Monks visiting from the Drepung Loseling Phukhang Khangtsen Monastery create a mandala at the Pacific Asia Museum, Pasadena, California, November 2010. Here, the 'religious object' in the museum is not so much the mandala itself, for that is destroyed at the end, but the process of creating it, which is seen as a meditation. Photo: Courtesy of the Pacific Asia Museum.

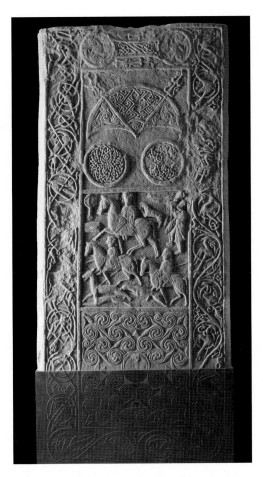

Figure 7: The Hilton of Cadboll stone, as it stands today in the National Museum of Scotland. This dramatic Pictish monument was carved around 800, and as well as its enigmatic Pictish symbols and hunting scene, originally bore a large Christian cross. Its later story is as interesting as its origins. Reused as a tombstone in the seventeenth century, it was then abandoned until the 1860s, when it became a garden ornament. In 1921, it went to the British Museum, but within months the Scots had successfully claimed it back. A campaign to get it returned from Edinburgh to Hilton of Cadboll succeeded in securing a replica, but not the original. Photo: National Museums Scotland.

Figure 8: Members of the Loyal Arthurian Warband group of Pagans, opposing the removal of the 'Seahenge' timber circle before its excavation. 'Seahenge' was the nickname of an early Bronze Age monument discovered on a beach in north Norfolk in 1998. Huge controversy developed over whether it should be excavated and 'rescued' from the sea, some Pagans taking the view that the site was sacred and should be left to the elements. In the end, though, the monument, comprising a circle of oak posts surrounding an inverted oak tree root, was excavated, conserved and re-erected in the Lynn Museum in nearby Kings Lynn. For Pagans, in particular, the links between sacred site and religious object are strong. Photo: Norfolk Historic Environment Service.

Figure 9: Department of the Holy Relics of the Prophet at Topkapi Palace Museum, Istanbul. The Holy Qur'an is read continually, with nearby screens scrolling the text in Turkish and English. This is the final room of a gallery that serves as both a shrine and a museum for the relics of the Prophet Mohammed. Photo: Wendy Shaw.

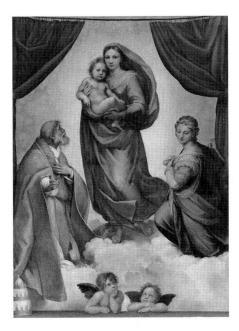

Figure 10: Raphael's Sistine Madonna is a classic example of a religious object which takes on a new life as a work of art. Photo: Scala Group Spa.

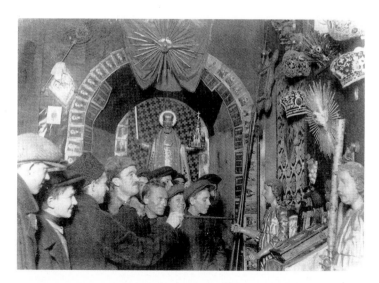

Figure 11: A gallery tour in the Central Antireligious Museum, in the former Strastnyi Monastery, Moscow, in 1930. Workers are taught to despise religious objects, which now fight for atheism. (Illustration from Martel 1933)

Figure 12: A cast-iron Sussex fireback of the early seventeenth century (in fact a Victorian replica). It depicts two Reformation Protestant martyrs, possibly even the ironmaster Richard Woodman, who was burned at the stake in 1557. It is certainly based on a woodcut in *Foxe's Book of Martyrs*. Many everyday items are 'religious objects' in the sense that they carry religious images and hence stories. Photo: By kind permission, Barbican House Museum, Sussex Archaeological Society.

Figure 13: Altar of Loucetius Mars and Nemetona, Roman Baths Museum, Bath. This full-size video-projection of a pilgrim from Trier installing the altar brings to life a Roman antiquity in a way that without modern technology would be very difficult indeed. Photo: Bath & North East Somerset Council Heritage Services.

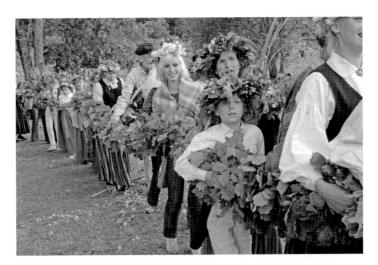

Figure 14: Summer Solstice Festivity organized by the Turaida Museum Reserve, Latvia, in 2010. Many open-air museums organize revivals or reenactments of traditional ceremonies which (at least originally) had a religious basis. The new emphasis in recent years on the role of museums in preserving and celebrating 'intangible heritage' offers new opportunities for museums to interpret religion, but also makes more urgent questions about what is authentic. At present, events such as this seldom make use of original museum objects. Photo: Turaida Museum Reserve.

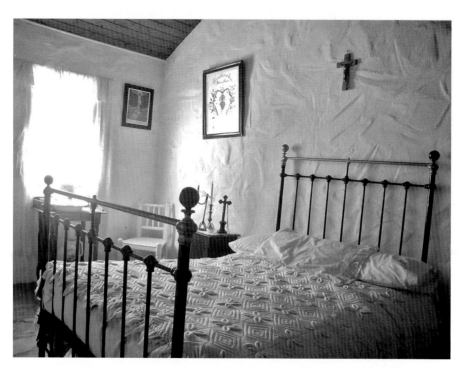

Figure 15: Bedroom of a County Mayo, western Ireland peasant house in the later nineteenth century. This reconstruction is included in the Knock Museum to show that those privileged to witness the 1879 apparition of the Virgin Mary and other saints were ordinary country people, if devout ones (note the crucifixes, holy pictures and rosary). Here, though, simple household objects have become 'objects explanatory' in a religious cause, if not actually 'objects militant'. Photo: Crispin Paine, with kind permission of The Knock Museum.

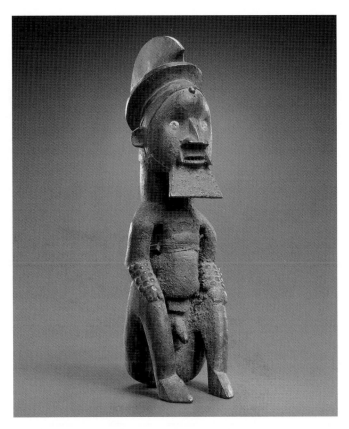

Figure 16: *Bitégué* statuette of the Batéké people north of Brazzaville in the Republic of the Congo. These protective figures were placed by the head of household in a corner, facing the door. This one was rescued by Lehuard, a railway engineer in colonial French Moyen-Congo, from one of the local Roman Catholic missionary's Saturday bonfires of 'heathen idols'. Through his son Raul's collection and an exclusive Paris 'tribal art' gallery, it eventually came to the Louvre; it is now in the Musée du Quai Branly in Paris (Corbey 2000a: 4). This statuette has, thus, run the gamut of meanings: religious object, curio, commodity, art object, ethnographic specimen. Photo: 2011 Musée du Quai Branly © SCALA, Florence.

THE FAMILY IDOLS OF POMARE,

Which he relinquished, and sent to the Missionaries at Eimeo, either to be burnt, or sent to the Society.

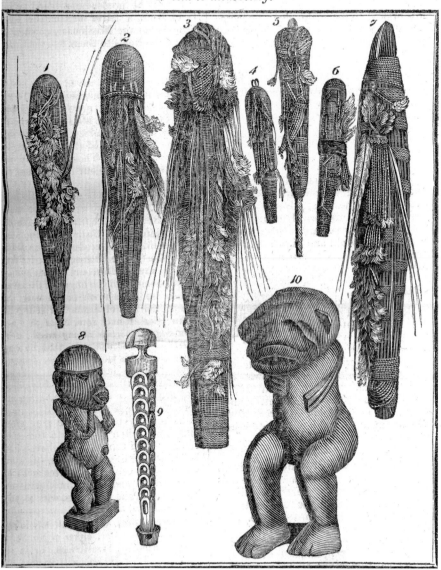

Figure 17: The Family Gods of Pomare, the 'King of Otaheite', sent to the London Missionary Society in 1816. No. 3 was named as Temeharo in Pomare's letter, who stated that his father had added the red feathers, which he acquired from Lieutenant Watts of the Penrhyn in 1788. Illustration: *Missionary Sketches* 3 October 1818, and *Missionary Chronicle* 26 December 1818. Photo: School of Oriental & African Studies.

Figure 18: This harmless-looking amethyst in London's Natural History Museum was once described as 'trebly accursed and stained with blood, and the dishonour of everyone who has ever owned it'. The 'cursed amethyst' is the classic example of a dangerous object committed to a museum by its frightened owner. Photo: Natural History Museum.

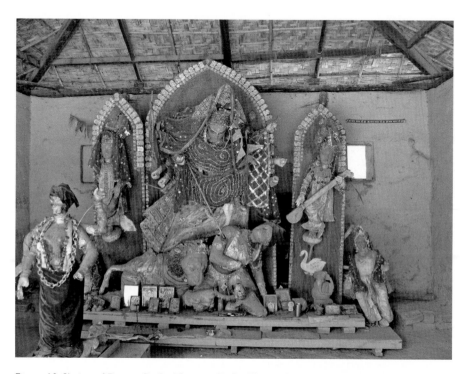

Figure 19: Shrine of Durga, Crafts Museum, Delhi. The traditional rite of creating a clay image of the goddess Durga, and committing her to the River Ganges at the end of her annual festival, has been exported to many parts of the world by Bengali migrants. One made in the British Museum courtyard in 2006 was committed to the Thames. But this one, made in the Crafts Museum in Delhi, was retained in the museum and was deteriorating; how to dispose of it without causing offense? Eventually, the museum decided to immerse it on the traditional day, the last day of Durga Puja. Even so, there were some people at the museum who were upset that there was no proper ceremony, 'until they understood that this was not a "holy" idol but an old, broken and abandoned one.' Photo: Anil Bhardwaj, with kind permission of The Crafts Museum, New Delhi. I am grateful to Ruchira Ghose for this.

Figure 20: Kabul Museum, 1995. We cannot know what is in the minds of these soldiers relaxing in the wrecked museum, but this Buddha image seems for the present to have lost both its religious and its museum significance. Photo: Steve McCurry.

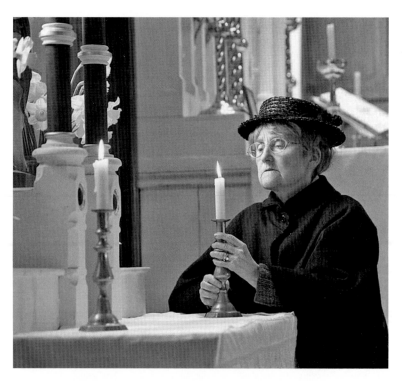

Figure 21: Eileen Davy, dressed in the style of around 1900, preparing the side altar for Mass in the St John the Baptist Church, reconstructed in the Ulster Folk and Transport Museum, Belfast. However, Mrs Davy is not *really* preparing the altar, but putting on a show for visitors; yet Mrs Davy is actually a Catholic, so there remains an element of ambiguity. Photo: Ulster Folk and Transport Museum (National Museums Northern Ireland).

icons about to undergo conservation work or to be exhibited in secular places. The spirit of the Buddha is removed, and it becomes a mere material object (Suzuki 2007: 139).

Objects can pose danger to museum staff in all parts of the world, it seems. Lissant Bolton, Head of Oceania at the British Museum, describes how a conference of Pacific Region museum staff discussed at length the danger that unrecognized spiritual power inherent in objects posed to curatorial staff. A few years earlier, when she was working at the remarkable Vanuatu Cultural Centre in Fiji, staff arranged to protect her by getting a renowned sorcerer, Aviu Koli, to 'kill' the power of objects she would be working with. 'The objects were alive with spiritual power that needed to be controlled. The centre's staff told stories of the objects restless in their glass cases at night, stories told to me with a rueful uncertainty about whether they would or could be believed' (Bolton 2008: 226). Claude Ardouin, now a curator at the British Museum, reports:

> I had that kind of experience when I was the director of the National Museum [of Mali] in Bamako. Both from staff and visitors. It was all about the attitude towards power objects, e.g. a couple of Bamana *boliw* and masks from very powerful male secret societies that we had in the collection and on display. We had to manage a situation when some of the junior staff were extremely reluctant to touch them at all or to be in the same room. But others had no problem with that so it was overcome smoothly.

Such reactions are indeed often as personal as they are cultural, in the sense of shared by the community at large. In the West, objects are occasionally given to museums in order to break their power, but almost invariably, these are objects understood to carry a curse, or to be more vaguely 'unlucky'. At the far end of the enjoyably old-fashioned minerals gallery in London's Natural History Museum is The Vault, a high-security display of some of the museum's more precious jewels. Round the back of the display is found 'the cursed amethyst'. This belonged to the extraordinary polymath Edward Heron-Allen, who besides being a palaeontologist at the museum was also a violinmaker, novelist, local historian of West Sussex, palm-reader, Persian linguist and friend of Oscar Wilde. According to his letter which accompanies the jewel:

> This stone is trebly accursed and stained with blood, and the dishonour of everyone who has ever owned it. It was looted from the treasure of the Temple of the God Indra at Cawnpore during the Indian Mutiny in 1855 and brought to this country by Colonel W. Ferris of the Bengal Cavalry. From the day he possessed it he was unfortunate, and lost both health and money. His son who had it after his death, suffered the most persistent ill-fortune till I accepted the stone from

him in 1890. He had given it once to a friend, but the friend shortly afterwards committed suicide and left it back to him by will. From the moment I had it, misfortunes attacked me until I had it bound round with a double-headed snake that had been a finger ring of Heydon the Astrologer, looped up with zodiacal plaques and neutralized between Heydon's Magic Tau and two scaraboei of Queen Hatasu's period, bought from Der-el-Bahari (Thebes). It remained thus quietly until 1902, though not only I, but my wife, Professor Ross, W. H. Rider and Mrs Hadden frequently saw in my library the Hindu Yoga, who haunts the stone trying to get it back. He sits on his heels in a corner of the room, digging in the floor with his hands, as if searching for it.

Heron-Allen gave it away again and a further series of disasters predictably occurred. Eventually, in 1904, he packed it in seven boxes and put it in a bank vault 'with directions that it is not to see the light again until I have been dead thirty three years. Whoever shall then open it, shall first read this warning, and then do as he pleases with the jewel. My advice to him or her is to cast it into the sea. I am forbidden by the Rosicrucian Oath to do this, or I would have done it long ago.' In fact, his daughter gave it to the museum in 1944, just one year after his death. The whole letter is given in Richard Fortey's admirable *Dry Store Room No. 1: the Secret Life of the Natural History Museum*. Fortey points out that a story of a curse is a good way of protecting jewels from burglars; yet that hardly seems worthwhile for a semi-precious stone like an amethyst. Though Heron-Allen's daughter and grandson apparently wouldn't touch it, there is still something a bit odd about the story, not least that in 1921 Heron-Allen published a short story about a 'Purple Sapphire'—seemingly identical to the amethyst—stolen from an Indian temple (now a temple of Visnu in Naghpur) that, brought to England, causes mayhem. Eventually it is given to a museum, which is immediately struck by lightning, and where 'the assistants and even the charwomen hated it'. Would he have published such a light-hearted story if he had really been afraid of his jewel?[2]

Cursed jewels, of course, pop up constantly in English light fiction, from Wilkie Collins's *The Moonstone* to Agatha Christie's *The Mystery of the Blue Train* and Philip Pullman's *The Ruby in the Smoke*, not to mention Tolkien's *Lord of the Rings*. Stories in which the object is deliberately deposited in a museum are less common, but *The Adventure of the Frightened Baronet*, a 1945 pastiche on a Sherlock Holmes tale by the American writer August Derleth, is one.

Probably the most famous real 'cursed jewel' is the Hope Diamond, one of the largest and most valuable jewels of all. According to one legend, a priest stole it from the forehead of a *murti* of Rama—a story adopted by Wilkie Collins for *The Moonstone*. Thereafter, it passed through a succession of owners, almost all of whom suffered terrible disasters, earning it a fearsome reputation as an enormously powerful

and accursed object. It was given to the Smithsonian Institution in 1958 and can be seen in a bullet-proof case in Washington's National Museum of Natural History. The 'jewel stolen from an Indian temple' is clearly a persistent Victorian theme. Even more common is the Curse of the Mummy. The British Museum's 'unlucky mummy' was famous in the late nineteenth and early twentieth centuries, and is said to have been bought by one of four young English travellers in Egypt during the 1860s or 1870s. Two died or were seriously injured in shooting incidents, and the other two died in poverty within a short time. The mummy-board was passed to the sister of one of the travellers, but as soon as it had entered her house, the occupants suffered a series of misfortunes. The celebrated clairvoyant Madame Helena Blavatsky is alleged to have detected an evil influence, ultimately traced to the mummy-board. She urged the owner to dispose of it and, in consequence, it was presented to the British Museum.[3]

It was even accused of sinking the Titanic. In reality, this is not a mummy at all, but the inner coffin lid of an unknown woman of the twenty-first or twenty-second dynasty. Jasmine Day, in *The Mummy's Curse*, suggests that many of these legends were created by bored attendants in big museums who had little contact with the actual curators and little opportunity to learn about the things in their galleries, but did want to entertain the public—in alliance, of course, with journalists in search of a good story. But the popularity of these tales perhaps met a more serious public need. Roger Luckhurst suggests that behind these terrors lies a paranoia directly reflecting the politics of the British Empire towards the end of Victoria's reign, and especially the struggles of Egyptians to throw off British and French domination; 'Mummies . . . still provide us with much of the apparatus that demonises Arabic superstition, fanaticism, vengeance and cruelty' (Luckhurst 2010: 19).

Objects are still given to museums by nervous owners. Often they are apparently quite mundane objects, but their owners feel they are bringing bad luck. Thus, an Aberdeen lady gave her museum an 'unlucky' tourist kachina doll, and a Bristol man gave his a modern Mexican vase, bought in a government craft shop: 'he felt that he had a run of bad luck thereafter that he blamed on the vase. Giving it to the museum neutralised it and de-stressed him.' The same museum has in its archaeology collection an Anglo-Saxon strap-end that was discovered by metal detectors in the 1980s.

> The story I have been told about this item was that the detectors initially withheld information about the correct findspot—the box with the strap end was on a bedside cabinet and during the middle of the night one of the finders claimed to have seen it rise off the surface and hover above the cabinet. He was so worried about what he had witnessed that he bought the item to the museum to give it to us—stored in a box with a modern crucifix for 'protection'. (Gail Boyle, *pers. com.*)

Bristol Museum once tried positively to exploit owners' fears. 'In the 1960s, when the Tutankhamun exhibition was on, there was a lot in the press about the curse of the mummy. Bristol Museum capitalised on that by running a piece in the local paper offering to give a home to any Egyptian objects that people felt were "cursed". We acquired one small scarab whose owner felt it had brought bad luck' (Sue Giles, *pers. com.*). Museum staff still get nervous, too. 'One member of staff gets "bad vibes" from an Egyptian stone fragment, a piece hacked out of the wall of the tomb of Sety I. She can't explain why, and no other pieces in the Egypt collection give her the same feeling.'

MUSEUM, TREASURY OR SHRINE?

A very different type of powerful object that occasionally ends up in a museum is the Holy Relic. Here we return to the collection that is partly a museum and partly a shrine—the collection of sacred things that is also open to the public, whether that public is devout or not.

Every religious site has some sort of keeping-place for its treasures, especially for regalia when not in use, and for votive gifts. Thus, for instance, churches in Ethiopia usually have a *beta gabaz* to house their manuscripts, textiles, processional crosses and plate, of which the cream is brought out to show to visitors. Buddhist temples and Shinto shrines in Japan have a centuries-old tradition of keeping their valuable holdings in 'treasure-houses' (*hōzō*). The Shōsō-in Treasure Repository in Tōdaiji was established in the mid-eighth century to house its temple treasures and Buddhist regalia, including the personal items of Emperor Shōmu (reigned 724–749) (Suzuki 2007: 130). Although these were primarily storage-houses, exhibitions were organized from time to time. These took two forms. *Kaichō* ('opening of the curtains') were aimed at raising funds, and in return for their donations visitors benefited from the spiritual solace and merit offered by temple icons. *Mushiboshi* ('airings') were intended primarily to allow the paintings, calligraphy, robes, manuscripts and so on to be aired in summer and inspected for mould or pests. In the seventeenth and eighteenth centuries, they became public exhibitions—'eagerly anticipated events at which objects of iconic status, beauty, and prestigious pedigree were momentarily available for viewing . . . a fixture in guidebooks and calendars that enumerated Kyoto's observances, entertainments, and sacred and historical wonders' (Kornicki 1994, quoted in Suzuki 2007).

So, Japanese temples and shrines were ready to be massively influenced, from the later nineteenth century, by the secular museum and a new understanding of the aesthetic. Today, many treasure-houses function effectively as museums, with entry charges, showcases and labels. Yet, their religious icons have not been entirely

reinterpreted as works of art. The seventh-century wooden statue of the deity Avalokitesvara, *Kudara Kannon*, was ejected from his Buddhist temple home during the Meiji regime's anti-Buddhist campaign of the 1870s, but by 1897, he was exhibited at the new Nara National Museum and registered as a National Treasure. In 1930, he returned to Hōryūji temple as a 'guest deity'; in 1941, he was moved to the new Hōryūji Treasure Museum; in 1997, he toured Japan; in 1998, visited the Louvre; and on his return home became the centrepiece of a revamped Treasure Museum. Today, his ambivalent role as both internationally famous work of art and as religious icon persists. On the one hand, he is exhibited in a showcase designed to protect from ultra-violet light and even earthquakes, with museum-style lighting and a minimal museum-style label. On the other hand, he is surrounded by temple-style red wooden barriers, and has before him an offering table bearing ritual objects—flower-vase, large golden reliquary, and candle and incense holders. At the table's foot is a donations box 'reminding visitors that offerings of prayers and coins could cause their wishes to be granted by the smiling Bodhisattva' (Suzuki 2007: 139). Moreover, directly below him in the basement, donors have deposited hand-copied Buddhist scriptures, 'a practice of showing one's devotion to the deity, and establishing a "special connection" with him.'

In Indonesia, the temple/shrine involves a complicated pattern of use of heirlooms as power symbols. When Indonesia became a republic in 1945, some of the country's princes began to open museums within their palace compounds, partly to bring in now much-needed tourist income, and partly publicly to affirm their place as the centre of Indonesian culture. Many of the objects in these museums are *pusoko*, sacred heirlooms. All families possess *pusoko*, which are typically stored at the top of the house under the rafters, but the importance of dynastic *pusoko* cannot be exaggerated. Without them the ruler has no authority and his rule is without any divine sanction; in one Sulawesi kingdom, the state *kris* was seen as being the ruler, while the actual ruler claimed to be acting as its viceroy. Traditionally, these sacred heirlooms are kept in a special building in the heart of the palace complex, available only to the ruler and his immediate family, and then only when wearing formal costume. Once a year, however, the royal *pusoko* are paraded through the town, honoured with jasmine garlands and ceremonial umbrellas, in a long torch-lit procession led by albino buffalo, while night-long prayers are said in the palace mosque. The ceremony commemorates the court's ancestors, and disseminates the sacred power of the court's *pusoko* by showing them in public. For local people, showing some of them in a museum must have the same effect; small bunches of flowers are sometimes to be seen offered before them.[4]

Within an individual faith tradition, too, there may be struggles between different factions and tensions between different practices. In the Catholic Church, relics were

for a long time out of fashion, and it was this that led a Californian layman, Thomas Serafin, to lead a campaign to rescue unloved relics, especially from eBay. The campaign is now run through a charity called The Apostolate for Holy Relics, which has the 'long term goal to establish a permanent site which will serve both as a museum for the display of the collection, and a religious shrine and place of pilgrimage'. The collection at present comprises some 1,200 relics. In 2002, a selection was exhibited in a museum at (of all places) Forest Lawn Memorial, the cemetery-cum-theme-park which inspired Evelyn Waugh's *The Loved One* and Jessica Mitford's *The American Way of Death.*[5]

One of the most challenging situations where objects regarded as relics are kept in an ostensibly secular museum is in Topkapi Palace Museum in Istanbul, where the Relics of the Prophet are displayed. The tensions surrounding different understandings of these powerful objects are, of course, made the more acute by the political and ideological tensions within Turkish society between secularism and some forms of Islam. The Ottoman Sultan Selim I seized the Relics of the Prophet when he captured Cairo in 1517, and had them installed in a special building in his palace complex in Istanbul. Other relics accumulated, and they remained the object of pilgrimage and devotion until Atatürk's revolution. Thereafter, they remained closed to the public until 1962, even though most of the palace had been open to the public as a museum since 1924. The recent redisplay of the collection has made a major concession to their status as relics. While the greater part of the display is on secular lines—the showcases are deliberately designed to emphasize aesthetic values and positioned to prevent circumambulation—it 'recognizes the aniconic spirit of Islam by avoiding the creation of a space of veneration. Rather, it emphasizes the use of light, sound, and space to move from the secular towards the sacred' (Shaw 2010: 129). The 'sacred' here is a continuous twenty-four-hours-a-day, seven-days-a-week live recitation of the Qur'an (Figure 9). During opening hours, this takes place in a special final room, with screens giving translations of the Arabic in Turkish and English; when visitors are absent, it takes place, unamplified, beside the relics. Though there is plenty of room for debate and disagreement over how the balance is drawn, one observer concludes, 'The procession from history to place, from place to person, from person to relic, and from substance to sound brings the nonbeliever to an understanding of an essential element of Islam, while reining in the tendency of believers to transform a museum of relics into a shrine.'

Here, the shrine/museum is offering two quite separate services: the shrine to devotees, the museum to tourists, and these two distinct audiences understand the relics in quite distinct ways. In the next chapter, we shall examine the oft-heard claim that modern museums are 'secular temples', and ask what that might mean for their exhibits.

7 OBJECTS ELEVATING

How objects in museums can be purely secular, yet as works of art or works of nature have spiritual power and the ability to elevate the soul

Religious objects in museums are seldom alone. Helped by their curators, they assemble together in order to tell a story, create an impression and to persuade. One of their aims is to elevate through beauty the souls of their visitors: they reinvent themselves as works of art. Moreover, they gather together in buildings that reinforce the idea that they are secular holy relics in modern temples of art. Natural history museums have two traditions: presenting specimens as evidence of 'the wonderful works of the Lord', and presenting specimens as evidence of evolution. All use the building, together with the displays and objects, to create a total environment in which the visitor plays an active, almost ritual, role.

In a secular museum, objects are normally seen as secular. Yet, one of the strangest features of modern Western culture has been the way in which art has taken on many of the characteristics of religion. While for some, spirituality lies in the very making of art, with the artwork merely the by-product, for others it is the relationship between the artworker and the work of art that is at the core; for others, again, the relationship between the viewer and the beautiful. The great work of art has *ipso facto* spiritual power, and contemplating it must necessarily elevate the soul of the viewer. This attribution of spiritual power to works of art has a long and still-flourishing tradition in the West, and has had a massive impact on art galleries and museums. For

many people, indeed, the primary purpose of an art museum is precisely to assemble together elevating objects. The museum functions very much like a temple and its exhibits have become powerful relics.

William Hazlitt remarked in 1824 that, 'A visit to a genuine Collection is like going a pilgrimage—it is an act of devotion performed at the shrine of Art!' (quoted in Siegal 2008), and the great museum commentator Kenneth Hudson quotes a 1797 German view: 'A picture gallery appears to be thought of as a fair, whereas what it should be is a temple, a temple where, in silent and unspeaking humility and in inspiring solitude, one may admire artists as among the highest among mortals' (Hudson 1987: 48). Museums continue to struggle with that tension between temple and fair.

THE MUSEUM AS TEMPLE

The notion that museums are modern secular temples, and their objects the modern world's relics[1] is very common; numerous commentators have seen museums as 'temples'. The American art historian Carol Duncan, in particular, has pointed out that many of the great art museums of the world are not merely modelled on classical temples—all columns and pediments—but are deliberately designed as stage sets for a ritual in which the visitor is a principal performer, 'like other cultures, we, too, build sites that publicly represent beliefs about the order of the world, its past and present, and the individual's place within it' (Duncan 1995: 8). Museums are excellent examples of such microcosms, and art museums, Duncan argues, are particularly careful, elaborate and costly examples. It isn't just that the visitor approaches up great flights of steps, guarded by lions, and enters through monumental doors to an imposing entrance hall. Rather, the whole building is designed to create in the visitor a mood apart from everyday concerns, reflective and receptive to the art arrayed inside. The visitor is invited to enact the ritual, aided by sequenced spaces and arrangements of objects, lighting and architectural details that 'provide both the stage and the script'. The visitor follows a set route, behaves in a particular way, largely keeps silence and pauses to venerate a succession of shrines. Having made his or her pilgrimage, the visitor receives edification in return. The ritual

> is seen as transformative: it confers or renews identity or purifies or restores order in the self or to the world through sacrifice, ordeal, or enlightenment. The beneficial outcome that museum rituals are supposed to produce can sound very like claims made for traditional, religious rituals. According to their advocates, museum visitors come away with a sense of enlightenment, or a feeling of having been spiritually nourished or restored. (Duncan 1995: 13)

A classic icon of the progression from cult object to art object is given by Raphael's *Sistine Madonna* (Figure 10). Pope Julius II commissioned this work for the high

altar of the abbey church of San Sisto in Piacenza in 1512, to mark that town's accession to the Papal States. It remained there until 1754, when the Saxon elector Augustus II bought it for his collection in Dresden. There, it took on a new role as a work of art, or rather a dual role, as an object of beauty, but also as a representative of the famous artist Raphael. The director of the Gemäldegalerie is said to have welcomed it formally into the gallery as 'His Excellency, Raphael of Urbino'. It took another fifty years, however, for the Sistine Madonna to become noted as *the* supreme work in the gallery, a recognition attributed by Henning (2011: 177) to the Romantics.

The Romantics' elision of Truth and Beauty almost created a religion of beauty, in which the worship of the beautiful was the duty and delight of all, and every object in the museum was by definition beautiful, and therefore holy. For John Ruskin, this link between beauty and goodness worked at both the individual's level, and at that of society. The moral well-being of society was intimately linked to the capacity to create beauty. Moreover, the beauty and truthfulness of a work of art reflected the beauty of nature. The museum Ruskin set up in Sheffield, aimed at the city's steelworkers, displayed Verrocchio's *The Madonna Adoring the Christ Child*, illuminated medieval manuscripts, nature studies, watercolours, casts and photographs of architecture (especially of Ruskin's beloved Venice), medals and reproductions of Greek coins, Japanese ceramics, and marble and mineral specimens.[2]

East Asia has an equally strong tradition of the elevating power of works of art, and the spiritual benefit of their contemplation. This has been taken up powerfully in Japan by some of the new religious movements, which have used their considerable resources to buy art on the world market to stock their new museums (Stalker 2003). One of the most outstanding is the Miho Museum near Kyoto, which reflects the philosophy of the Shumei spiritual organization:

> Art and beauty have the power to nourish and refine the soul. Not only do they bring pleasure but they profoundly move the heart and mind. Beauty fosters a deeper appreciation of life and all creation. Throughout history, art has touched the part of the human spirit that exists above the struggle for survival and beyond the sphere of reason. It can put humankind in touch with the best qualities of human nature. It is for this reason that Shumei encourages the integration of art and beauty into daily life. When touched by beauty we place a higher value on life and on all creation.[3]

The museum's outstanding collections from around the world are housed in an equally outstanding museum building designed by I. M. Pei, which cost $215m (Robson 2010: 124). A similar approach was taken by Pope Pius XII when he established the Collection of Modern Religious Art in the Vatican. Again, no attempt was

made to claim that all the works exhibited were specifically Catholic; rather, the aim was to celebrate human creativity and spirituality, and perhaps to link the Church with that more diffuse religious instinct (Apostolos-Cappadona 2006a: 251).

THE LANGUAGE OF MISSION

Part of the reason museums are so often referred to as 'temples' comes from confusion of the two ways in which modern museums use objects 'spiritually' to improve their visitors. The first of these is well illustrated by the following story, related by Seth Koven (1994: 38). In the 1880s, Clara Grant was a guide at an art exhibition aimed at the working class in the East End of London. She explained to one group of visitors how the painting *The Legend of Provence*, 'tells of Sister Angela, the convent child, enticed away by a young foreign knight'. In later years, she returns to the convent, disillusioned and hopeless, to beg readmission, and, waiting at the gate, she sees a vision of herself as she might have been, and a greater vision of the Blessed Virgin, who assures her that none within know of her absence, for she kept her place. 'One evening', Grant recounted, 'I noticed a man, apparently a workman, with a remarkably fine face. He lingered until I was alone, and then said, "Do you think that a true and safe doctrine to teach, that we can start again after wrong doing?" I tried, unavailingly I think, to make him see that, though scars may remain, justice demands and the Christian faith confirms, the right to a fresh start. Later in the evening I found him in another room wrapped in thought before the *Prodigal Son*.' A year later she met him again, and he confessed to her that he was still tormented by guilt because he had stolen a book from a wealthy home several years ago. How far both religion and museums were here being used as twin rods in a programme of social control is for discussion.

In that story, it is the *image* that is the agent of spiritual and moral improvement, or rather the memory of the Bible story that the image evinces; the prodigal exhibition-goer is moved to repentance and hope by the painting mirroring Christ's parable that hangs before him. For many curators and cultural commentators, though, it is the *beauty* of a work of art that can make the viewer into a better person. This has been an immensely powerful force in Western culture (as it has in other societies, too) and has indeed been a major motive for the establishment of art galleries. It is the belief that beautiful things make people better that prompts the wealthy and powerful to divert resources to making them available. Needless to say, the motives here are mixed—'making people better' often means 'making people behave better'. Henry Cole, effectively the inventor of the modern museum, said in 1854: 'Museums can instruct both young and old . . . they are temples where all can worship in harmony; they teach good habits of order, and cleanliness, and politeness . . . Museums are antidotes to brutality and vice' (quoted in Tait 1989).

As both urbanization and democracy rapidly grew in Europe and North America in the nineteenth century, the museum was adopted as an instrument of social development, and even of control. This 'new apparatus for the production of knowledge' (Hooper-Greenhill 1992) took on the job of informal public education, aimed sometimes at the proletariat, but more often at the middle and upper working classes. In this new seriousness of purpose, museums used a very similar language to that of the churches. Beauty, whether in works of art or of nature, was elevated to a divine principle, whose contemplation improved the soul. Museums used—indeed, they still use—the language of faith, even of mission, to describe their efforts not only to improve the lot of the poor, but to improve society itself.

RELIGIOUS OBJECTS THAT DON'T CHANGE

There is, we must note, a class of religious object that exceptionally does not change its meaning when it enters the museum. This is 'religious art', where the curator and the artist cooperate to allow the work of art to express a spiritual purpose. There have long been such works—the *Legend of Provence* story makes that very clear—but they become more readily recognizable in the context of modern and contemporary work, where the term 'religious' is often eschewed in favour of the less culturally loaded 'spiritual'.[4] There is indeed a distinct movement in contemporary art to valorize the spiritual. It has been called 'spiritually diffuse, institutionally critical, and focused on the common spirit that resides within humanity, contemporary religious art reflects the globalisation of contemporary culture encouraging artists from the widest spectrum of ethnicity, race, gender, geography and religions' (Apostolos-Cappadona 2006b: 393). Sometimes such works do place themselves, more or less comfortably, in a distinct faith tradition—Saint Louis University's Museum of Contemporary Religious Art still reflects its Jesuit origin, and New York's Museum of Biblical Art celebrates the Jewish and Christian basis its name implies. But more often, they are simply 'spiritual', in the sense of 'a system of belief that is private, subjective, largely or wholly incommunicable, often wordless, and sometimes even unrecognised' (Elkins 2004: 1). It is, indeed, that very incommunicability and wordlessness that gives point to the work of art. The object, then, is largely on its own when it first attempts to speak to visitors, which makes it the more dependent for any success on what its curator supplies: the building in which it is displayed, the company it is obliged to keep, the interpretation—labels, public programmes, marketing—its curator cares to supply (Smart 2010: 86).

One might even see some modern and contemporary artworks as invoking a third kind of elevating object. Here it is not the *image* that evokes an inspiring or motivating memory—many modern works are quite abstract—nor is it the *beauty* of the work—many modern works are intended to be seen as ugly. Instead, the artist

is attempting to speak to the viewer through the artwork, evoking a mood of spirituality. Through the story of modern art in the twentieth century there ran a thread of spirituality, but it was one that remained highly individual, both in the sense that it was usually quite separate from the orthodox traditions, and in the sense of being very personal to the artist. However, it was effective in a market dominated by museums and dealers only when supported by curators. A recent study of a leading American modern art curator tells how he, '[r]epeatedly characterized the museum as a secular temple of art', whose 'basic purpose should be to stimulate the aesthetic responses of its public to a richer, spiritual life, to a fuller enjoyment of the spiritual over the material, of relationships rather than things' (Brennan 2010). Such a personal message, abetted by the curator, can, of course, cause offence as well as inspire and elevate. Such offence is sometimes deliberate, sometimes it occurs just because the artist's concept of the spiritual clashes with that of the viewer. Works regarded as obscene or blasphemous—some of the work of Gilbert and George, for example, or Robert Mapplethorpe—should be seen as the flipside of this strange modern idea that art is an opportunity for an *artist* to talk about spirituality (Mitchell 2005).

THE SCIENCE MUSEUM AS TEMPLE

While it is works of art that are most commonly credited with power to elevate—to spiritually improve—the visitor, and art museums that are seen as their temples, scientific specimens can also be elevating. Chris Arthur (2000: 13) quotes Diane Ackerman's response to a display of microscopic invertebrates in New York's American Museum of Natural History:

> Relishing their intricacy and variety, I felt so startled by joy that my eyes teared. It was a religious experience of power and clarity, limning the wonder and sacredness of life, life at any level, even the most remote. (Ackerman 1995: 332)

From their earliest days, museums, and especially natural history collections, have been seen as demonstrating the wonders of Creation, the wonderful works of God. By the mid-nineteenth century, this idea had become the central tenet of 'natural theology'. This was the idea that—far from conflicting with religion, an idea that had yet to become popular—science was contributing to the worship and to the understanding of God. Richard Gresswell, one of the promoters of the University Museum in Oxford, called in 1853 for a museum where each specimen would occupy 'precisely the same relative place that it did in God's own Museum, the Physical Universe in which it lived and moved and had its being' (quoted in Yanni 2005: 64). The museum should be set out as a microcosm of creation, in which every species took its place in a hierarchy leading up from the simplest organisms to humankind at the top.

It was, of course, in Oxford's University Museum that the famous debate took place between Bishop Wilberforce and Thomas Huxley, after which that museum, at least, became associated in the public mind with evolution. Indeed, after Darwin, the sight of the exhibits in a natural history museum probably prompted the idea of evolution in most visitors' minds. Whatever the intention of the curators, a sizeable proportion of visitors now saw specimens as evidence of evolution rather than of God's handiwork, though, as Yanni so nicely puts it 'religious visitors were not going to recant their creed after one afternoon in the dinosaur gallery' (1999: 11). For some of those curators, indeed, 'the study of natural science was a kind of religious contemplation, and the scope of the museum's displays was thus enormously important in communicating that religious purpose' (Yanni 1999: 65). The aim was to create an informative microcosm of the natural world, as a testimony now not to Creation, but to Nature, conceived almost as itself a deity. The study of Nature's works becomes spiritually improving in a very similar way to the study of great works of art.

BASTIONS OF SECULARISM

But by no means all museums have abandoned the purely 'scientific' stance. In France, in particular, the twin traditions of separation of Church and State, and commitment to one common culture, have reinforced in state museums the refusal to accept anyone's perspective but the curator's. Here, for example, is the Head of International Relations at the Musée Quai Branly, the museum of 'primitive art' founded by President Jacques Chirac, speaking in 2006:

> We at the Quai Branly, as elsewhere in France, have decided to respect the principle of *laïcité*. Therefore, we do not take into consideration any claim based on religion or ethnicity . . . If you really believe that these things have a profound meaning, well, the museum isn't made for that. The museum is not a religious space. (quoted in Price 2007: 122)

So the museum has no hesitation in displaying Australian Aboriginal *churinga*, sacred things—access to which is strictly prohibited to the uninitiated. Raymond Corbey says of these:

> *Churinga* are long, oval, rather flat objects made of wood or stone upon which abstract motifs of circles, lines, and spirals are scratched, up to several feet long. They are considered extremely sacred and secret . . . Much has been written about their meaning to the various groups of Aborigines who used and sometimes still use them. One might say that they are the embodiment or metamorphosis of totemistic primeval beings or ancestors, the so-called Dreamings. They are associated not only with specific myths, songs, and anecdotes, but are also closely related to specific places and routes to which the patterns refer and to

the activities of the Dreamings there. *Churinga* figured in a number of rituals, including initiations . . . They are inseparable from the identity of Aboriginal individuals and clans, from places in which they reside, and from the areas through which they move. Aboriginal rights to land have been recognized under Australian law to an increasingly greater degree in recent years. Various Australian anthropologists have recently argued that, in view of this inseparability, the recognition of landrights also implies the recognition of Aboriginal rights to the 'cultural property' now preserved in many museums worldwide, including *churinga*. (Corbey 2000b: 19)

Indeed, one view might be that Quai Branly's display adds a further, spiritual, assault upon a people who have already suffered so much.

There is an underlying assumption in this book that it is a good thing that museums should make explicit the religious meaning of the objects in their care, both out of concern for the feelings of people to whom such objects are significant, and in order to help visitors understand them more fully. This assumption, though, comes very much from a European background. Well under half of English adults regularly practice any sort of formal religion, and by most measurements, England has been a predominantly secular country for some three generations or more, so here it seems natural to challenge museums to take religion more seriously. When one turns to a country such as India, however, the situation looks very different. There, religion—often in its most triumphalist and intolerant forms—is on the rise, and it is secularism that feels beleaguered; the secular ethos on which the nation was built seems under threat from religious fundamentalism. Indeed, overtly and sometimes aggressively Hindu political parties have held power at both state and federal level. The demolition of the Babri mosque at Ayodhia by Hindu fundamentalist fanatics, and the widespread riots and killings that followed, showed only too clearly the lethal power that material objects can hold. As a result, some secularists have come to see museums as bastions of reason against the forces of communalism and unreason, and are understandably reluctant to admit the possibility of religious practice within the museum walls, or even to give space to explaining the background and intended function of religious objects. Objects are presented as evidence, as art-historical, archaeological or scientific objects which help visitors to understand the world from a secular, scientific and rational perspective. Efforts to introduce a religious understanding are seen by many as sinister attempts to overthrow reason in the name of irrational religious fundamentalism. Of course, many of these museums were set up with other than purely educational aims in mind. The promotion of national unity and valorization of the national state is one common motive. In India, for example, the National Museum was founded immediately after independence, and the

foundation stone of its present building was laid by Nehru. But nationalism has long had a close association with secularism, and is not at all regarded as a similar threat to secular values, as is religion.

A more subtle critique of the efforts by secular museums to interpret their religious objects and to involve modern adherents of their faith is made by Tapati Guha-Thakurta (2007). She was asked by an Indian couple from Los Angeles whether it did not upset her to see so many of 'our gods' in Western museums, and she argues that such efforts to restore religious meaning to such gods—she instances the Newark Tibetan altar and the initiatives of various museums to accommodate Durga puja—can be a patronizing modern form of Orientalism. Not only do these efforts privilege the 'religious' as 'the all-important marker of tradition, authenticity and of the "original" cultural lives of all such expropriated Indian objects', but they also take on an unintended role in international (cultural) politics and the politics of India itself—for example the efforts to create a dominant Hindu nationalism. As with the effects of repatriating objects to source communities (chapter five), the effects of reinterpreting 'art' objects as 'religious' objects once again need the greatest care.

Another argument in support of the secular viewpoint sometimes heard is that around the defence of public space. Public space—space in which anyone may feel welcome and belonging—is increasingly under threat, particularly in the UK. The threat comes from a variety of directions; from commerce in the ever-growing takeover of public shopping streets by private malls that control access through doors, rules of behaviour, rules of dress, cameras and security guards; from government, in the shape of security cameras, stop-and-search, the banning of drinking or smoking, and so on. There is also a threat, some people argue, from special-interest groups that seek to do their own thing in a public space, to the discouragement of others—and allowing faith groups to worship in a museum is effectively a private takeover, however brief. Museums, too, are public spaces, and it is their responsibility to establish rules to keep them so. This means a ban on intrusive worship, and resistance to claims to control interpretation of objects. Effectively, it means that objects in museums must be seen as purely secular.[5]

Religious objects can be stripped by museums of all their 'religious' character, so that in the museum's intention they become mere works of art or simple scientific specimens. But in the next chapter, we shall look at a completely different way for objects to behave: retaining a religious character, but in order to fight against their former owners. Objects, too, can be converted, and they often take on the enthusiasm of the convert.

8 OBJECTS MILITANT

How religious objects are converted and fight for their new masters

Objects can be given a new meaning and be recruited to fight for their new owners. Thus museums of atheism in the Soviet Union used icons, relics and other religious objects as evidence of the corruption and mendacity of the churches; missionary exhibitions used 'heathen' objects to demonstrate the impotence of the old faith in the face of the new; Creationist museums display fossils as evidence against evolution.

MUSEUMS OF ATHEISM

Perhaps the most dramatic examples of objects in museums being reused to present the arguments of their new masters were in the anti-religion museums of the Soviet Union.[1] The 1920s and early '30s saw a complete reorganization of museums in the Soviet Union. They had a new purpose: to help in the broad education of the masses—and in particular the promotion of a Marxist understanding of history—and to support the Five Year Plan. To effect this new mission, museums adopted a completely new approach, involving quite new display techniques and an elaborate programme of outreach. This new museology made possible anti-religious museums, a Soviet invention that for the first time assembled religious artefacts and used them to attack both the institutions of religion and religion itself. Initially this was by exposing the crimes and tricks of the clergy; later it was also by promoting the rival claims of science, and by showing how religion developed in all parts of the world along with the Marxist phases of social development, and had become a handmaiden

of bourgeois capitalism. In all three campaigns *objects* were central—though the new didactic or 'talking museum' approach was universally deployed by anti-religion museums, they all used objects to tell their story.

Atheist propaganda and the struggle against religion began immediately after the Bolsheviks seized power in 1917. While social change would, under Marxist theory, bring religion to disappear, Leninists argued that the party should actively help to eradicate religion as a vital step in creating 'New Soviet Man'. The energy with which the party struggled against religion, though, varied considerably from time to time and from place to place, as did its hostility to particular faith groups. The 1920s saw the closure of innumerable churches and synagogues (and to a lesser extent, mosques) and the active persecution of clergy and harassment of believers. From 1930, though, Stalin introduced a less aggressive approach, and wartime support for the government earned for the Russian Orthodox Church, at least, a level of toleration which lasted until Stalin's death. Under Khrushchev, anti-religious efforts resumed, if spasmodically, and they lasted until the end of the Soviet Union.

While all museums played their part, a whole new category of museum came into being to serve the struggle. In the first twenty years of so of the Soviet regime, hundreds of 'Museums of Atheism' were established across the Soviet Union, in public buildings and factories, or in former churches, synagogues and mosques, many of them set up by the League of the Militant Godless, created by the Communist Party to lead the anti-religion drive. Many were no doubt crude and amateurish. However, in 1929, Moscow's Strastnoi (Passion) Monastery became the Central Anti-Religious Museum, the first of any serious ambition (Figure 11). Four years later, the French writer René Martel reported that its displays were based on the idea that all religions were similar superstitions, which they demonstrated by juxtaposing 'idols, fetishes, Christian images and objects of witchcraft' (Martel 1933: 156), a perhaps rather simplistic analysis of the displays, but a recognition that the new museum was taking a much more sophisticated approach to its mission. In 1932, the Leningrad Academy of Sciences invited the ethnologist 'Tan' Bogoraz to set up in the great Kazan Cathedral in Leningrad a Museum of the History of Religion and Atheism. This was a big step forward, not least because of the magnificence and fame of the building, and the collections of the existing State Antireligious Museum in St Isaac's Cathedral were soon transferred to the new museum. It put anti-religious museums on a completely new level.

The emphases of the anti-religion museum displays developed over the years. However, three themes ran through them all: exposing the tricks and crimes of the clergy, opposing science to the superstition of religion, and showing how the growth of religion reflected the underlying economic base. The first and most dramatic way in which objects were deployed in these museums, a way unique to them, involved

the deliberate deployment of sacrilege. Sacrilege is the misuse of holy things, and, when deliberate, can be seen as an act of aggression, often indeed it is almost an act of revolutionary violence. Most consideration of sacrilege (blasphemy) in modern societies has been concerned with artists and others attacking through their work a power structure, whether the religious or the secular establishment, and with the counter-action of believers or of the State (Plate 2006). In the latter case, we speak of censorship. But in the Soviet Union, the situation was more ambiguous: who was the aggressor? Who was committing the sacrilege, who was the censor? The anti-religion museums committed sacrilege, as a means of challenging the 'superstitions' of visitors, as a step to altering their consciousness. Like the breaking of any taboo, to misuse an object previously used for a religious purpose is provocative—intended quite deliberately to cause shock and offence. Here it was the state, or at best the Militant League, which was deliberately taking religious objects and holding them up to ridicule and derision, in order to break their emotional power and to change their meaning.

Meaning could be changed, too, in a way that looks at first quite gentle and sympathetic, but in reality was often equally violent to the beliefs and feelings of believers. Innumerable works of art were seized from closed monasteries and churches and placed in art galleries. For believers, any such seizure of Church property was sacrilege, but the treatment of a sacred icon as a mere 'work of art' was particularly blasphemous. It was replacing a window into heaven with a skilled assemblage of paint and wood.

One of the earliest emphases of the anti-religion campaign was the attack on the saints. In museums, this mainly took the form of explaining away the preservation of relics, and the exposure of miracle-working icons. If one wants convincingly to show that a relic or an icon is a fraud, one needs to show the original. King Henry VIII's commissioners understood that when they organized a demonstration of how the 'miraculous' Boxley Rood of Grace (a wooden image of Christ on the cross) could be made to move its eyes and lips, thanks to a series of levers (Finucane 1977: 208). The anti-religion museums took exactly the same approach, exposing the hidden workings of a 'miraculous' icon, and explaining the process of natural mummification. 'Sacred' things are fakes at worst, powerless at best. Bodies of the saints, for centuries venerated in the monasteries of Kiev and Moscow, were torn from their tombs and publicly exhibited:

> Doctors and agitators were stationed by the almost carbonized and mummified bodies of the saints to give scientific lectures to the spectators on the reason why these bodies had not putrefied. 'If a dead body is placed in a dry airy space', they explained to the gaping crowd, 'the bacteria of decay cannot develop, decomposition is arrested, and the corpse dries up. If a mummy of this kind falls into

> the hands of the priests, it is immediately declared to be the relics of a saint. If
> a dried body of this kind is not forthcoming naturally, then you need only suf-
> ficient skill, a few pounds of cotton wool, and the skull of any dead person you
> like, and in a trice you can manufacture relics'. (Fülöp-Miller 1927: 187)

This was in the Museum of National Hygiene in 1927, but the Moscow anti-
religious museum had similar displays a decade later (Powell 1975). The French
socialist travel writer Francois Drujon describes it in 1935:

> In the main hall, a crowd of workers, peasants and children surround a comrade
> leading a tour. He shows them an old painting representing the Virgin Mary. It
> is the Virgin crying. 'It is a miraculous Virgin', he says, 'because it cries when
> you look at it.' At this moment the guide passes behind the wall and the Virgin
> begins to cry. He then asks the visitors to step behind the painting, where they
> see a small bucket of water, a siphon, and a rubber ball. 'Here is how miracles
> are made', he cries. (translated in Jolles 2005)

To neuter an object and render it harmless, place it in a context that voids it of power.
The Soviet museums had a great advantage over their English Reformation or French
Revolution predecessors: the power of 'comparative religion'. Both the Moscow mu-
seum and the Leningrad museum used comparative displays of religious objects to
show that religion was all one and all a delusion. Juxtaposing icons, crosses and statues
of saints with Babylonian, African or South Sea images and totems (White 1930: 73)
at once neutered them, changing their meaning from sacred objects to harmless
museum objects, 'religious' objects that merely illustrated a passing phase in human
evolution. People who had laughed at exotic objects from 'primitive' societies were
being invited to see objects from their own culture as exactly the same. In this way,
anthropological research was directly able to serve the anti-religious cause, and able
to do so in a way that appealed most to the more sophisticated visitor. We have here
an alliance between a scholarly interest in the history and anthropology of religion
and anti-religion; the great collections built up by Soviet ethnographers served both
aims. They promoted museum research in order to understand how religion had
developed—what exactly it was that made people adopt irrational and reactionary
beliefs and practices.

Most foreign visitors tended to find the anti-religion museums naïve and em-
barrassing, and in Leningrad some saw the contrast between the magnificent ca-
thedrals and the sad displays inserted into them as depressing. But Soviet visitors
flocked to these new museums in astonishing numbers. In 1930, the president of the
League of the Militant Godless was boasting that the Moscow museum had attracted
a quarter of a million people in its first year—as many as had visited the famous
Tretyakov Gallery (quoted in Jolles 2005: 432). The Leningrad museum attracted

257,000 visitors in 1956; by 1983, this had grown to more than 700,000. Much of this was achieved by organized group tours; in 1960, museum workers averaged nearly seventeen guided tours daily. Outreach effort was equally impressive, and activities apparently included lecturing on atheism in schools, factories and cultural organizations, setting up provincial 'atheism houses' and clubs, the training of atheist propagandists, and the creation of touring exhibitions—as well as the usual research and publication. In the 1930s, a museum workshop supplied reproduction exhibits to other museums, and organized touring exhibitions 'which toured the whole country and reached the remotest villages' (Martel 1933: 160).

MISSIONARY COLLECTIONS

> Now this museum is altogether different from every other museum in the world. It is a not a mere collection of curious, or beautiful, or valuable things . . . [Its] chief purpose . . . is to show what men are without the Gospel.

We have seen how Bolshevik anti-religion museums could reflect an alliance between mission and anthropology, under the umbrella of 'science', arguing that theirs was a correct, scientific understanding of religion, and thus naturally aligned with the science of anthropology. Just the same approach was taken in 1922 by the Catholic Church, when Pope Pius XI initiated the Pontifical Missionary Exhibition, which later became the Missionary and Ethnological Museum in the Lateran Palace, and was eventually merged into the Vatican Museums. The exhibition's aim was, the pope said, to 'show the contribution of the missions to science', and like the Soviet museums it combined academic ethnography with mission. The objects, too, were used in a very similar way to those in the museums of atheism—to show the corruption and inferiority of the old society, and the infinite superiority of the new:

> Scenes of anthropophagi, paintings of martyrs, photographs, barely dressed cannibals, hands armed with arrows or poisonous spears, bestial faces, deformed limbs born out of grotesque ornamentation, hideous masks of unimaginable travesties, collections of ridiculous amulets, grimacing idles, monstrous fetishes, witness of atrocious sacrifices, seats tainted in human blood. (Dubois 1926, quoted in Kahn 2011)

The similarity to the displays of feudal and bourgeois society in the contemporary Soviet museums is obvious, but the comparison goes deeper than that. Just as the Soviet anti-religion/anthropological museums were based on a Marxist theory of human development that derived from Victorian ideas of human evolution, so, too, the Pontifical Missionary Exhibition (and to some extent its successor museums) was based on a theory similarly founded on the idea that society and its religion reflects

its material basis. Kahn (2011)[2] has shown how Fr Wilhelm Schmidt, the exhibition's curator and author of a twelve-volume book on *The Origin of the Idea of God* (1912–54), developed a theory of human evolution that he set out in the Ethnology gallery, at the heart of the exhibition. Objects sent in by missionaries from many different parts of the world were organized to present his complicated classification of 'primitive cultures', in which increasing technical and material sophistication led people further and further away from the primitive belief in the one God. It was the role of the Catholic Church to lead them back again, just as for the communists it was the role of the party to lead people back to primitive communism.

By the 1920s, though, museums had been turning sacred objects against their former devotees for over a century. The 1826 catalogue of the London Missionary Society's museum stated:

> the most valuable and impressive objects in this Collection are the numerous, and (in some cases) *horrible*, IDOLS, which have been imported from the South Sea Islands, from India, China, and Africa; and among these, those especially that were given up by their former worshippers, from *a full conviction of the folly and sin of idolatry*—a conviction derived from the ministry of the Gospel by Missionaries . . . Many of the articles in this Collection are calculated to excite, in the pious mind, feelings of deep commiseration for the hundreds of millions of the human race, still the vassals of ignorance and superstition; whilst the success with which God has already crowned our labours, should act as a powerful stimulus to efforts, far more zealous than ever, for the conversion of the heathen. (quoted in Altick 1978: 299)

In their early days, missionary museums seem to have concentrated mainly on enabling their supporters to imagine and to understand the remote lands in which their missionaries were working. Thus they exhibited stuffed animals, insects, pressed plants and minerals, as well as domestic objects, clothes and other examples of local life. As missions became increasingly successful, however, the museums of the missionary societies grew increasingly triumphalist. In the London Missionary Society museum,

> Pride of place in the museum was taken by the heathen images discarded by the Christianized inhabitants of the Polynesian islands visited by LMS missionaries from 1797 onwards. Prominently displayed amongst these were the family gods of the King of Tahiti who, as early as 1816, had indicated his wish that these 'idols be sent to Britane' . . . 'for the inspection of the people of Europe, that they may satisfy their curiosity and know Tahiti's foolish gods'.[2]

Other trophies included a Siva figure, and even a Virgin and Child, donated by Roman Catholic converts to Protestantism from Mysore (Seton 2012). The Museum

of Methodism in London still displays 'Chief Thakambau of Fiji's war club', given to the missionaries after his conversion.

Another important aim of these museums was to show the opportunities for economic development. Among the many objects sent home by David Livingstone were a slave yoke, a set of elephant molars for the British Museum, a sample of coal, cotton and a cotton loom, smoking paraphernalia, a comb and weapons (Cannizzo 1998). The missionary societies valued, as part of their promotional and fundraising endeavours at home, objects that illustrated the triumph of Christianity, the natural qualities of local people, their 'degradation' and 'superstition' (and in earlier years their oppression by slavery), but also their potential and that of their land to become a European-style peasant farming community. (Most Victorian missionaries saw little or no distinction between Christianity and a rural version of the European lifestyle.) Nor let us forget the three-way alliance between object, meaning and power. Christian missionary effort in the nineteenth century was sometimes in conflict with colonial power—for example, in the Congo—but much more often they were in close alliance. In 1958, the Church Missionary Society gave the Manchester Museum a *Gelede* mask from Nigeria with an attached label: 'This was taken from a Heathen temple in a small town that was destroyed by Governor Glover between 1864 and 1870' (Poulter 2007: 56).

EXHIBITING EVOLUTION

Objects presented in museums to show the origins and development of humankind can cause much offence to people who explain those origins in a different way. This is as true in museums in developing countries as in those in developed, though sometimes conflict is avoided in the former simply because museums are seen there as élite institutions, seldom visited by those with traditional views. Sometimes, too, people simply keep 'science' and 'religion' in different compartments of their minds. Thus, a worker at the Ethiopian National Museum in Addis Ababa wryly commented on how the Ethiopian public is proud that their museum houses Lucy, the earliest known skeleton of *homo sapiens*, even while they are loyal to the Bible-based understanding of the Ethiopian Orthodox Church. In many such museums in developing countries, the Evolution/Creationist dichotomy is paralleled by an Elite/Popular dichotomy, and often too a Colonial/Independence one. National pride in a newly independent country, combined with a concern that the museum should serve ordinary people and reflect their priorities and concerns, can conflict with the scientific education mission of the museum. At the Botswana National Museum, a survey of visitors to the evolution gallery revealed that when asked seventy per cent found it offensive to their religions (Segadika 2008: 112). In such museums, there is

a vigorous debate on how, and how far, to reflect traditional understandings in their displays and public programmes.[3]

In European countries, an acceptance of evolution can be assumed of the great majority of museum visitors, and almost all museums do so. There, a 'traditional' view—especially Adam and Eve—can even be used ironically or metaphorically, for example as a peg on which to hang a human-evolution display. One local history museum in Gloucestershire uses figures of Adam and Eve to flank its small prehistory display. Eve bears the title 'Stroud and the Garden of Eden', with a very brief outline of the Palaeolithic and Mesolithic periods locally: 'Early peoples had short life-spans. They depended on natural resources and had no settled home.' Eve asks, 'How does this compare with the Biblical image of paradise?' Adam bears the title 'And then came people':

> Many cultures tell stories about the creation of the earth and its first human occupants.
>
> Christians believe that the first people on earth were Adam and Eve, living in a paradise—the Garden of Eden. In the 1600s, it was calculated that God created the world in 4004 BC. Geology and archaeology show us that the earth is very much older than this.

CREATIONIST MUSEUMS

Creationism is the idea that the Earth and everything in it was created by God just a few thousand years ago, pretty much as it is today. It is particularly strong in the United States, where half of all Americans hold the theory—to the bemusement of most people in the rest of the developed world (Miller et al. 2006). The latest and largest of the half-dozen or so Creationist museums in the world is outside Cincinnati, opened in 2007 on forty-seven acres of Kentucky farmland. The founder was Ken Ham, an Australian biology teacher who had started the organization 'Answers in Genesis' in 1994. The museum has all the characteristics of a very well-funded modern museum—high-quality design, and a mix of dioramas (including the now-famous scene of small children playing with baby dinosaurs), models, live animals, interactives, planetarium, videos, sophisticated animatronics and a large shop and café, much of it aimed clearly at children. It sets itself in deliberate opposition to 'evolution' museums, adopting just the same techniques. The museum offers a vision (as Peter Williams of Miami University put it) of 'an alternative universe to that accepted by mainstream science and mainline religion, but presented in the idiom of contemporary mass culture and museology rather than the fusty world of an older generation's fundamentalism' (Williams 2008: 373).

What the Creation Museum does not offer is much in the way of original objects, but, as we shall see in the next chapter, this is a characteristic of the new generation of 'museums' that present a particular religious perspective. Britain's only Creationist museum was opened in 1995, a few hundred yards from HMS Victory in Portsmouth, by the Creation Science Movement, itself founded in 1932. Very much smaller and a great deal less slick than the Cincinnati museum, it is still imaginatively laid out, with a busy shop. The displays are presented in a series of twelve showcases, each putting forward an argument in favour of the Creationist case. One that catches the eye is dedicated to the Bombardier Beetle that, when threatened, can shoot boiling noxious gases from its rear end. The display argues that it 'could not evolve gradually. Too weak an explosion and the predator would eat the beetle. Too strong and the beetle would blow itself up!' The next display suggests that Chinese ideograms incorporate a memory of Adam and Eve and of Noah and the Flood. The displays use text, models, diagrams and interactive displays to make their point. Very few original objects are included—the principal one is a nest of dinosaur eggs. Dominating the displays, though, is a 20-foot-long model dinosaur, and here again a Creationist museum is stealing the clothes of 'evolution' museums. Just across the Solent is the Isle of Wight's 'Dinosaur Isle' museum, which brilliantly combines scholarly research, a lively museum learning service, and a fun attraction for holidaymakers. Here, the dominant Iguanodon model is accompanied by other model dinosaurs, but more importantly by a fine selection of original dinosaur bones, many recently excavated.

A century and a half ago, a remarkable precursor of the modern Creationist museum was based entirely on original specimens. It was opened just at the time scientists were struggling to reconcile the discoveries of geology with the Bible. James Bateman was the son of a successful ironfounder and banker, who in 1840 set himself up as a country gentleman at Biddulph Grange in Staffordshire. More than that, he was a passionate and very productive botanist and horticulturalist who published major studies on orchids, and who developed beside his house a remarkable garden, today one of the National Trust's best known. Bateman was also, it appears, a devout Evangelical Christian, excited by current scientific discoveries but acutely aware of the challenges they presented, particularly in reconciling what the fossils were saying about the origins of the earth with the biblical account of creation. In 1862, three years after *On the Origin of Species by Means of Natural Selection* appeared, he wrote to Darwin about some orchids he had sent:

> I much wish you would take up the subject of the marvellous changes—I might almost call them metempsychosis—to which Orchids are prone. Though by no means a convert to your theory as to the 'Origin of Species' I wish the matter to be thoroughly ventilated and cannot but think that facts of great significance

may be gathered in the direction I have indicated. If you put me in the witness-box I shall be happy to tell all I know.[4]

It was just at this time that Bateman opened in a yard behind his house his Gallery of Geology. A hundred feet long and divided into seven bays, it was based on the idea that each of the six days of Creation saw the emergence of different strata of rock, and different fossils. In each bay, a series of specimens showing the various strata were let into the wall, and above them examples of fossils from those strata. The six bays began with the granites and proceeded with the slates, the limestones, the old red sandstone, the coal formations, and so on. On the opposite wall were various geological maps and sections, and in the centre a series of tables carrying further specimens. Sadly the seventh bay, devoted to the Sabbath, has been destroyed, and indeed the whole gallery has been badly damaged; the National Trust is preparing to restore it (Baker and Adstead 2008). One irony is that some of the best specimens chosen by Bateman to illustrate Creation ended up in a teaching collection in Keele University, where, no doubt, they have been used for generations to teach evolution.

OBJECTS HATED

When objects become militant, they must expect to be controversial—they cannot stand above the political or ideological fray if they are fighting a corner, whether that corner is religious mission or its atheist opposite. Happily though, few museum objects attract real hatred. When museums are, occasionally, attacked, the motive is generally desire for loot, or occasionally inter-communal or class hatred, as with the looting of the Baghdad museum, or the 2009 murder by a white separatist of a guard at the Washington Holocaust Museum, or incidents in the Balkan wars. It is perhaps another indication of how museums drain objects of their power that religious objects in museums are seldom attacked. We have seen already one exception, when a Christian overturned the St Mungo Museum's Siva Nataraj. It was Christians, too, who reacted volubly when a Witchcraft Museum opened in the village of Bourton-on-the-Water in the English Cotswolds at Easter 1956. Witchcraft was still taken very seriously in the Cotswold hills at that time: a murder believed to have been associated with witchcraft had taken place only some ten years before. The new museum was the private collection of Cecil Williamson, and amongst many other exhibits included a life-size wax figure of an almost naked witch-priestess lying upon an altar.[5] The opening of the Witchcraft Museum prompted demonstrations outside against 'Satanism', and these were followed by the hanging of a dead cat outside the museum door, and finally by an arson attack. The museum hung on in Bourton for five years, but then moved to Boscastle in Cornwall, where it still thrives. Similarly, in 1978 a local businessman opened the American Atheist Museum in a small community in

southwest Indiana, and saw it riddled with bullets and a cross burned on the lawn; in 1987, he closed the museum and moved to San Francisco.[6]

We may perhaps conclude that it is usually the *museum* that attracts opposition, while its objects can be reinterpreted by the visitor in a favourable light. The visitor argues, as it were, that it is not the fault of the object that it is being used to tell such a wicked story.[7] In the next chapter, we shall look at how religious objects are used to promote the faith of their owners—when a faith group is using a museum to present itself both to itself and to a wider public, or when a liberal establishment is seeking to promote communal harmony.

9 OBJECTS PROMOTIONAL

How religious objects promote the faith of their masters

> More commonly, objects are used by faith museums to explain their faith, both to their own faithful and to outsiders. This has been especially a characteristic of European Protestant churches. Now museum techniques are being used—often on a huge scale—by other faiths, as well. The same techniques are used to promote mutual understanding between faiths.

Since they were first invented, museums have been used to reinforce the identity of their promoters and to advance their ideology. Museums and museum objects have been used to promote world-empires, nation-states, commercial companies, local communities—and particular faiths. In recent years, much attention has been given to the National Museum, and to the way in which new nations have used the museum not just as a symbol of independent statehood (a motive sometimes nicknamed 'the National Airline syndrome'), but also to colonize the nation's past, to claim the rights of the modern polity to inherit the culture of all those peoples who have lived in its territory before. The underlying aims are twofold: to enable the nation (and particularly perhaps its leaders) to hold up its head as a cultured people among the nations of the world, and, by celebrating all the diverse cultures of its peoples, to promote national unity.

THE NEW FAITH ATTRACTIONS

Something of the same has long taken place in the field of religion, but there is today a vast expansion of museums and museum-type visitor attractions intended

to promote particular religions, very often from the perspective of one—usually very prosperous—section of that faith. One of the most remarkable of these is Akshardham, the huge temple/theme park complex in Delhi created by the Swaminarayan movement, a wealthy Hindu organization based in Gujerat but active internationally. Akshardham attracts over two million visitors annually. Once through the scarily rigorous security screening, one finds oneself in beautiful and spotlessly maintained gardens amongst a variety of impressive sandstone buildings, in 'ancient Hindu' style and covered with high-quality carvings, of which the largest is the great temple itself. Everything about the place is superlative, not least the two principal visitor-attractions; a walk-through display of the life and teachings of Guru Swaminarayan, and a boat-ride through the ancient culture of Hindu India. Both are state-of-the-art, the former involving sophisticated animatronics and lighting, the latter a boat-ride through a succession of engaging dioramas purporting to show the idyllic life of Vedic India, where all was harmony and happiness, and where, it seems, most scientific and technological discoveries (including space travel) were made millennia before they were made in China or the West. The ride concludes with a paean to the future of humankind and of India—subtly elided with Hinduism.

Two other huge projects in India are the Khalsa Heritage Project and the Maitreya Project, one Sikh, the other Buddhist. The Khalsa Heritage Project has acquired a hundred-acre site at Anandpur Sahib in northwest India, where in 1699 the leader of the Sikhs, Guru Gobind Singh, formally instituted the Khalsa Panth of saint-soldiers. They plan to build there a huge complex comprising exhibition galleries, library and archive, and auditorium, together with a 6,500-square-metre air-conditioned museum. The cost is estimated at $56 million. The Maitreya Project plans to build, at Kushinagar in northern India where the Buddha died, a vast Buddhist centre. The heart of the project is a 500-ft high statue of the Buddha, seated on a seventeen-storey building, which will contain temples, exhibition halls, a museum, library, audio-visual theatre and visitor facilities. The project is estimated at more than $200 million.[1] Not to be outdone, the Jains are planning an enormous museum in Chennai, while the Dalai Lama's Tibetan government in exile has already opened a more modest attraction at its headquarters in Dharamsala which is part museum and part shrine—in English it is called a museum, in Tibetan a Shrine Room (Singh 2010).

OBJECTS FOR EVANGELISM

Large-scale visitor attractions promoting a religious cause are by no means restricted to Asia. The United States has plenty, almost all based on Evangelical Christianity—some, indeed, linked to missionary television and radio stations. Two impressive

examples are the Holy Land Experience in Orlando, Florida, and Bible Walk, in Mansfield, Ohio.

Holy Land Experience is one of America's largest religious theme parks, and attracts between 1,500 and 2,500 visitors a day. Founded in 2001 with a $16 million budget and with a particular aim to sell Christianity to Jews, in 2007 it was taken over by TNB, the world's largest religious broadcasting company. While its daughter attraction in Buenos Ares includes a synagogue, a mosque and a shrine to Gandhi, the Orlando mother site is strongly Christian and evangelical, although (like much US evangelicalism) it is very conscious of its Jewish heritage, and indeed has caused great controversy by its curious eliding of 'Protestant' Christianity and Judaism (Branham 2008: 20). Here, the replica sites and buildings are populated not by wax figures, but by actors who present short plays and interact with visitors—one can easily have one's photograph taken with Jesus after the Resurrection. For example, from the site's publicity:

> Wilderness Tabernacle: Behold the High Priest as he takes you on a journey through Israel's ancient priesthood, culminating with the glory of God revealed above the Ark of the Covenant. 30-minute presentations. Jerusalem Street Market: Browse the Middle Eastern marketplace, see the city well, and interact with Jerusalem's own street merchants. Temple Plaza: Soaring six stories high, the gleaming white and gold temple, which was the center of Jerusalem's religious life, serves as a backdrop for the Temple Plaza. Hosts live musicals, presentations, and events.

The Experience has the usual cafés ('Centurion's Treats', 'Simeon's Corner'), children's play-park, shop and gardens, plus an auditorium and movie theatre. But if the emphasis here is on live performance (and visitors can meet a bloody Jesus being cursed by Roman soldiers), the Experience does indeed make use of promotional objects, both through a forty-five by twenty-five-foot model of ancient Jerusalem, and notably though the 'Scriptorium'. This is a conventional museum displaying 'several thousand manuscripts, scrolls, and other religious artifacts . . . The walk-through experience of The Scriptorium transports visitors to historical and geographical areas of the world where displayed biblical documents originated and gives guests a dramatic understanding of the history of the Bible, how it parallels the history of civilization, and the impact it has had upon the world.'[2]

Bible Walk is clearly much less well funded than the Holy Land Experience, and lies in a town a great deal less attractive to tourists. Yet it still manages to draw between 30,000 and 50,000 visitors a year.[3] The site was opened in 1987 by a local pastor. It is essentially a very large religious waxworks, comprising more than 300 wax figures presented in seventy dioramas arranged in a series of tours: 'The Life of Christ', 'Miracles of the Old Testament', 'Museum of Christian Martyrs' and 'Heart of the

Reformation', which 'depicts the men and women who gave their lives to bring the Bible to the common man in a language they could understand'. The site incorporates four more conventional museum collections: a collection of historic Bibles, a collection of woodcarvings of biblical scenes, works by a Korean artist, and a remarkable collection of folk art votive objects. Made by immigrants to the US in the early twentieth century, these are small dioramas created from a miscellany of beads, coins, tie-pins, cuff-links etc. Interestingly, Bible Walk attributes an element of sanctity to its whole site. The promotional brochure suggests, 'You may want to take off your shoes when you visit because you will be standing on holy ground', and mentions how Mansfield used to have many churches, was much visited by a Methodist preacher, and was the site of a Union Army camp where soldiers were trained 'to set the captives free'.[4]

Most of these new projects, however, are notable for how few historic objects they use. 'Objects promotional' here are often modern media such as dioramas, animatronics and videos, rather than the traditional museum object. As the Delhi-based designer of the Khalsa Heritage Complex puts it:

> The story to be told within the Museum's monumental architectural spaces is deeply spiritual, passionate and emotional. The exhibition design therefore strives to convey this spirit by the creation of a variety of immersive environments that transport visitors into a different time and space, thereby enhancing their capacity to receive the intended communication. A multi-layered communication strategy ensures that visitor aspirations are met, in a language and level of detail of their choice. The visitor to the Khalsa Heritage Museum will not only leave better informed but will also be emotionally moved. Cutting edge communication technologies juxtaposed with original artefacts have been seamlessly integrated with the vernacular aesthetic to highlight a robust, living culture.[5]

Of course, it *is* difficult sometimes to tell of the more cerebral or emotional aspects of a faith using original objects alone, and one of the major reasons that religion is getting taken more seriously in museums is precisely that modern display techniques—especially audio-visual techniques—allow the curator a much larger pallet of communication methods. Objects can be helped to speak nowadays by much more than simply the old-fashioned label and the odd blown-up photograph. The successful museum is the one that uses other display techniques to reinforce the objects' voice, but that gives original objects the leading role—for they have a power to speak that nothing else has.

OBJECTS AND FAITH

Some faiths are closely associated with a particular visual culture, long accepted as a style within the world's heritage of art. Most notable of these is Islam, where an

'Islamic Museum' might be a museum established to promote, celebrate or explain Islam, but is much more likely to be a museum of beautiful objects created in the particular tradition of Islamic art.

The International Museum of Islamic Cultures in Jackson, Mississippi, is one of the very few that does indeed seek to explain Islam, but aims to do so *through* its historic culture rather than presenting it directly: 'The goals of the Museum are to educate the public about Islamic history and civilization and to help provide educational tools for teaching global consciousness, historical literacy, and multicultural appreciation.' Other Islamic art museums follow the example of that in Doha, Qatar, which declares its ambition to be the foremost museum of Islamic art in the world, and to be the flagship project to 'mould the State of Qatar into a capital of culture'. It mentions nothing about promoting an understanding of Islam, though its first temporary exhibition was about interactions between Islamic art and that of other cultures and religions. The Doha museum was opened in 2009, but the same understanding of objects as art is found in much longer-established museums, for example the Islamic Museum in Jerusalem, founded in 1922, or Cairo's Museum of Islamic Art, which began in 1881. Because museums derived from the European Enlightenment, and first spread through the world thanks largely to European imperialism, the role of those early Islamic (art) museums was always ambiguous. The ones in the Ottoman Empire were especially problematic, for the empire was simultaneously trying to take on the trappings of a modern nation, while asserting its caliphate role as the leader of the Islamic world in the face of rising Arab nationalism (Shaw 2002). Like that in Doha today, the department of Islamic art in the Ottoman Imperial Museum was at once trying to use the history and culture of Islam as a reinforcement of Ottoman imperial power, and to mould late-nineteenth-century Istanbul into a capital of modern culture. Religious objects here are less promoting a faith than promoting a very particular political power.

The role played by Jewish religious objects in museums is quite different. Though as wide a variety of objects can tell the story of Jews and Jewish tradition as the material culture of any other peoples, religious objects are effectively the only category of Jewish historical object that is quite distinctively Jewish. Religion has often been seen as the only or the most distinctive difference between Jewish and non-Jewish cultures; at times, for instance the idea of 'Jews as Englishmen (Germans, Frenchmen. etc) of the Mosaic persuasion' was used as an argument for equality in societies that could be tolerant in terms of religion, but not so much in terms of ethnic subcultures.[6] As a result, Jewish religious objects tend to find themselves presenting Judaism rather than merely Jewish history. Certainly the balance has often been the subject of argument (Pieren 2010), but though Jewish museums today are primarily concerned with the history and culture of Jews

generally or of particular Jewish communities, in the earlier twentieth century they mainly presented ritual objects, and most do still try to present the belief and practice of Judaism. Thus, the Jewish Museum London (opened 2010) has a gallery—'Judaism: a Living Faith'—which both displays the museum's outstanding collection of ritual objects and seeks to explain the practices of Judaism in the synagogue and at home.

It is interesting to contrast the Museum of Methodism, beside John Wesley's House in City Road, London, with the Museé Internationale de la Réforme on the site where the citizens of Geneva voted to adopt John Calvin's Reformation. The former is strong on objects, but has been criticized for its failure to help the untutored visitor to understand what Methodism was and is at heart all about (Paine 2000: 163). The latter is understandably thin on original historic objects, but won the 2006 Council of Europe Museum Prize, and was praised by the judges for its effective communication of complex theological concepts, notably by imaginative multimedia effects.

This museum occupies a big eighteenth-century town house beside Geneva Cathedral. It tells the story of the Protestant Reformation using books, documents, paintings and recorded music, but the core of the Reformation was a dispute over doctrine—how to present that in a way that engages the modern visitor? The museum tackles head-on the great issue at the heart of Calvinism, but almost impossible for moderns to comprehend: the predestination from the beginning of every human soul either to heaven or to hell. Moreover, it does so in a way that—while dependent on audio-visual techniques—integrates original objects. This is the 'Theological Banquet', where a dining table is set for nine theologians whose portraits look down on their chairs, which double as showcases for copies of their principal works. The twice-hourly show begins with Calvin's portrait and place setting spotlit, while his voice expounds his doctrine of predestination. Each theologian in turn responds, ending with Rousseau accusing the pastors of Geneva of no longer knowing what they believe or even what they pretend to believe (Leahy 2008: 255). This is probably as effective a way of introducing a secular audience to remote and difficult ideas as can be imagined with current technology, but the integration of objects—the theological books—roots the message in true materiality, giving it a particular power.

The most unlikely objects can be persuaded to help argue the case for a religious cause. Knock Museum, part of the complex of the Shrine of the Virgin Mary at Knock, Ireland, uses objects with great imagination to tell the story of St Mary's apparition to a group of villagers in 1879. Most remarkable is how the curators have used quite mundane objects to support the story and reinforce the message. 'Life changes but faith is constant' is the argument of an otherwise bizarre collection of

(for example) a Box Brownie camera, 'Liquid Silk Stockings', ration book, cigarette cards, fish knife.[7] A reconstructed local blacksmith's shop is there because, 'At the forge and elsewhere the news [of the apparition] spread': the forge is shown as the local meeting place. A reconstructed local cottage (Figure 15) shows how St Mary chose to reveal herself to everyday country people. Most remarkable of all in the Knock Museum are items relating to the Irish National Land League, the campaign to protect poor peasant farmers. The League was founded just a few months before the apparition, and just a few miles away, in response to failing harvests, falling prices and widespread hunger. It is often pointed out that Marian devotion in Europe tends to flourish in times of social stress, and it is impressive that the Knock Museum draws explicit attention to the way in which the League parallels the Knock devotion.[8]

OBJECTS FOR MUTUAL UNDERSTANDING

One of the more notable features of museums in the developed world over the past generation has been the growth of the idea that museums *cannot* truly be neutral places of education and entertainment, or even forums of public debate, but on the contrary should be explicit about their values, and positively seek to be agents of social change. Mark O'Neill, leader of the team that created the St Mungo Museum of Religious Life and Art in Glasgow, said, 'St Mungo's is not an objective museum. It exists explicitly to promote a set of values: respect for the diversity of human beliefs' (O'Neill 1995: 50). The agenda of most museums, when they consciously take a stand, is a liberal one, and a major aim is to promote community harmony.[9] And, indeed, it is true that, in the UK at least, over the past twenty years or so, society has been asking two things of museums: that they provide diversion for families' leisure time, and that they promote community harmony (Sandell 2006).

In St Mungo Museum of Religious Art and Life, objects appear in two forms. On the ground floor is a selection of striking and often beautiful objects from each of the world's major faith traditions; these adopt two meanings: as representative icons of their faith, and as works of art. In effect, this gallery is a way in for visitors from the familiar art gallery—the Gallery of Religious Art—to the didactic and perhaps more serious first-floor gallery, the Gallery of Religious Life. This is a gallery of comparative religion; here, crowded displays show how different religions tackle common human experiences. Showcases are devoted to the human life cycle—birth, coming of age, sex and marriage, death—and to war and peace, divine rule and the afterlife. For each of these themes, comparable objects from a variety of faiths and cultures are assembled, while more detail is offered on individual faiths by a series of five showcases devoted to what the museum sees as the five main world religions. The aim is clearly to encourage mutual respect among adherents of different faiths both by

learning more about other religions, and by appreciating the ways in which different traditions approach the same human issues. However, we have already seen (chapter three) that visitors do not inevitably respond with empathy and understanding. At one extreme, visitors may see such comparative displays as blasphemous, at the other they may see them as confirmation that all religion is superstitious nonsense. They may even simply see unfamiliar things as bizarre and alien, confirming their prejudices (Campbell 2007: 60). One problem is that these objects all relate to ritual, and without explanation, this relationship is unclear if one has not personally experienced the ritual—unless one has attended a christening service, the point of a christening robe is far from obvious. Photographs help show how things are used, and text helps to explain underlying beliefs, but short video or audio clips are even more effective.

The Museé des Religions du Monde at Nicolet, Quebec, also aims 'to help the visitor understand the religious and social behaviour of his neighbor . . . to bring about a little tolerance in the face of difference' (Royal 2007: 154). Like St Mungo's, this museum puts a heavy emphasis on community activities and learning services. However, it originated in a concern to rescue religious heritage in the face of declining religious practice and post-Vatican Council simplification of Catholic practice, and it not only has an active programme of conservation of its own collections, but is creating an inventory of religious heritage held by Quebec religious communities. Religious objects are again being used to defend a liberal ideology of mutual respect and understanding.

In a recent broadcast, Alain de Botton (2011) asked art museums to go much further down the road towards being agents of social and personal change. They should take seriously their role as modern society's equivalent to churches, by using their art objects to try to make people 'good and kind and wise':

> What if they gave up on the neutral, bland captions they tend to use and put beneath each picture a really directive set of commands telling us, for example, 'Look at this image and remember to be patient.' Or, 'Use this sculpture to meditate on what you too could do to bring about a fairer world'? There would be galleries devoted to evoking the beauty of simplicity, the curative powers of nature, the dignity of the outsider or the comfort of maternal nurture.

Here, objects become so intensely promotional that they are effectively being coopted as religious objects. In this chapter we have seen how many objects—often things that seem entirely unreligious—can be pressed into the service of a particular faith or ideology, and can help to promote it. The role of objects described in the next chapter may prove more sympathetic to many readers—it is the role of objects (often deployed by disinterested outsiders) in explaining religion or religious culture.

10 OBJECTS EXPLANATORY AND EVIDENTIAL

How religious objects explain their faith and their culture

Secular museums have long used objects to explain the religion and the culture behind them. Such explanations reflect equally strongly the philosophy, aims and interpretive techniques of their curators. Examples are objects explaining popular religion, and objects illustrating the history of medicine. Far less often do museums use their objects to build a theoretical understanding of the phenomenon of religion.

We have looked, during the course of this book, at a wide variety of ways in which religious objects in museums behave, and at their relationships with their curators and their visitors. Here in this final chapter, we look at the ways in which religious objects explain their faith, or the culture from which they spring. This is perhaps the most obvious way in which objects are used in museums, the way museum visitors have come to expect. It is also the way in which religious objects are most at the mercy of their curators, for to present an unfamiliar faith or an unfamiliar culture via the medium of objects cannot but reflect the ideology, recognized or not, of the curators, and also has to mean using text, illustrations, audio-visual media and other interpretive and contextualizing techniques—giving yet more power to the curator.

Religious objects may find themselves in history museums, art galleries, folk museums, archaeology museums, anthropology museums, faith museums or even those few museums which set out to tell the story of religion as a world-wide human

phenomenon. All save art galleries and faith museums approach religious objects from a secular perspective, using them either to explain the role of religious practice in their evolving culture, or to explain an aspect of that culture expressed in religious objects—usually popular art or ceremony. Very briefly, we will look at two closely linked examples of religious objects explaining the stories of their societies: objects explaining popular religion, and objects explaining the history of medicine.

RELIGIOUS OBJECTS AND POPULAR CULTURE

Second only to treating them as 'art', museums have reinterpreted religious objects as illustrative of popular culture. In 'folk museums' and social history museums generally throughout the world, one will find 'religious objects'; they are ubiquitous in museums in Roman Catholic societies, but—though one may sometimes have to look more carefully—they appear too in museums in many other cultures and societies. Images in paint, carved wood, print, bronze or ceramic depict gods or gurus, religious scenes or preachers. Prayer books and rosaries recall individual piety. Souvenirs from pilgrimages include holy water or earth, or other items bringing back into the home not just the memory but also some part of the actual material sanctity of the pilgrimage site. Many of these things are personal items, but others relate to the family, particularly items associated with rites of passage—take for example the wedding dresses and christening robes that throng our costume collections.

Folk museums also include religious objects that relate to the wider community and speak of social organization, notably perhaps the banners of religious guilds or images and symbols paraded in popular festivals. Thus 'Snap', the processional dragon preserved in Norwich Castle Museum, became a feature of the eighteenth-century mayor-making festivities, and of the mock mayor-making in the nineteenth. His predecessors, though, had accompanied St George, who on horseback on his feast day every year led the Guild of St George to the cathedral for Mass. Once in the museum, these items illustrate the 'folk religion' of the community's past, and often also its folk aesthetic and crafts. Objects such as cast-iron firebacks (Figure 12) or Stuart embroideries (Figure 2) enter museums either because they are seen as fine examples of the creativity of ordinary people in the past—supporting, but distinct from, the High Art of the professionals—or because they throw light on local industries in the past. Thus, the iron firebacks in museums in Surrey and Sussex (notably Lewes, Hastings and Guildford) are products of the iron industry which flourished from around 1500 until the early nineteenth century.

One example of a class of religious object that is to be found in a variety of secular museums is the amulet or charm. Edward Lovett was the chief cashier of a City bank, but in the evenings 'he walked through the slums of Edwardian London,

buying strange objects: amber charms and lucky left-handed whelk shells from sailors and barrow men', children's toys and other objects that illustrated the life of London's poor.[1] Items collected by Lovett are now held by the Science Museum, the Pitt Rivers Museum in Oxford, the Cuming Museum in Southwark, South London, and the Wellcome Collection. Very few are on display, despite the extraordinary power they have to reveal the intimate lives of the poor in both urban and rural England in the days before compulsory health insurance. Those sold by Lovett to the Pitt Rivers Museum are listed on the museum's admirable website[2]; they include the forefeet of a mole in a small bag, carried as a cure for cramp, Sussex; twigs of ash in a small bag, carried as a cure for fits, South Devon; piece of amber carried by a fisherman as a cure for rheumatism, Suffolk; a stone for rubbing on warts to cure them, South Devon.

In this world, there is no distinction between physical health, mental health and general wellbeing, and what has been called 'an informal domestic form of spirituality translated as luck' (Hill 2007: 79). It is notable how many of these amulets, though, betray not merely a vague search for luck, but a positive fear of evil. The collection includes ' "shepherd's crown" a fossil *echinus*, placed on window sill outside to "keep the Devil out", Sussex; "Hag stone", a naturally perforated flint with latchkey attached, from a cottage door, S. Devon; sheep's heart stuck with pins and nails (model) as formerly used in S. Devon for "breaking evil spells" '. One of the better-known objects in the Pitt Rivers Museum is labelled

> Silvered & stoppered bottle, said to contain a witch. Obtained about 1915 from an old lady living in a village near Hove, Sussex. She remarked, 'and they do say there be a witch in it, and if you let un out there'll be a peck o' trouble.'

Not everyone shared her caution. The Pitt Rivers collections also include an onion pierced with pins, labelled with the name of a fellow villager, and hung in the chimney of the Barley Mow pub in Rockwell Green, Somerset, in 1872. When a number of these onions fell out of the chimney in a storm one night, this one was acquired by the great anthropologist Edward Tylor, who lived locally. He noted, 'King James would have certainly burnt him but, even now there is a lurking belief in the hamlet that it may be an effective means of bewitching, & if any accident happens within a few weeks to any of the persons who had their names on the onions, I should not wonder if their friends took physical means of retaliation.'[3]

Such objects of superstition are neither restricted to rural areas, nor indeed to the distant past, nor are they to be sharply distinguished from 'religious objects'. As we have noted, popular religion has always been constructed by the people from a mixture of popular traditions (of which the 'educated classes' were at one time largely ignorant) and elements taken from official religion. Thus, in the poor areas of many

English cities in the earlier twentieth century, it was considered extremely unlucky if a new mother failed to attend church to be 'churched' immediately after childbirth.

MEDICINE, MAGIC AND RELIGION

Those of us who are privileged to live in a country with an effective public health service have almost forgotten this once-dominating link between religion and health. Unless we are Jehovah's Witnesses or belong to a group practicing spiritual healing, it is exclusively the search for spiritual rather than physical health (and for some perhaps the fear of death) that prompts us to approach the gods, to engage—if we do at all—in religious activities. For most of human history, it was quite otherwise. At the top of London's Science Museum is the Wellcome Museum of the History of Science, formed from the collections of the medicine-magnate and super-magpie Henry Wellcome (Larson 2010). Its rather tired displays include an introductory section devoted to medicine in the Ancient World, and here there is some recognition of the common origins of medicine and religion, with (for example) a splendid model of the Temple of Asclepius, statues of medieval healer-saints, and nineteenth-century Iranian divination bowls. The greater part of these displays, however, is devoted to mainstream, Western professional medicine. A few years ago, clearly, the museum recognized the limitations of this approach, and inserted a new section devoted to four other medical traditions: Ayurvedic, Unani Tibb (also from South Asia), African and Chinese. Here, objects concerned with spiritual as well as biological healing appear much more often. Ayurvedic medicine offers an eighteenth-century Indian Buddha, a Dhanvantari figure from the modern USA and Yantra meditation plaques from nineteenth-century India. African medicine (where 'the physical and spiritual aspects of your body are equally important') offers items as diverse as a BaKongo container for the *nkisi* force and a 'Koranic board' from Nigeria on which quotations from the Qur'an are written, washed off and the water drunk.

In some ways, though, this inclusion of non-Western traditions points up the museum's almost exclusive understanding of Western medicine as professional 'biomedicine'. In the Science Museum, science curators curate the displays. Cross London to the British Museum, and one finds another gallery funded by the Wellcome Trust. But here, the museum's anthropologists curate the displays, and the result is very different indeed: similar objects are invited to tell quite different stories. The *Living and Dying* gallery is at the very centre of the museum, and displays (as the introductory panel puts it) 'people's reliance on relationships to maintain well-being' and 'how people try to avert life's ordinary dangers, and respond to sickness and trouble when they happen. These different approaches arise from the diverse ways people understand the world.' These themes and sub-themes are illustrated by objects

from a great variety of cultures, from the Solomon Islands to the Catholic Mediter-ranean. In the centre of the gallery is an installation that looks at the health of a man and a woman in Britain today. It is dominated by the thousands of pills they might consume, and the overall message of the gallery is the oddity of modern Western medicine—the norm is the traditional relationships-based holistic approach. A very different view from that of the Science Museum.

OBJECTS IN THEORY

Every museum has an underlying philosophy, whether or not it makes it explicit or even recognizes it. Sometimes this philosophy is very clear, as in those museums we have been considering which use their objects to urge a particular faith or a par-ticular ideology. At other times, the whole of society conspires, it seems, to conceal the assumptions underlying a museum's displays—so concealing the activity of its objects. History museums are particularly guilty of this. Take the 'folk museum'. When the German 'Volk' was anglicized to mean 'people' or 'popular', it acquired a strong overtone of 'working class', and more particularly of 'rural working class' or 'pre-industrial working class'. There is a distinct class narrative underpinning folk-life collecting. The material culture of working people is collected as part of a 'scientific' effort to record their lives, but in the process those lives are romanticized and identi-fied as subtly other and subtly inferior. Religious objects are often part of this, either as examples of 'folk art'—the artisan skills of a particular region—or as 'popular cul-ture', the ways in which religion is done materially (and less properly) by 'The Folk'.

The Pitt Rivers Museum is part of Oxford University, and more than many mu-seums is conscious of the theory that underlies its displays. General Pitt Rivers himself developed his collections as a way of presenting his understanding of the evolution of human society, an understanding based on his study of the history of guns. He saw all aspects of human life, not just technology, as developing from the simple to the complex and sophisticated. It was a theory that reflected the evo-lutionary understanding of natural science, but one that was also of clear benefit to a technologically advanced society keen to justify its imperial ambitions in less 'advanced' parts of the world.

Religion, too, was explained as progressing through humankind's story from the simple to the sophisticated, and the monotheist religions—even for some Protes-tant Christianity—were seen as the highest understanding humankind had reached. 'Primitive' religion had survived in many parts of the world, though, and it was part of the mission of empire to replace it with a more advanced faith. Fascinatingly, it could also be found surviving in odd interstices of developed societies such as Brit-ain's, where unsophisticated labourers still followed superstitious practices—which

must surely soon die out in the face of universal education. Edward Tylor, whom we met living in Somerset, is sometimes called 'The Father of Anthropology' and was the first Professor of Anthropology at Oxford; he was mainly responsible for the initial layout of the Pitt Rivers Museum. Tylor believed that human culture had evolved from 'the religion of savages' who interpreted the experience of spirits in dreams and hallucinations as inhabiting or 'animating' such objects as trees and stones, and had proceeded in a series of stages from animism to polytheism, to monotheism. Some people, though, had been left behind, and evidence of the 'savage' stage was still to be found—including presumably in Rockwell Green. Tylor saw such survivals as dangerous and disgraceful: 'the remains of crude old culture which have passed into harmful superstition, and to mark these out for destruction . . . for the good of mankind' (quoted in Holdsworth 2004; see also Gosden and Larson 2007: 77; and Wingfield 2009).

All this view of human society has, of course, disappeared long since. James Fenton, who wrote his much-loved poem *The Pitt Rivers Museum* in 1970, understood that clearly:

> For teachers the thesis is salutary
> And simple, a hierarchy of progress culminating
> In the Entrance Hall, but children are naturally
> Unaware of and unimpressed by this . . . Yes
> You have come upon the fabled lands where myths
> Go when they die . . . And we do well to bring large parties
> Of schoolchildren here to find them.
> Outdated
> Though the cultural and anthropological system be . . .

Yet the museum's religion displays still reflect, even with their more modern labels, something of that outdated system—certainly they give no hint of any new underpinning general theory.

It is disappointing how seldom museum objects are used to support any general theory of religion. Archaeology museums sometimes approach this with their prehistoric collections, but generally this use of religious objects, which one might expect to be a major justification for museum collections, seems to have receded into the past. Two examples of very different scholars who did use religious objects to develop an understanding of religion were the British antiquary Richard Payne Knight (1751–1824) and the German theologian Rudolph Otto (1869–1937). Knight built up a personal collection of Greek and Roman antiquities, paid for with the fortune he inherited from his grandfather, a Coalbrookdale ironmaster (Stumpf-Condry and Skedd 2004). His theories were undoubtedly eccentric, for he claimed that the worship of the phallus was the root of all religion, including Christianity. Yet, though

few may now take this idea seriously, his thesis was based on the evidence he saw in his collection of antiquities, in a way that was exceptional in its day; he turned to literary material only for corroboration (Williams 2003: 215). Knight's collection is now a highlight of the British Museum's 'Enlightenment' gallery.

Quite different was Rudolf Otto, a theologian whose thinking has been taken very seriously by students of religion for a hundred years. Otto spent much of the first half of his life travelling the world in search of spiritual truth, and it was his own observation and participation in humankind's enormous variety of rites that led to his understanding that it is from personal involvement and behaviour that people derive their religious understanding, rather than from creeds and doctrines. The idea of a museum of religious objects as a means of studying religion grew, but it was not until he had become famous through the 1917 publication of his seminal book *Das Heilige* that the project became possible. Central to Otto's understanding of 'The Holy' was his belief that every human being possesses a natural ability to recognize the *numen*, the numinous; most of his book is taken up with examining the human response to it. There remains an ambiguity as to whether, in the case of holy objects in particular, holiness can be innate or is always the product of their interaction with people, but religious objects are key to his thinking. The first displays of the Marburg Museum of Religions were opened in 1929 as a part of the University of Marburg, and—much enlarged by later curators—the collections continue to be actively used for the university's religious studies courses (Bräunlein 2005: 286).

INTERPRETING AND CONTEXTUALIZING

We have seen above (chapter four) how the design of a museum gallery can heavily influence, if not actually determine, the way visitors understand the objects displayed—the meaning he or she gives them. Museum designers understand this well, and long before they discuss with the curators what text, illustrative material or other techniques they will use to help tell the agreed story, they will have agreed a particular *atmosphere* for the display. Baroque paintings may be hung against deep-hued brocade, Inuit carvings displayed in sparkling glass showcases in front of ice-blue walls, Amazonian artefacts in a jungle-green gallery. Before the visitor has more than stepped over the threshold, curator and designer are conspiring to influence the way he or she responds to the objects on display, to re-empower silenced objects and to impart to the visitor something of what (when religion is involved) Joan Branham (1994/5) called 'vicarious sacrality'. Icons presented in a dimly lit room painted a rich red or purple, with points of light evoking candlelight, are at once recognized as *icons*, whereas to display them against white walls in a conventional art gallery signals that they are to be received as works of art.

Increasingly, museums are going further in recreating the original context of religious objects, though such efforts are still often very modest. Paintings originally intended as the backdrop of Christian altars are displayed—as in London's National Gallery and the V&A—on plinths roughly reflecting the form of altars, so that the visitor at least sees them at the height for which they were designed.[4] Many of the West's greatest works of art were designed to be seen principally at Mass, and to link the actions of the priest with images of Christ, his mother, disciples or saints, to create a rich theological understanding and affect. But seldom is their context recreated any more fully, with elaborately dressed altars bearing crucifix, candles and altar card (the priest's prompt-card), let alone showing the priest and server in vestments. The V&A displays a splendid and huge nineteenth-century Burmese Buddhist altar, whose fruit bowls contain replica fruit, but then the whole thing is enclosed in dim lighting in an enormous glass showcase, which instantly turns it again into a 'museum object'. Just occasionally, a temporary exhibition goes further. The old Museum of Mankind in London used to hold 'immersive' exhibitions which occasionally reproduced sacred places: Ashanti in Ghana, Wahgi in Papua New Guinea.

To create a whole environment in which the visitor can be immersed is difficult and expensive. Museums are beginning to interpret ritual objects through video. The 2009 'Baroque' exhibition at the V&A used a video to demonstrate how a baroque-period High Mass became 'a compelling, multisensory performance', in which the magnificent altar frontal, vestments, reredoses and plate all played their part alongside music and movement. More emphasis on the beliefs underlying the ritual practices which in turn underlie many religious objects was given by a video offered in the Seattle Art Museum's exhibition 'Discovering Buddhist Art: Seeking the Sublime'. In this, the Japanese priest Shunsho Manabe explained the Shingon 'eye-opening' ritual he performed on the museum's Kishitigarbha Bodhisattva sculpture, to bring the spirit of Bodhisattva into the sculpture.[5]

In the Roman Baths Museum at Bath is an altar presented by a German pilgrim to the sacred baths from Trier, and dedicated to his home-town gods, Loucetius Mars and his consort Nemetona. A very large screen beside the altar shows a lifesize video of 'him' positioning his altar and pouring on libations (Figure 13). It is particularly difficult to convey the character of ancient religions, and to explain the use of their objects. Just around the corner in the Bath museum stands, in its original position, the great central altar of the Roman temple of the mother goddess Sullis Minerva. Her sacrifices would surely have been a great deal more dramatic and bloodier, involving the ritual slaughter of bulls perhaps, and the burning of their innards. There is no similar video reconstructing this! Occasionally, perhaps, we should confront our squeamishness, and actively seek to face up to and understand the character of

Roman religion; perhaps the links it created between the natural world and human spirituality might have resonance for people today.

Another interpretive technique common at history museums, particularly open-air and site museums, is first-person interpretation. The visitor to a museum such as Colonial Williamsburg or Ironbridge—and very many smaller ones—will meet innumerable people dressed in historic costume and demonstrating crafts or talking to visitors about life in the chosen period. Their popularity with visitors, effectiveness as a means to teaching about history, and often their excellent background research, is well attested. It is perhaps not surprising that museums seem very seldom to use this technique to interpret religious sites and objects.[6] Yet English cathedrals very commonly use role-play and drama in their learning programmes. Typical is Chichester Cathedral's 'Pilgrims and Pilgrimage' programme, aimed at seven- to eleven-year-olds:

> This lively workshop involves role-play: each child will be given an identity in advance and a costume on the day. The children are then given the chance to interview two or three 'real' adult pilgrims in the Cathedral (these might include the King, a nun, friar or a palmer) who will lead them on a costumed pilgrimage to the Shrine where they can offer their prayers and gifts. Each child will receive a copy of the Prayer of St. Richard.[7]

There is, of course, an ambiguity here: many of the children taking part must be unbelievers, coming from entirely secular households, yet when they 'offer their prayers', are they simply play-acting, or is the hope that they may become attuned to offering genuine prayer? And when is prayer 'genuine'? Ancient cathedrals are, of course, as much museums, historic sites and tourist attractions these days as they are places of worship, but secular museums seem to do nothing similar.

OBJECTS PROMOTE A DEEPER UNDERSTANDING

Despite the growing use in museums of modern technology, the overwhelming weight of object interpretation in museums of almost every type rests on the two techniques that have been used by museums from the very beginning: the guided tour, and the object label. Both use words almost exclusively, which immediately favours a credal, intellectual understanding of religion, rather than a sensual, emotional, experiential one, which is how the overwhelming majority of believers actually consume religion and its objects.

In a recent study of how three smaller museums present the story of Christianity's first few centuries in England, Elizabeth Long (2007) showed how seldom

museums attempt to draw their audiences into any real empathy with religious faith, or into debate over questions of religion. Rather, they present religion primarily as the creator of cultural forms, certainly not as an answer to ultimate questions, or as a source of comfort. This is not surprising: it is extremely difficult to help visitors to grasp something of what believers in the past may have thought or felt—historical exhibitions seldom carry emotion. It is difficult, but not impossible, as the various Holocaust museums around the world can show; museums indeed can allow original objects to generate emotion—the sight of a pile of gas-chamber victims' shoes is always movingly terrible.[8] Moreover, museums can find analogies with visitors' own experience. An imaginative exhibition at the Asian Civilisations Museum in Singapore presented, through a collection of football paraphernalia, the experience of a football pilgrim to Liverpool, alongside Buddhist, Muslim and other pilgrimages.

> The Liverpool pilgrim display was a great way to introduce secular pilgrimages for visitors who may not be so familiar with religious experiences. They can employ the feelings of a football fan—the ecstasy they feel at the moment of a winning goal or being in the stadium they have seen so many times on television—to help them understand how religious pilgrims feel on their trip. (Chin 2010: 212)

The learning officer at the Manchester's National Football Museum does a 'Football as a Religion' talk, with a stadium tour to follow. Some school parties link this with a visit to a church, cathedral, temple or mosque.[9]

When museums do try to present a 'religion', too often they assume a unity of practice and belief that is simply not to be found. In reality, all religious groupings of more than a handful of members are formed of people with their own distinct 'take' on their faith, and often very diverse practices, as well. Buckley (2000: 92) gives the example, among the churches of Northern Ireland, of the Presbyterian Church:

> Some Presbyterians are evangelicals, some are liberal. Some are Calvinists, to the point that they disagree with both the evangelicals and the liberals. Some Presbyterians are baptized as adults with total immersion. Others oppose the practice. There are charismatic Presbyterians who speak with tongues. Some Presbyterians claim to have been saved. There are British Israelite Presbyterians who think that the British are descended from the lost ten tribes of Israel. Many Presbyterians believe the Pope to be Antichrist, and indeed all Presbyterian ministers sign a document to this effect when they are installed into their congregations . . . Many others think that both these views are nonsense.

It was no doubt ever thus, and museums which purport to present 'a faith' must tread very carefully indeed. Safer, perhaps, and perhaps also more illuminating, is to follow Buckley's advice and address cross-cutting themes such as particular rituals, seasonal customs, or moral and societal attitudes.

One successful example of just this approach was the exhibition held at the Provincial Museum of Alberta, Canada, in 2000, *Anno Domini: Jesus Through the Centuries*. The exhibition was organized by David Goa, who as the museum's Curator of Folk Life had spent many years researching the immigrant communities of the Province, from the Hindus to the Doukhobors, and had himself made a spiritual journey from the his parents' Swedish Lutheranism to Orthodoxy. The exhibition grew from the work of Jaroslav Pelikan, author of *Jesus Through the Centuries: His Place in the History of Culture*, and was based on Pelikan's remark, 'Jesus is far too important a figure to be left only to the theologians and the church', but it became far more than a mere history of images—rather it was an examination of what Jesus meant to different groups in different ages. The exhibition (an on-line version is still available[10]) was organized in eighteen themes, each looking at an aspect or understanding of Jesus that has influenced Western civilization through the past two millennia, and each illustrated by three or four objects bringing out aspects of that theme. 'It explored not what Jesus *meant*, for that is the province of Christians and Churches, but what his person and teaching have been *taken to mean*' (Goa 2012). Yet the exhibition was intensely personal, based on a profound belief in the redeemable quality of humankind and the contribution that a Christian understanding can give to the redemption of all humankind; its triumphant success with the public is a testimony to what giving one curator his head could achieve.

> For three months thousands of people came, young and old, those who claimed the tradition and those for whom the Christian tradition is troubling if not worse. They stayed and pondered life's questions in dialogue with Jesus through the centuries. While it was the most popular exhibition our museum has ever had, drawing some 114,000 people, most important to my mind is the depth of engagement I was privileged to witness during those 90 days. Many came and lingered for three or four hours, asked if they might pitch their tent and stay; many returned two or three times to think again and ponder their own life experience in the face of this grand language of meaning we call the Christian tradition. (Goa n.d.)

Goa's genius is his ability to relate to people—to understand not just where they are coming from and where they are standing now, but where they might travel. People instinctively recognize this ability, rare in the museum world, and it allows the fortunate curator to understand what objects will easily speak to each individual, and how that relationship will be framed. At the time of writing, Goa is leading a proposal for a new, international exhibition along even more ambitious lines. *U: Rediscovering the Human Spirit* plans to use 150 of the world's greatest works of art to explore some of the profoundest questions of human life. Here, religious objects in museums move onto a quite new plane of purpose.

11 CONCLUSION

What have we learnt and how can we help religious objects in museums fulfil their public duties?

WHAT SHOULD RELIGIOUS OBJECTS BE DOING IN MUSEUMS?

What have we learnt during this rather rapid scamper through the public and private lives of religious objects in museums worldwide? What should we be asking religious objects to do in museums? What should we be asking museums to do with them? There is, of course, a severe limit on what we *can* ask museums to do. Museums are simply a medium. Just as with books or the cinema or television or the Web, no one can impose a duty on museums—museum owners will use them in whatever way they think best. Faith groups will continue to use museums and museum-techniques to promote their particular understanding of life. We need not complain about that, for we can visit their museums to learn how they understand the world, and our visits will add to the richness of our experience and of our appreciation of humanity's diversity. The problem is, rather, that it is only particular faith groups that have the resources to create the most effective visitor attractions, just as only they can afford to own television channels and to build mega-churches. It is the rich, too, who have the power to contradict the discoveries of science, and so to close down human enquiry—at worst, as with the denial of climate change, endangering humankind. When they end up in militant faith museums (whether that faith is a particular religious understanding, atheism or Creationism), it is difficult to see how religious objects can avoid becoming pawns in a growing spiritual inequality in the world, making their own contribution to the dominant power of the already-wealthy.

When those objects are in public museums, though, the position is quite different. Then, we can reasonably ask that they be allowed to express themselves in all the voices they can. Objects have a unique power to speak to people, and do so on a quite different level to words, or even to images. That is why religious objects in museums must have an exceptional role and responsibility in the great cause of helping humankind to understand human motives.

A DUTY TO MAKE SOCIETY BETTER

Museums aren't just for fun—though they have always been a part of the entertainment industry as well as in the research and education business. They have a very serious social function, a function they need to recognize and pursue if they are to deserve their public support. The first duty of museums is to help visitors understand the world and to enjoy the beautiful. Their second duty is to translate that understanding into respect and care—what used to be called 'love'. Here is where the most urgent responsibility of museums lies in the twenty-first century: to encourage mutual understanding and, hence—if possible—communal harmony.

We have seen what a variety of approaches to religion are to be found in museums, and what a variety of practices. We must not forget, though, in celebrating that diversity, and the increasing attention that museums pay to religion, just how limited that attention still is. The impact of religion on the world is growing apace, and global migration and communications make contrasting faith traditions, which in past generations could safely ignore one another, rub against each other in ways that can lead to conflict as readily as to mutual enrichment. Museums have scarcely yet begun to examine their responsibility in this field. The most urgent and immediately socially useful duty facing religious objects in museums is helping people to understand religion.

The power of religion in human affairs creates an urgent need for all the world's people to understand the motive force of religion, and to understand the religion of others. What matters is not just to understand the beliefs of others, let alone the 'official' beliefs of a world religion, but rather to understand religion as it is lived day by day by confused and individual people, however strange their attitudes, unfamiliar their motivation and peculiar their practices.[1] The aim should be to help us see the world through the eyes of believers. This surely is the answer to those who fear the takeover of museums by religious fundamentalists, and the betrayal of the scientific, rationalist tradition on which they say that museums should be based. Because religion is to a very great extent done through objects, museums offer a unique environment in which to gain this empathy and understanding.

But religion is too important, and understanding it is too important, to depend on a local community-relations agenda, however urgent. A modern museum, it has

been suggested,[2] is at its best a crucible of new ideas. The curator is an alchemist, trying to come up with new ways of telling old stories and drawing new stories from old objects. But for all the curator's power within his or her museum, the interpretation of every museum object must be a three-way negotiation between object, curator and visitors. The object's aim must be to present all the meanings it bears. For a religious object, that may be a variety of understandings of its religious status and role, for even when it was still 'at home' in a religious context, it very probably bore different meanings to different people. A chair in the nave of a church will have quite different meaning to the priest who looks down on it from the pulpit, the elderly lady who has sat in it week after week for much of her life, and the church cleaner. For all three, though, it will carry meanings of faith and worship. To the outsider, the object has other meanings again, and when it arrives in a museum it gains further meanings and purposes. The curator's responsibility is to allow all these meanings to come out, or at least to be available to the visitor.

OTHER THAN WORDS

This book has been written in words—a serious disadvantage, particularly when the subject for discussion is the human mind on the one hand, and objects on the other. It is one of the strangest aspects of the academic attention given over the past few generations to the material and the visual that it has been expressed almost entirely in words. It has created an ever-greater gulf between those who can read and speak the now quite obscure and difficult language of material culture studies, and those who just deal day-to-day with objects. This is more than just a normal specialist/layperson divide. It reflects a distinct academic privileging of text, and an insistence that the tangible and the visual can have their meaning explained only in words—sometimes, one suspects, the longer and less familiar the better.

We would all benefit from a bridging of the gap between those with the cultural capital to feel at ease with this academic language, and those who work with or simply enjoy and experience the objects they discuss. Museums which hold religious objects have a particular advantage when it comes to addressing the nature of the material, simply because religious objects have had so many different meanings attributed to them, and so many people in so many different cultures have tried to explicate those means, not only in words, but through a huge variety of kinds of performance. For example, a challenge to the museum world might be to develop an exhibition that addresses the difference between the embodied and the representational, and all those issues surrounding the nature of the 'holy' object which we have only been able to touch on here—and, moreover, only in words. Exhibitions that address these issues through real objects and images might make real contributions

themselves to human understanding, rather than merely illustrate the insights of those who originally thought and wrote in words.

BE ENQUIRING, BE CRITICAL

We need much more information on how people respond to religious objects in museums—how they regard them and how they respond to them. As we have seen (chapter three), much research is going on into how visitors respond to, interrelate with, objects in museums generally. People respond to objects very largely on the basis of what they know already—what context they put them into. It would be invaluable to know much more about what people understand about religion, and about religious objects in particular, before they visit the museum. Such knowledge would enable curators to target exhibitions more precisely and to measure at least part of their success—their success in conveying information, if not their success in inspiring. No longer would they have to make assumptions drawn from their visitors' age, education, religion, social class and so on. Once the visitor is in the museum, how does he or she respond to the display generally, and in particular to the individual objects? We really still know very little about how we respond to objects of any kind, and religious objects come with a great deal of added baggage, and baggage of a very special kind. We can hope that the present limited techniques will soon be augmented by the insights of cognitive psychologists, neuroscientists and others. Just what exactly is going on in our heads when we are moved—or intrigued, or disgusted or just interested—by an object? What exactly is the difference between relating to an object through sight alone, through touch and smell, or through a formal—ritual—pattern of behaviour? Finally, do museum objects really change people? Can religious objects really have a spiritual impact on museum visitors, and what does this mean in terms of both brain function and modified attitudes and behaviour? We need much more hard evidence to support our claims about religious objects' public duties.

We need to be much more critical of the way museums use and present religious objects. There is invariably an ideological agenda behind a museum display, and that means a political agenda. Sometimes, museums try to avoid forcing one particular understanding of their objects on the visitor by refusing to offer any interpretation. Such efforts invariably end in failure. An example is Washington's National Museum of the American Indian, where, as we saw, a 'traditional' understanding of Native American history underlies displays which largely avoid offering information at all. But, 'The failure to provide a narrative and chronology is itself a powerful statement about both narrative and chronology, since the implication is that Native peoples have changed little over time and remain rooted to the lands where, it is implied, they originated' (Jenkins 2005). Sometimes museums are up-front about the beliefs

that underlie their presentations, and this is most welcome. Too often, though, curators (in local history museums, especially) simply present their collections without considering the assumptions about history that they are inevitably putting before the visitor. We need more carefully to critique museum displays from this perspective.

BE BRAVE, BE IMAGINATIVE

Museums need to be much braver. They need to be braver in allowing people access to objects, and to interact with them in their own way. This may well result in less-tidy museums, and will certainly impose major responsibilities on museum staff to manage and mediate between the conflicting needs of visitors. Visitors allowed more generous access to a devotional object might want not merely to gaze, to pray, to kiss, to touch or to make offerings of flowers and ex-votos, but might want to burn incense, sweetgrass or candles, to wash and clothe the figure, to paint or apply gold leaf or even to hammer in nails. One can easily see why museums have traditionally allowed visitors only to gaze. Yet there is already a strong tendency to allow visitors greater freedom in touching, a move which promises to stimulate much more investigation of the ways in which people experience things as well as greatly to enlarge visitors' interaction with museum objects (Chatterjee 2008; Pye 2007). If museums are to fulfil their promises to reinvent themselves as places that truly belong to 'the people', they need to be braver and more generous in allowing individual people to do their own thing in their galleries.

Museums also need to be braver in the stories they tackle and what they say. There is a strong tendency in museums, as in other media, to self-censor. 'Will the Trustees wear it?' 'How will this play in the press?' 'Must we upset our sponsors in this way?' 'Won't this cause a row?' Religion, as politics, is a perilous field which arouses strong feelings on both a personal and (more dangerously) on a community level. Yet, if museums are to make a real contribution to public debate in a world increasingly dominated by religion, they will have to take risks when and where they can. All museums should be as imaginative as the best are in using religious objects to tell stories about the human condition. As I write, London museums have had exhibitions about the Hajj, relics, ex-votos, amulets, Italian altarpieces, and John Martin's *Apocalypse* paintings. They are often trying hard not merely to put their displayed collections into their historic context, but to use them to challenge and engage with their audiences, and to ask questions of modern big-city society. Many of them are accompanied by highly imaginative events, for, as we have seen, much of the initiative in tackling religion, among the 'Big Issues', has been led by museum learning and outreach people. Such encouraging signs, in just one city at one time, suggest that museums are increasingly allowing objects to speak in a variety of different tongues. There is no limit to the possibilities for making religious objects speak to the day-to-day concerns

of every visitor, not just of those interested in history or who appreciate art. At a time when the relationship between money-making and morality are the subject of intense public debate, the Palazzo Strozzi in Florence recently staged an exhibition on Botticelli's relationship with his wealthy commissioners, and how he responded through his painting. The exhibition showed how the new generation of Florentine bankers manoeuvred their way around the Church's ban on usury, and used art both to demonstrate their orthodoxy and to suggest—for example, by clothing the Holy Family in sumptuous costume—that wealth was good (Parks 2006).

There has been a tendency in this book to focus on what Christopher Wingfield (2010: 53) has called 'charismatic' objects. But most religious objects in museums are not charismatic at all. They are the everyday objects that go to tell the story of religion and of the lives lived by religious communities of all sorts of shapes and conditions. In chapter eleven, we noted the collection of amulets displayed in the Cuming Museum in south London. Just down the Walworth Road is the new Salvation Army Museum which tells the story of another aspect of nineteenth- and twentieth-century working-class religion and culture. This museum, of course, is provided by the Salvation Army itself, just as the Museum of Methodism is provided by the Methodist Church, but they stand as a challenge to secular history museums to tackle the story of religion in their local communities. What is needed everywhere is museum-based research into the ways in which religion has actually been done, by local communities and individuals, and how that doing changed to reflect and to underpin economic and social change. There has been a tendency, in the UK at least, for history museums to be blind to most religion, noticing it only when it is a defining characteristic of an immigrant community. Moreover, when museums do, rarely, offer displays on religion locally, it is almost always 'official' religion that is presented. We need to build up collections that represent the changing story of local religious groups, and collections that represent the unofficial 'popular' religion at individual and family level.

Above all, religious objects in secular countries have a duty to help their visitors to understand what this 'religion' business is all about. Visiting an ancient temple or reading a newspaper report about a religious conflict or just negotiating the traffic outside a church on Sunday morning—all these can prompt in some people the reaction that all God-bothering is arrant nonsense, silly at best, dangerous at worst. Yet, if we are to understand the world we live in, we all must understand this religion business, for religion has played such a huge part in creating that world, and is still doing so today. We all must understand not only religious belief and practice, but also the religious impulse—what 'devout' feels like inside, what are the devotee's motives and how they explain those to themselves. Religious objects have a duty to help their visitors empathize with religious people; because so much of religion is done with objects, religious objects in museums have a unique responsibility to help visitors understand religion.

NOTES

Introduction

1. Compare, too, controversy over the sale of body parts or blood (Titmuss 1970; Sandel 2012).
2. While religious objects change their meaning when they enter a museum, ordinary, secular objects can take on a religious significance, even a sanctity, when they enter a religious context. In Ethiopia, even weapons, deposited in a church, can be refused permission to move across to a secular museum on the grounds that they have acquired a level of sanctity.
3. These include Sullivan and Edwards (2004), Bräunlein (2004), Claussen (2009), Beier-de-Haan and Jungblut (2010), and Roque (2011). See also the special issues on museums of *Material Religion*, 8/1 (March 2012), and of *The Journal of Religion in Europe*, 4/1 (2011), an issue that introduces recent German scholarship to an English-speaking audience.
4. Such as Michel (1999), Kamel (2004), Minucciani (2005), Wilke and Guggenmos (2008), Hughes and Wood (2010) and Lüpken (2010).
5. As this book goes to press, a special issue has been published on Museums and Religion.
6. Buchli (2002) offers a helpfully concise account of material culture studies in its more recent incarnation. Hicks (2010) gives a more detailed and perhaps critical account; see also Hicks's blog at http://weweremodern.blogspot.com/2010/05/material-culture-studies-introduction.html (Accessed November 2011).
7. http://www.columbia.edu/~sf2220/TT2007/web-content/Pages/syllabus.htm (Accessed October 2011).
8. Whitehead (2011) offers a helpful guide through the debate on religious materiality. I am most grateful to Amy Whitehead for allowing me access to her thesis.
9. Harvey offers a useful summary of how various thinkers over the past three centuries have viewed the relationship of people with things.

Chapter 1: Objects Curated

1. 'Curator' here is a convenient term for the whole museum team, which certainly includes curators, but in larger museums can also include managers, researchers, collections managers and registrars, exhibition, graphic and web designers, interpreters, lighting and A-V specialists, text-writers, display technicians, photographers, guides, learning officers,

publishers—not to mention all concerned with the building, from architects to mainte-
nance staff. All help to influence, if not to control, how the object speaks to the visitor.

2. A story often told about the great American showman P. T. Barnum has him concerned
that people were not passing quickly enough through the turnstiles of his museum. He
therefore put up a sign 'To the Egress', and visitors rushing to see this new attraction
found themselves out again on the street.

3. The British Museum's director said, 'We can't of course know how visitors approach the
objects on display in the British Museum, but many visitors surely still use the Holy
Thorn Reliquary for its original devotional purpose of contemplation and prayer' (Mac-
Gregor 2010: 430).

4. See, for example, Hall 2004, and the two principal relevant Codes of Ethics: Interna-
tional Council of Museums (http://icom.museum/what-we-do/professional-standards/
code-of-ethics.html. Accessed October 2011), and the Institute of Conservation (http://
www.icon.org.uk/index.php?option=com_content&task=view&id=121&Itemid=. Ac-
cessed October 2011).

5. Research Centre for Museums and Galleries, University of Leicester. *An Evaluation of
Sh[out]!—the Social Justice Programme of the Gallery of Modern Art, Glasgow, 2009–2010*.
2009.

Chapter 2: Objects Visited

1. See the useful summary in vom Lehn, Heath and Hindmarsh (2001).

2. Morgan (2005: 106) suggests that our approach to a religious image is governed by con-
tract, and lists nine such compacts: 'images will generate widely varying interpretations
and responses depending on the contractual conditions under which they are viewed.'

3. http://www.honour.org.uk/node (Accessed October 2011).

4. Yet the exhibition was very much an *art* exhibition. It may have been unusual in its title
and its emphasis on the religious iconography of the paintings, but the paintings were
presented as usual as works of art, not as the icons or liturgical tools many of them once
were. Moreover, the paintings were exactly the 'works of art' one would expect in the
National Gallery. Three-fifths were from the fifteenth to seventeenth centuries, only one
from the nineteenth, and the five from the twentieth were all by 'big name' artists. How
interesting it would be to hold an exhibition following the development of these images
in mass-produced and popular iconography.

5. Enthusiasm is similarly reported from an American exhibition, 'The Body of Christ', in
Houston, Texas, in 1997. 'Bless this museum and the wonderful people who brought this
exhibit together—it honors Jesus and Catholicism', was one among 200 pages of com-
ments in the visitors' book (Clifton 2007: 111).

6. I am grateful to Irna Qureshi for this account.

7. http://www.vam.ac.uk/collections/asia/asia_features/jainism/jain_views/index.html (Ac-
cessed February 2010).

8. 'Faith that is set in stone', *Times Online*, 14 August 2007.
9. www.meander.co.uk/british.php.
10. http://www.lsjs.ac.uk/programmes.asp?submID=382 (Accessed February 2010).
11. I am grateful to Nicola Abery for this information.

Chapter 3: Objects Worshipped and Worshipping

1. Wingfield (2009) sees the Sultanganj Buddha as one of a small class of 'charismatic' objects to which individuals, institutions and groups may seek to respond with co-option, iconoclasm or idolatry.
2. http://www.aucklandmuseum.com/156/world-war-1-sanctuary (Accessed April 2011).

Chapter 4: Objects Claimed

1. A helpful short summary of the debate over human remains in Britain is Carver 2011.
2. See the debate between Tiffany Jenkins and Mark O'Neill in *Material Religion: The Journal of Objects, Art and Belief*, 2/3, November 2006; and Jenkins 2010.
3. *The Daily Telegraph*, 17 April 2004.
4. http://www.amnh.org/rose/meteorite_agreement.html.
5. http://hermitagemuseum.org/html_En/02/hm2_6_0_84.html. See also Paine 2012.
6. I am grateful to Alison Brown for pointing me to this. See also Brown and Whitby-Last (forthcoming), Conaty (2008); Lokensgard (2010); and Zedeno (2008).
7. There is an entire literature on the construction of memory, and on how societies select and create the memories they use to create structure, meaning and power. Perhaps the most stimulating discussion remains that of the great Raphael Samuel (1994).

Chapter 5: Objects Respected

1. I am grateful to HH Judge David Taylor for this reference.
2. See the video at http://www.guardian.co.uk/artanddesign/2009/mar/24/british-museum-relics-discovery (Accessed February 2010).
3. See notably, 'Honouring the Ancient Dead' (http://www.icon.org.uk/index.php?option=com_content&task=view&id=121&Itemid=); but see also Jenkins 2010.

Chapter 6: Objects Demanding and Dangerous

1. www.theratanachurch.org.nz/history.html (Accessed March 2010).
2. I am grateful to Joan Navarre for discussion of some of these questions.
3. www.britishmuseum.org/research (Accessed March 2011).
4. I am grateful to Henry Brownrigg for drawing my attention to these traditions; see Heins 2004; and Jessup 1990.
5. www.apostolateforholyrelics.com/home.php (Accessed March 2011).

Chapter 7: Objects Elevating

1. Spira (1994) saw museum objects as the direct descendants of Christian relics, both gratifying a natural appetite for a sense of objective or innate value.
2. www.ruskinatwalkley.org (Accessed March 2011). It is, incidentally, fascinating to see how Ruskin's emphasis on beauty allowed him to display reproductions as happily as originals—an approach that sets him apart from the cult of the artist, and which parallels the tradition that sees copies as able to inherit the sanctity of their originals.
3. http://www.shumei.org/artandbeauty/artandbeauty_00.html (Accessed August 2010).
4. This does not mean that a work cannot also carry other meanings.
5. I am grateful to David Anderson for drawing attention to this point of view. The issue of museums as public space has attracted considerable discussion; see Barrett 2011.

Chapter 8: Objects Militant

1. I have published a slightly fuller account of these museums as Paine 2010b.
2. I am grateful to Alison-Louise Kahn for sight of this.
3. London Missionary Society 1826, quoted in Wingfield 2012. I am grateful to Chris Wingfield for sight of this.
4. We have seen (chapter five) that the Museum of the American Indian surrenders completely to a 'traditional' interpretation.
5. www.darwinproject.ac.uk/entry-3356 (Accessed March 2011).
6. See http://witchesinthemist.lefora.com/2009/02/10/cotswolds-witchcraft-in-the/ (Accessed February 2010).
7. *Milwaukee Journal*, 31 January 1981. Available at http://news.google.com/newspapers?nid=1499&dat=19810131&id=o24aAAAAIBAJ&sjid=wysEAAAAIBAJ&pg=5208,5292080 (Accessed September 2011). *Philadelphia Inquirer*, 22 June 1987. Available at http://articles.philly.com/1987–06–22/news/26183740_1_atheism-era-ends-religion (Accessed September 2011).
8. Occasionally, though, objects do attract real hatred, and these are almost always works of art, usually ones deliberately intended by the artist to provoke. We saw the examples of the annotated Bible (p. 24 above); more typical is the offence caused by such artists as Robert Mapplethorpe (Plate 2006).

Chapter 9: Objects Promotional

1. www.maitreyaproject.org.
2. http://www.holylandexperience.com/ (Accessed February 2010). See also Wharton (2006).
3. Julie Mott-Hardin, *pers com*.
4. http://www.livingbiblemuseum.org/ (Accessed February 2010).
5. http://khalsaheritagecomplex.org/khc.html (Accessed February 2010).

6. I am grateful to Kathrin Pieren for this point, and for discussion of this question generally.
7. Improbable objects can also appear in a more purely religious context. The church of the Gesu Nuovo in Naples preserves many personal possessions of Saint Giussepe Moscati—including an Edinburgh tram ticket.
8. It is a pity that Knock Museum does not put the 'apparition' into its iconographic context as it does into its political context. The increasing availability of steel engravings and lithographs of religious subjects, and of plaster statues, had by the 1870s given the Catholic laity a whole new visual vocabulary. The museum's audio-guide points out that some of the apparition witnesses were able to recognize St John because they had seen his statue in a church visited on holiday. It would be good to see contemporary images that perhaps influenced the forms in which the apparition was received.
9. The latest such development is the proposal for a Museum of American Religion, linked to a Ladies Golf Club in a gated community in Florida. Its purpose is 'to bring interfaith understanding, mutual tolerance and common interest cooperation between the Abrahamic religions'. It already holds an impressive collection of nineteenth-century Catholic material. www.americanmuseumofreligion.org (Accessed March 2011).

Chapter 10: Objects Explanatory and Evidential

1. Lovett published an illuminating comment on the challenges of collecting: 'The collector in search of folk-beliefs and articles connected with them meets with far more difficulties than the collector of old china or other merely material objects. The objections to giving him information arise from a double set of motives, those of the ardent believer who will not expose sacred things to an outsider, and those of the unbeliever who refuses information about what he considers to be degrading superstitions or discreditable survivals' (Lovett 1909: 227, quoted on the Pitt Rivers Museum website, http://england.prm.ox.ac.uk/englishness-Edward-Lovett.html. Accessed August 2010.) The ninety amulets he gave to the Cuming Museum in Southwark can be seen on that museum's website.
2. http://england.prm.ox.ac.uk/englishness-Edward-Lovett.html.
3. http://england.prm.ox.ac.uk/englishness-tylors-onion.html.
4. As early as 1856, the Königliche Gemäldegalerie in Dresden displayed Raphael's altarpiece the *Sistine Madonna* in an altar-like setting (Henning 2011: 181).
5. This video can be seen at http://www.seattleartmuseum.org/exhibit/exhibitDetail.asp?eventID=4442.
6. But see Gretchen Buggeln's (2010) account of just such a performance at Colonial Williamsburg.
7. http://www.chichestercathedral.org.uk/dyn/pages/education/education.shtml.
8. Yet, these have given rise to some controversy. The US Holocaust Memorial Museum in Washington has been criticized by some Jews as encouraging a quite un-Jewish prolongation of mourning, and has even been called 'Catholic' in its approach, the progress of the visitor from display to display being compared to the progress of the devotee past

the Stations of the Cross, and the choosing of evocative and emotive objects—the piles of shoes, the hair of victims—being too like the veneration of relics (McKeown 2007).

9. Peter Evans, *pers. com.*
10. http://www.virtualmuseum.ca/Exhibitions/Annodomini/entrance-en.html.

Chapter 11: Conclusion

1. Which is not to assume that mutual familiarity and understanding necessarily leads to mutual love and respect. The Balkan wars showed how easily a community can come to demonize as the Other people who were previously neighbours and friends.
2. By BBC journalist John Wilson, among, no doubt, many others.

REFERENCES

Ackerman, D. (1995), *A Natural History of Love*, New York: Vintage Books.

Altick, Richard D. (1978), *The Shows of London*, Cambridge: Harvard UP.

Ambrose, Timothy, and Paine, Crispin ([1993] 2012), *Museum Basics*, 3rd ed., Abingdon: Routledge.

Apostolos-Cappadona, Diane (2006a), 'Vatican Museum: Collection of Religious Art', *Material Religion: The Journal of Objects, Art and Faith*, 2/2, 251–3.

Apostolos-Cappadona, Diane (2006b), 'Saint Louis University Museum of Contemporary Religious Art', *Material Religion:The Journal of Objects, Art and Religion*, 2/3, 393–4.

Arthur, Chris (2000), 'Exhibiting the Sacred', in Crispin Paine (ed.), *Godly Things: Museums, Objects and Religion*, London: Routledge.

Asma, Stephen T. (2001), *Stuffed Animals and Pickled Heads: The Culture and Evolution of Natural History Museums*, New York: Oxford University Press.

Baker, Paul, and Adshead, David (2008), 'And God Saw That It Was Good: More Than a Curiosity: James Bateman's Biddulph and the Rock of Ages', *National Trust Arts, Buildings & Collections Bulletin* Summer, 3–4, http://www.nationaltrust.org.uk/main/w-abc-summer08.pdf.

Barrett, Jennifer (2011), *Museums and the Public Sphere*, Chichester: Wiley-Blackwell.

Bate, Jonathan (2011), *The Public Value of the Humanities*, London: Bloomsbury.

bdrc (2009), *Research into Issues Surrounding Human Bones in Museums*, report for English Heritage, http://www.english-heritage.org.uk/server/show/nav.19819, accessed April 2010.

Beier-de-Haan, Rosemarie, and Jungblut, Marie-Paule (eds) (2010), *Museums and Faith*, Luxembourg: Musée d'Histoire de la Ville de Luxembourg.

Benjamin, Walter (1973), 'The Work of Art in the Age of Mechanical Reproduction', in Walter Benjamin, *Illuminations, Essays and Reflections*, London: Fontana Press.

Bennett, Tony (1995), *The Birth of the Museum: History, Theory, Politics*, London: Routledge.

Bharadia, Seema (1999), *The Return of Blackfoot Sacred Material by Museums of Southern Alberta*, MA thesis, Department of Anthropology, Calgary, Alberta.

Blain, J., and Wallis, R. J. (2008), 'Sacred, Secular, or Sacrilegious? Prehistoric Sites, Pagans and the Sacred Sites Project in Britain,' in J. Schachter and S. Brockman (eds), *(Im)permanence: Cultures In/Out of Time*, Pittsburg: Penn State University Press.

Blayre, Christopher [Edward Heron-Allen] (1921), *The Purple Sapphire and Other Posthumous Papers*, London: Philip Allan, http://www.horrormasters.com/Collections/SS_Col_Blayre.htm.

Bolton, Lissant (2008), 'The Object in View: Aborigines, Melanesians, and Museums', in Alan Rumsey and James F. Weiner (eds), *Emplaced Myth: Space, Narrative, and Knowledge in Aboriginal Australia and Papua New Guinea*, Honolulu: University of Hawai'i Press.

Branham, Joan (1994/1995), 'Sacrality and Aura in the Museum: Mute Objects and Articulate Space', *The Journal of the Walters Art Gallery*, 52/53.

Branham, Joan (2008), 'The Temple That Won't Quit: Constructing Sacred Space in Orlando's Holy Land Experience Theme Park', *Harvard Divinity Bulletin*, Autumn.

Bransford, John D., Brown, Ann L., and Cocking, Rodney R. (eds) (2000), *How People Learn: Brain, Mind, Experience, and School*, Washington: National Academy Press.

Bräunlein, Peter J. (ed.) (2004), *Religion und Museum: zur Visuellen Repräsentation von Religion/en im Öffentlichen Raum*, Bielefeld: Transcript.

Bräunlein, Peter J. (2005), 'The Marburg Museum of Religions', *Material Religion: The Journal of Objects, Art and Belief*, 1/2, 285–287.

Brennan, Marcia (2010), *Curating Consciousness: Mysticism and the Modern Museum*, Cambridge, MA: MIT Press.

Brooks, Mary (2004), *English Embroideries of the Sixteenth and Seventeenth Centuries in the Collection of the Ashmolean Museum*, Ashmolean Handbooks, Oxford: Ashmolean Museum.

Brown, Alison, and Whitby-Last, Kathryn (eds) (forthcoming), *Obstacles and Solutions to the Repatriation of Sacred-Ceremonial Objects to their Indigenous Owners*, Report of a conference held at the University of Aberdeen, February 2010, Aberdeen: University of Aberdeen.

Buchli, Victor (ed.) ([2002] 2007), *The Material Culture Reader*, Oxford: Berg.

Buckley, Anthony D. (2000), 'Religion, Ethnicity and the Human Condition: A View from a Northern Ireland Museum', in Crispin Paine (ed.), *Godly Things: Museums, Objects and Religion*, London: Routledge.

Buggeln, Gretchen (2010), 'Remarks on the Recent Interpretation of Religion at American History Museums', in Rosemarie Beier-de-Haan and Marie-Paule Jungblut (eds), *Museums and Faith*, Luxembourg: Museé d'Histoire de la Ville de Luxembourg.

Campbell, Alison (2007), *Instigating Change: Investigating the Meaning(s) of Religious Objects in St Mungo Museum of Religious Life and Art*, MA thesis, University of Alberta, Edmonton, Canada.

Cannizzo, Jeanne (1998), 'Gathering Souls and Objects: Missionary Collections', in Tim Barringer and Tom Flynn (eds), *Colonialism and the Object: Empire, Material Culture and the Museum*, London: Routledge.

Caple, Chris (2000), *Conservation Skills: Judgement, Method and Decision Making*, London: Routledge.

Carrier, David (2006), *Museum Skepticism: a History of the Display of Art in Public Galleries*, Durham & London: Duke University Press.

Carver, Emma (2011), 'The Public Display of Excavated Human Remains', *Conservation Bulletin*, 66 (September), 11–13.

Caygill, Marjorie (1985), *Treasures of the British Museum*, New York: Harry N. Abrams Publishers.

Chatterjee, H. J. (ed.) (2008), *Touch in Museums: Policy and Practice in Object Handling*, Oxford: Berg.

Chin, Karen (2010), 'Seeing Religion with New Eyes at the Asian Civilisations Museum', *Material Religion: The Journal of Objects, Art and Religion*, 6/2, 193–216.

Church of England/English Heritage (2005), *Guidance for Best Practice for Treatment of Human Remains Excavated from Christian Burial Grounds in England*, London: English Heritage.

Clarke, John (2009), 'The Robert H. N. Ho Family Foundation Gallery of Buddhist Sculpture', *Orientations*, May.

Claussen, Susanne (2009) *Anschauungsache Religion: zur Musealen Repräsentation Religiöser Artefakte*, Bielefeld: Transcript.

Clavir, Miriam (2002), *Preserving What Is Valued: Museums, Conservation and First Nations*, Vancouver: UBC Press.

Clifton, James (2007), 'Truly a Worship Experience? Christian Art in Secular Museums', *Museums—Crossing Boundaries, Res 52*, Autumn.

Conaty, Gerry (2008), 'The Effects of Repatriation on the Relationship between the Glenbow Museum and the Blackfoot People', *Museum Management and Curatorship*, 23/3, 245–59.

Corbey, Raymond (2000a), 'Arts Premiers in the Louvre', *Anthropology Today*, 16 (August), 4.

Corbey, Raymond (2000b), *Tribal Art Traffic: A Chronicle of Taste, Trade and Desire in XColonial and Post-Colonial Times*, Amsterdam: Royal Tropical Institute.

Cuisenier, Jean, and de Tricornot, Marie-Chantal (1987), *Musée National des Arts et Traditions Populaires: Guide,* Paris: Réunion des Musées Nationaux.

Curtis, Neil G. W. (2003), 'Human Remains: the Sacred, Museums and Archaeology', *Public Archaeology*, 3, 21–32.

da Silva, Neysela. (n.d.), *Religious Displays: An Observational Study with a focus on the Horniman Museum*, MA Dissertation, Institute of Education, University of London.

Dalrymple, William (2009), *Nine Lives: in Search of the Sacred in Modern India*, London: Bloomsbury.

Davie, Grace (1997), 'Christian Belief in Modern Britain: the Tradition Becomes Vicarious', in Stephen Platten et al., *New Soundings: Essays on Developing Tradition*, London: Darton, Longman and Todd.

Davie, Grace (2003), 'Seeing Salvation: the Use of Text as Data in the Sociology of Religion', in Paul Avis (ed.), *Public Faith?: The State of Religious Belief and Practice in Britain*, London: SPCK.

Davis, Peter (2004), 'Ecomuseums and the Democratisation of Japanese Museology', *International Journal of Heritage Studies*, 10/1.

Davis, Richard H. (1997), *Lives of Indian Images*, Princeton, NJ: Princeton University Press.

Davis, Richard H. (2009), 'The Dancing Shiva of Shivapuram: Cult and Exhibition in the Life of an Indian Icon', in Amanda Millay Hughes and Carolyn H. Wood, *A Place for Meaning: Art, Faith, and Museum Culture*, Chapel Hill, NC: Ackland Art Museum.

Day, Jasmine (2006), *The Mummy's Curse: Mummymania in the English-Speaking World*, London: Routledge.

de Botton, Alain (2011), 'A Point of View: Why Are Museums So Uninspiring?', *BBC News Magazine*, 28 January, http://www.bbc.co.uk/news/magazine-12308952, accessed March 2011.

Dillon, Robin S. (2007), 'Respect', in Edward N. Zalta (ed.), *The Stanford Encyclopedia of Philosophy*, http://plato.stanford.edu/entries/respect, accessed March 2009.

Drumheller, Ann, and Kaminitz, Marian (1994), 'Traditional Care and Conservation, the Merging of Two Disciplines at the National Museum of the American Indian', in Ashok Roy and Perry Smith, *Preventive Conservation Practice, Theory and Research*, Preprints of the Contributions to the Ottawa Congress, 12–16 September 1994, London: International Institute for Conservation of Historic and Artistic Works.

Duncan, Carol (1995), *Civilizing Rituals: Inside Public Art Museums*, Routledge: New York.

Duah, Francis Boakye (1995), 'Community Initiative and National Support at the Asante Cultural Centre', in Claude Daniel Ardouin and Emmanual Arinze (eds), *Museums and the Community in West Africa*, Washington: Smithsonian Institution Press.

Dubois, Henri (1926), *L'Exhibition Missionaire*, Vatican City, unpublished.

Durbin, Gail, Morris, Susan, and Wilkinson, Sue (1990), *A Teacher's Guide to Learning from Objects*, London: English Heritage.

Elkins, James (2004), *On the Strange Place of Religion in Contemporary Art*, New York & London: Routledge.

Elliott, Mark (2006), 'Side Effects: Looking, Touching, and Interacting in the Indian Museum, Kolkata', *Journal of Museum Ethnography*, 18.

Evans, E. Margaret, Mull, Melinda S., and Poling, Devereaux A. (2002), 'The Authentic Object? A Child's-Eye View', in Scott G. Paris, *Perspectives on Object-Centered Learning in Museums*, Mahwah, NJ: Lawrence Erlbaum Associates.

Fakatseli, Olga, and Sachs, Julia (2008), *The Jameel Gallery of Islamic Middle East: Summative Evaluation Report*, London: Victoria and Albert Museum, at www.vam.ac.uk/files/file_upload/47897_file.pdf, accessed March 2010.

Falk, John H. (2009), *Identity and the Museum Visitor Experience*, Walnut Creek, CA: Left Coast Press.

Farrar, Steve (2007), 'Out of the Cupboard and Calling to You: The Cursed Delhi Purple Sapphire', *The Sunday Times*, 25 November.

Finucane, Ronald C. (1977) *Miracles and Pilgrims: Popular Beliefs in Medieval England*, London: J. M. Dent.

Fisher, Philip (1997), *Making and Effacing Art: Modern American Art in a Culture of Museums*, Cambridge, MA: Harvard University Press.

Fülöp-Miller, René (1927), *The Mind and Face of Bolshevism: an Examination of Cultural Life in Soviet Russia*, London: G. P. Putnam's Sons.

Gaskell, Ivan (2003), 'Sacred to Profane and Back Again', in Andrew McClellan (ed.), *Art and its Publics: Museum Studies at the Millennium*, Oxford: Blackwell.

Gell, Alfred (1998), *Art and Agency: an Anthropological Theory*, Oxford: Clarendon Press.

Gerstenfeld, Manfred (1999), 'Neo-Paganism in the Public Square and its Relevance to Judaism', *Jewish Political Studies Review*, 11, 3–4.

Goa, David J. (2012), 'The Gifts and Challenges of Anno Domini', *Material Religion: The Journal of Objects, Art and Belief*, 8/1.

Goa, David (n.d.), 'The Spiritual Geography of *Anno Domini*', *Watershed Online*, http://watershedonline.ca/community/spiritualgeography.html, accessed April 2010.

Gosden, Chris, and Larson, Frances (2007), *Knowing Things: Exploring the Collections at the Pitt Rivers Museum 1884–1945*, Oxford: OUP.

Greene, Virginia (1992), ' "Accessories of Holiness": Defining Jewish Sacred Objects', *Journal of the American Institute for Conservation*, 31/1.

Grimes, Ronald L. (1992), 'Sacred Objects in Museum Spaces', *Studies in Religion / Sciences Religieuses*, 21/4, 419–30.

Grimes, Ronald L. (2011), 'Ritual', *Material Religion: The Journal of Objects, Art and Belief*, 7/1, 77–83.

Guha-Thakurta, Tapati (2007), ' "Our Gods, Their Museums": The Contrary Careers of India's Art Objects', *Art History*, 30/4.

Guse, Daryl (2005), *A Tale of Two Gorges: Wagiman Rock Art and Sacred Places in the Northern Territory, Australia and Maryland, USA*, Presentation for the Australian Archaeology Association Annual Conference, Fremantle, Western Australia, unpublished.

Hall, Annie (2004), 'A Case Study on the Ethical Considerations for an Intervention upon a Tibetan Religious Sculpture', *The Conservator*, 28.

Harvey, Graham (2006), *Animism: Respecting the Living World*, New York: Columbia University Press.

Heins, Marleen (ed.) (2004), *Karaton Surakarta*, Jakarta: Yayasan Pawiyatan Kabudayan Karaton Surakarta.

Henning, Andreas (2011), 'From Sacred to Profane Cult Image: On the Display of Raphael's *Sistine Madonna* in Dresden', in Gail Feigenbaum and Sybille Ebert-Schifferer (eds), *Sacred Possessions: Collecting Italian Religious Art 1500–1900*, Los Angeles: Getty Research Institute.

Herle, Anita (1994), 'Museums and Shamans: a Cross-Cultural Collaboration', *Anthropology Today*, 10/1, 2–5.

Hicks, Dan (2010) 'The Material-Cultural Turn: Event and Effect', in D. Hicks and M. Beaudry (eds), *The Oxford Handbook of Material Cultural Studies*, Oxford and New York: OUP, 25–98.

Hill, Jude (2007), 'The Story of the Amulet: Locating the Enchantment of Collections', *Journal of Material Culture*, 12.

Holden, John (2004), *Capturing Cultural Value: How Culture has Become a Tool of Government Policy*, London: DEMOS.

Holdsworth, Chris (2004), 'Tylor, Sir Edward Burnett (1832–1917)', in H. C. G. Matthew and Brian Harrison (eds), *Oxford Dictionary of National Biography*, Oxford: OUP, http://www.oxforddnb.com/view/article/36602, accessed September 2010.

Hooper-Greenhill, Eilean (1992), *Museums and the Shaping of Knowledge*, London: Routledge.

Howes, Graham (2007), *The Art of the Sacred: An Introduction to the Aesthetics of Art and Belief*, London: I. B. Tauris.

Hudson, Kenneth (1987), *Museums of Influence*, Cambridge: Cambridge University Press.

Hughes, Amanda M., and Wood, Carolyn H. (2010), *A Place for Meaning: Art, Faith, and Museum Culture*, Chapel Hill, NC: University of North Carolina Press.

Isaac, Gwyneira (2007), *Mediating Knowledges: Origins of a Zuni Tribal Museum*, Tucson: University of Arizona Press.

James, Heather F., Henderson, Isabel, Foster, Sally M., and Jones, Siân (2008), *A Fragmented Masterpiece: Recovering the Biography of the Hilton of Cadboll Pictish Cross-slab*, Edinburgh: Society of Antiquaries of Scotland.

Jenkins, Philip (2005), 'The Antimuseum', *The Christian Century*, 8 February.

Jenkins, Tiffany (2010), *Contesting Human Remains in Museum Collections: The Crisis of Cultural Authority*, Routledge Research in Museum Studies, London: Routledge.

Jessup, Helen Ibbitson (1990), *Court Arts of Indonesia*, New York: The Asia Society Galleries.

Jolles, Adam (2005), 'Stalin's Talking Museums', *Oxford Art Journal*, 28/3, 430–55.

Jones, Siân (2004), *Early Medieval Sculpture and the Production of Meaning, Value and Place: the Case of Hilton of Cadboll*, Research Report, Edinburgh: Historic Scotland.

Kahn, Alison-Louise (2011), *The Politics and Ideologies Behind the Pontifical Missionary Exhibition in the Vatican in 1925*, Unpublished paper.

Kamel, Susan (2004), *Wege zur Vermittlung von Religionen in Berliner Museen*, Wiesbaden: VS Verlag für Sozialwissenschaft [Studies of the Museum für Islamische Kunst, Berlin, the Museum für Europäische Kulturen, Berlin, and St. Mungo Museum of Religious Life and Art, Glasgow].

Kavanagh, Gaynor (2000), *Dream Spaces: Memory and the Museum*, London: Leicester University Press.

Kaye, M. M. (ed.) (1980), *The Golden Calm: An English Lady's Life in Moghul Delhi*, Exeter: Webb & Bower.

Knell, Simon (ed.) (2007), *Museums in the Material World*, Leicester Readers in Museum Studies, London: Routledge.

Kopytoff, Igor (1988), 'The Cultural Biography of Things: Commoditization as Process', in Arjun Appadurai (ed.), *The Social Life of Things: Commodities in Cultural Perspective*, New York: Cambridge University Press.

Koven, Seth (1994), 'The Whitechapel Picture Exhibitions and the Politics of Seeing', in Daniel J. Sherman and Irit Rogoff (eds), *Museum Culture: Histories, Discourses, Spectacles*, Minneapolis: University of Minnesota Press.

van Kraayenoord, Christina E., and Paris, Scott G. (2002), 'Reading Objects', in Scott G. Paris, *Perspectives on Object-Centered Learning in Museums*, Mahwah, NJ: Lawrence Erlbaum Associates.

Larson, Frances (2010), *An Infinity of Things: How Sir Henry Wellcome Collected the World*, Oxford: Oxford University Press.

Leahy, Helen Rees (2008), 'Museé Internationale de la Réforme, Geneva', *Material Religion: The Journal of Objects, Art and Belief*, 4/2.

Litten, Julian W. S. (1997), 'Relics and Reliquaries in a National Collection', *Mortality*, 2/3, 273–75.

Lokensgard, Kenneth Hayes (2010), *Blackfoot Religion and the Consequences of Cultural Commoditization*, Vitality of Indigenous Religions Series, Farnham: Ashgate.

Long, Elizabeth (2007), *In the Right Spirit? The Representation and Interpretation of Christianity in Museums*, MA Dissertation, University of Leicester.

Lovett, E. (1909), 'Difficulties of a Folklore Collector', *Folklore*, 20/2, 227–8.

Luckhurst, Roger (2010), 'The Mummy's Curse: a Study in Rumour', *Critical Quarterly*, 52, 6–22.

Lüpken, Anja (2010), *Religion(en) im Museum: eine vergleichende Analyse der Religionsmuseen in St. Petersburg, Glasgow und Taipeh*, Duits: Lit Verlag.

MacGregor, Neil (2010), *A History of the World in 100 Objects*, London: Allen Lane.

Magar, Valerie (2005), 'Conserving Religious Heritage within Communities in Mexico', in H. Stovel, N. Stanley-Price and R. Killick (eds), *Conservation of Living Religious Heritage: Papers from the ICCROM 2003 Forum on Living Religious Heritage, Conserving the Sacred*, Rome: ICCROM.

Maggen, Michael (2005), 'The Conservation of Sacred Materials in the Israel Museum', in H. Stovel, N. Stanley-Price and R. Killick (eds), *Conservation of Living Religious Heritage: Papers from the ICCROM 2003 Forum on Living Religious Heritage, Conserving the Sacred*, Rome: ICCROM.

Marx, Karl (1965 [1887]), *Capital: A Critique of Political Economy*, Moscow: Progress Publishers; London: Lawrence and Wishart.

McKeown, Elizabeth (2007), 'Religion and Museums on the National Mall', *Religion and Culture Web Forum*, November.

McLellan, Andrew (1999), *Inventing the Louvre: Art, Politics and the Origins of the Modern Museum in Eighteenth Century Paris*, Berkeley: University of California Press.

Martel, René (1933), *Le Mouvement Antireligieux en URSS (1917–1932)*, Paris: Marcel Rivière.

Mauss, Marcel (1990 [1922]), *The Gift: Forms and Functions of Exchange in Archaic Societies*, London: Routledge.

Mellor, Stephen P. (1992), 'The Exhibition and Conservation of African Objects: Considering the Nontangible', *Journal of the American Institute for Conservation*, 31/1, 3–16.

Merriman, N. (1991), *Beyond The Glass Case: The Past, the Heritage and the Public in Britain*, Leicester: Leicester University Press.

Michel, Patrick (1999), *La Religion au Musée: Croire dans l'Europe Contemporaine*, Paris: L'Harmattan.

Miller, J. D., Scott, E. C., and Okamoto, S. (2006), 'Public Acceptance of Evolution', *Science*, New Series 313/5788, 765–66.

Minucciani, Valeria (2005), *Musei fra Immanenza e Trascendenza: Esposizioni e Raccolte di Arte Sacra e Beni Culturali Religiosi in Piemonte e Valle d'Aosta*, Milan: Edizioni Lybra Immagine.

Mitchell, W. J. T. (2005), *What Do Pictures Want? The Lives and Loves of Images*, Chicago: University of Chicago Press.

Morgan, David (2005), *The Sacred Gaze: Religious Visual Culture in Theory and Practice*, Berkeley: University of California Press.

Morris, Bernice, and Brooks, Mary (2006), 'Jewish Ceremonial Textiles and the Torah: Exploring Conservation Practices in Relation to Ritual Textiles Associated with Holy Texts', in Maria Hayward and Elizabeth Kramer (eds), *Textiles and Text: Re-establishing the Links between Archival and Object-based Research*, Postprints of the AHRC Research Centre for Textile Conservation and Textile Studies, 3rd Annual Conference 11–13 July 2006, Archetype Publications.

Moussouri, Theano, and Fritsch, Juliette (2004), *Jameel Gallery of Islamic Art: Front-end Evaluation Report*, Victoria and Albert Museum, at www.vam.ac.uk/files/file_upload/17175_file.pdf, accessed March 2010.

Musin, Aleksandr E. (2010), *Christian Antiquities in Modern Russia: Russian Orthodox Church and the Cultural Heritage of Russia at the Turn of Millennium* [In Russian with short English summary], Saint Petersburg.

Nelson, Victoria (2001), *The Secret Life of Puppets*, Cambridge, MA: Harvard University Press.

O'Neill, Mark (1995), 'Exploring the Meaning of Life: the St Mungo Museum of Religious Life and Art', *Museum International*, 185.

O'Neill, Mark (2008), 'Museums, Professionalism and Democracy', *Cultural Trends*, 17/4, 289–307.

O'Neill, Mark (2010), 'SHCG: a Community of Practice Based on Empathy and Rigour', *Social History in Museums*, 34.

O'Neill, Mark (2011), 'Religion and Cultural Policy: Two Museum Studies', *International Journal of Cultural Policy*, 17/2, 225–43.

Otto, Rudolph (1928), *The Idea of the Holy: an Inquiry into the Non-Rational Factor in the Idea of the Divine and its Relation to the Rational*, translated by John Harvey, London: OUP.

Paine, Crispin (2000), 'Religion in London's Museums', in Crispin Paine (ed.), *Godly Things: Museums, Objects and Religion*, London: Leicester University Press.

Paine, Crispin (2010a) 'Museums and Religion: a Quick Overview', in Rosemarie Beier-de-Haan and Marie-Paule Jungblut (eds), *Museums and Faith*, Luxembourg: Museé d'Histoire de la Ville de Luxembourg.

Paine, Crispin (2010b), 'Militant Atheist Objects: Anti-Religion Museums in the Soviet Union', *Present Pasts*, 1, http://www.presentpasts.info/article/view/10/18.

Paine, Crispin (2012), 'Money, Power, Holiness and Heritage in Russia', *Material Religion: The Journal of Objects, Art and Belief*, 8/2, 265–7.

Paris, Scott G. (2002), *Perspectives on Object-Centered Learning in Museums*, Mahwah, NJ: Lawrence Erlbaum Associates.

Parker, T. (2004), 'A Hindu Shrine at Brighton Museum', *Journal of Museum Ethnography*, 16.

Parks, Tim (2006), *Medici Money: Banking, Metaphysics and Art in Fifteenth-Century Florence*, London: Profile Books.

Pearce, Susan M. (1992), *Museums, Objects and Collections*, London: Leicester University Press.

Pieren, Kathrin (2010), 'Negotiating Jewish Identity through the Display of Art', *Jewish Culture and History*, 12/1–2, 281–96.

Plate, Brent (2006), *Blasphemy: Art That Offends*, London: Black Dog Publishing.

Poulter, Emma K. (2007), 'Connecting Histories: Gelede Masks at the Manchester Museum', *Museological Review*, 12.

Powell, David E. (1975), *Antireligious Propaganda in the Soviet Union: A Study of Mass Persuasion*, Cambridge: MIT Press.

Price, Mary Sue Sweeney (2004), 'Embracing the Spiritual at the Newark Museum', in Lawrence E. Sullivan and Alison Edwards (eds), *Stewards of the Sacred*, Washington: American Association of Museums.

Price, Sally (2007), *Paris Primitive: Jacques Chirac's Museum on the Quai Branly*, Chicago: University of Chicago Press.

Pye, E. (2007), *The Power of Touch: Handling Objects in Museums and Heritage Contexts*, Walnut Creek, CA: Left Coast Press.

Reedy, Chandra L. (1992), 'Religious and Ethical Issues in the Study and Conservation of Tibetan Sculpture', *Journal of the American Institute for Conservation*, 31/1.

Richmond, Alison (2005), 'The Ethics Checklist—Ten Years On', *Conservation Journal Online*, 50, at http://www.vam.ac.uk/res_cons/conservation/journal/number_50/ethics/index.html, accessed March 2010.

Robson, James (2010), 'Faith in Museums: on the Confluence of Museums and Religious Sites in Asia', *Proceedings of the Modern Languages Association of America*, 125, 1.

Roque, Maria Isabel (2011), *O Sagrado no Museu*, Lisbon: Universidade Católica Editora.

Royal, Jean-Francois (2007), 'Protecting and Interpreting Quebec's Religious Heritage: the Museum of Religions at Nicolet', *Material Religion: The Journal of Objects, Art and Belief*, 3/1.

Russell, Roslyn, and Winkworth, Kylie (2009), *Significance 2.0: A Guide to Assessing the Significance of Collections*, Canberra: Collections Council of Australia.

Sadongei, Alyce (2004), 'What About Sacred Objects?', in Sherelyn Ogden (ed.), *Caring for American Indian Objects: A Practical and Cultural Guide*, St Paul, MN: Minnesota Historical Society.

Samuel, Raphael (1994), *Theatres of Memory, vol. 1: Past and Present in Contemporary Culture*, London and New York: Verso.

Sandell, M. J. (2012), *What Money Can't Buy: the Moral Limits of Markets*, New York: Farrer, Straus and Giroux.

Sandell, Richard (2006), *Museums, Prejudice and the Reframing of Difference*, London: Routledge.

Segadika, Philip (2008), 'The Botswana National Museum and Tsdilo World Heritage Site Museum', in Paul Voogt (ed.), *Can We Make a Difference? Museums, Society and Development in North and South*, Tropenmuseum Bulletin 387, Amsterdam: KIT Publishers.

Seton, Rosemary (2012), 'Reconstructing the Museum of the London Missionary Society', *Material Religion: The Journal of Objects, Art and Belief*, 8/1, 98–102.

Shaw, Wendy M. K. (2002), 'Tra(ve)ils of Secularism: Islam in Museums from the Ottoman Empire to the Turkish Republic', in Derek R. Peterson and Darren R. Walhof (eds), *The Invention of Religion: Rethinking Belief in Politics and History*, New Brunswick: Rutgers University Press.

Shaw, Wendy M. K. (2010), 'Between the Secular and the Sacred: A New Face for the Department of the Holy Relics at the Topkapı Palace Museum', *Material Religion: The Journal of Objects, Art and Belief*, 6/1.

Sherman, Daniel J. (1994), 'Quatremere/Benjamin/Marx: Art Museums, Aura and Commodity Fetishism', in Daniel J. Sherman and Irit Rostoff (eds), *Museum Culture: Histories, Discourses, Spectacles*, Minneapolis, MN: University of Minnesota.

Siegal, Jonah (2008), *The Emergence of the Modern Museum: an Anthology of Nineteenth-Century Sources*, Oxford: OUP.

Simpson, Moira (1998), 'The Sacred and the Profane: the Need for Sensitivity in Using Ethnographic Resources in Education', *Journal of Museum Ethnography*, 10.

Simpson, Moira (2002), *Culturally Sensitive Material in North-East Museum Collections: An Initial Review*, Confidential report commissioned by the North-east Museums, Libraries and Archives Council.

Singh, Kavita (2010), 'Repatriation Without *Patria*: Repatriating for Tibet', *Journal of Material Culture*, 15/2.

Smart, Pamela (2010), *Sacred Modern: Faith, Activism, and Aesthetics in the Menil Collection*, Austin: University of Texas.

Smith, Jonathan (2005), 'To Take Place', in G. Harvey (ed.), *Ritual and Religious Belief: A Reader*, London: Equinox, 26–50.

Sofer, Andrew (2003), *The Stage Life of Props*, Ann Arbor, MI: University of Michigan Press.

Spira, Andrew (1994), *Sacred Art and Culture in Museums*, MA Dissertation, Museum and Gallery Management, City University, London.

Stalker, Nancy (2003), 'Art and the New Religions: From Deguchi Onisaburo to the Miho Museum', *Japanese Religions*, 28/2, 155–66.

Stovel, Herb, Stanley-Price, Nicholas, and Killick, Robert (eds) (2005), *Conservation of Living Religious Heritage: Papers from the ICCROM 2003 Forum on Living Religious Heritage: Conserving the Sacred*, Rome: ICCROM.

Stumpf-Condry, C. and Skedd, S. J. (2004), 'Knight, Richard Payne (1751–1824)', in H. C. G. Matthew and Brian Harrison (eds), *Oxford Dictionary of National Biography*, Oxford: OUP. Online ed., edited by Lawrence Goldman, May 2006, at http://www.oxforddnb.com/view/article/15733, accessed May 12, 2011.

Sullivan, Lawrence E., and Edwards, Alison (2004), *Stewards of the Sacred*, Washington: American Association of Museums.

Suzuki, Yui (2007), 'Temple as Museum, Buddha as Art: Horyuji's *Kudara Kannon* and Its Great Treasure Repository', *Museums—Crossing Boundaries, Res*, 52.

Tait, Simon (1989), *Palaces of Discovery: the Changing World of Britain's Museums*, London: Quiller Press.

Titmuss, Richard M. (1970), *The Gift Relationship: From Human Blood to Social Policy*, London: Allen & Unwin.

Tribe, Tania Costa (2000), 'Candomblé Shrines', in Karel Arnaut (ed.), *Re-visions: New Perspectives on the African Collections of the Horniman Museum*, London: Horniman Museum Press.

Turner, Kay (1999), *Beautiful Necessity: The Art and Meaning of Women's Altars,* New York: Thames & Hudson.

van der Meer, Michaël N. (2010), 'The Biblical Museum Amsterdam', *Material Religion: The Journal of Objects, Art and Belief,* 6/1, 132–5.

Van Huy, Nguyen (2008), 'The One-Eyed God at the Vietnam Museum of Ethnology: The Story of a Village Conflict', *Asian Ethnology*, 67/2, 201–18.

Vergo, Peter (ed.) (1989), *The New Museology*, London: Reaktion Books.

vom Lehn, Dirk (2008), *Examining 'Response': Video-based Studies in Museums and Galleries*, http://kcl.academia.edu/DirkvomLehn/Papers/187480/Examining_Response_Video-based_Studies_in_Museums_and_Galleries, accessed November 2011.

vom Lehn, Dirk, Heath, Christian, and Hindmarsh, Jon (2001), 'Exhibiting Interaction: Conduct and Collaboration in Museums and Galleries', *Symbolic Interaction*, 24/2, 189–216, http://kcl.academia.edu/DirkvomLehn/Papers/114326/Exhibiting_interaction_conduct_and_collaboration_in_museums_and_galleries, accessed November 2011.

Wallis, R. J. (forthcoming), 'Pagans in Place, from Stonehenge to Seahenge: "Sacred" Archaeological Monuments and Artefacts in Britain', in M. Thøfner and S. Heslop (eds), *Icon? Art and Belief in Norfolk*, Oxford: Ashgate.

Wharton, Annabel Jane (2006), *Selling Jerusalem: Relics, Replicas, Theme Parks*, Chicago and London: University of Chicago Press.

White, William C. (1930), 'The Triple-Barred Cross', *Scribner's Magazine*, LXXXVIII (July–December).

Whitehead, Amy (2011), *Religious Objects and Performance: Testing the Role of Materiality*, PhD thesis, Open University.

Wilke, Annette, and Guggenmos, Esther-Maria (2008), *Im Netz des Indra: das Museum of World Religions, sein buddhistisches Dialogkonzept und die neue Disziplin Religionsästhetik*, Berlin: LIT.

Williams, Peter (2008), 'Creation Museum', *Material Religion: The Journal of Objects, Art and Belief,* 4/3.

Wingfield, Christopher (2009), 'Is the Heart at Home? E.B. Tylor's Collections from Somerset', *Journal of Museum Ethnography*, 22.

Wingfield, Christopher (2009), 'Touching the Buddha: Encounters with a Charismatic Object', in Sandra H. Dudley (ed.), *Museum Materialities: Objects, Engagements, Interpretations*, London: Routledge.

Wingfield, Christopher (2012), *The Moving Objects of the London Missionary Society*, PhD thesis, University of Birmingham.

Williams, Jonathan (2003), 'Sacred History? The Difficult Subject of Religion', in Kim Sloan (ed.), *Enlightenment: Discovering the World in the Eighteenth Century*, London: British Museum Press.

Yang, Mayfair Mei-Hui (2004), 'Spatial Struggles: Postcolonial Complex, State Disenchantment, and Popular Reappropriation of Space in Rural Southwest China', *Journal of Asian Studies*, 63/3.

Yanni, Carla (1999), *Nature's Museums: Victorian Science and the Architecture of Display*, New York: Princeton Architectural Press.

Zedeno, Maria Nieves (2008), 'Bundled Worlds: The Roles and Interactions of Complex Objects from the North American Plains', *Journal of Archaeological Method and Theory*, 15/4, 362–78.

Zekrgoo, Amir H., and Barkeshli, Manada (2003), 'Collection Management of Islamic Heritage in Accordance with the Worldview and Shari'ah of Islam', in Herb Stovel et al., *Conservation of Living Religious Heritage: Papers from the ICCROM 2003 Forum on Living Religious Heritage, Conserving the Sacred*, Rome: ICCROM.

INDEX

Illustrations are referenced by figure number.

—S
—E
—L

Metropolitan Community Church, Glasgow, 23–4

Metropolitan Museum of Art, New York
Multicultural Audience Development
Initiative, 39

Michel, Patrick, 31–2

Miho Museum, near Kyoto, Japan, 73

Miller, Daniel, 9

missionary collections, 85–7

multi-faith museums, 31–2

Mummy's Curse, The, Jasmine Day (book), 67

Murray, Thomas, 33

murtis, 32–3

Musée des Religions du Monde, Nicolet, Quebec, 100

Musée Internationale de la Réforme, Geneva, 98

Musée National des Arts et Traditions Populaires, Paris, 22

Musée Quai Branly, Paris, 77–8, fig 16

Museum of African Art, Washington
nkisi figures, 28

Museum of Archaeology and Anthropology, University of Cambridge, 43–4

Museum of Biblical Art, New York, 75

Museum of Contemporary Religious Art, Saint Louis University, 75

Museum of Islamic Art, Cairo, 97

Museum of London Docklands, 42

Museum of Mankind, London, 108

Museum of Methodism, London, 86–7, 98

Museum of National Hygiene, 84

Museum of New Mexico, 52

Museum of Religions, Marburg, Germany, 107

Museum of the History of Religion and Atheism, Leningrad, 82–5

Museum of Witchcraft, Bourton-on-the-Water (moved to Bocastle), 90

museums, 2, 3, 18–20, 105–6, 113, 117
of atheism, 81–5
attacked, 90–1
as memorials, 42–3
'new museology', 17, 40
secular, 22–4, 77–9
as shrines, 37–42, fig 9
as temple/church, 13, 73–5
social role of, 12, 17–20, 74–5, 99–100, 114–15

Museums, Objects and Collections, Sue Pearce (1992) (book), 14–15

Mushiboshi, 68

Muslims, 18–19, 32–3, 59

Nara National Museum, Japan
Kudara Kannon, 69

National Anthropology Archives, Smithsonian Institute, Washington DC, 48

National Aquarium, Baltimore, 1–2

National Coordination of the Conservation of Historic Monuments, 61

National Football Museum, Manchester, 110

National Gallery, London, 36, 108
'Seeing Salvation' exhibition, (2000) 19, 29–30

National Museum of India, Delhi, 78–9

Nath Hanh, Thich, 40

National Museum of Mali, Bamako, 65

National Museum of Natural History, Washington DC
Hope Diamond, 66–7

National Museum of Scotland, Edinburgh
Early People Gallery, 47, fig 7

National Museum of the American Indian, Washington DC, 49–50, 58, 116

national museums, 93

National September 11 Memorial and Museum, New York, 42

Native American Graves Protection and Repatriation Act 1990 (NAGPRA), 46, 49

Native Americans, 49–50, 116

Natural History Museum, London, 35, 42
The Vault, 65–6, fig 18

Nelson, Victoria, 8

neo-pagans 28, 40, 61, fig 8

'New Age', 22